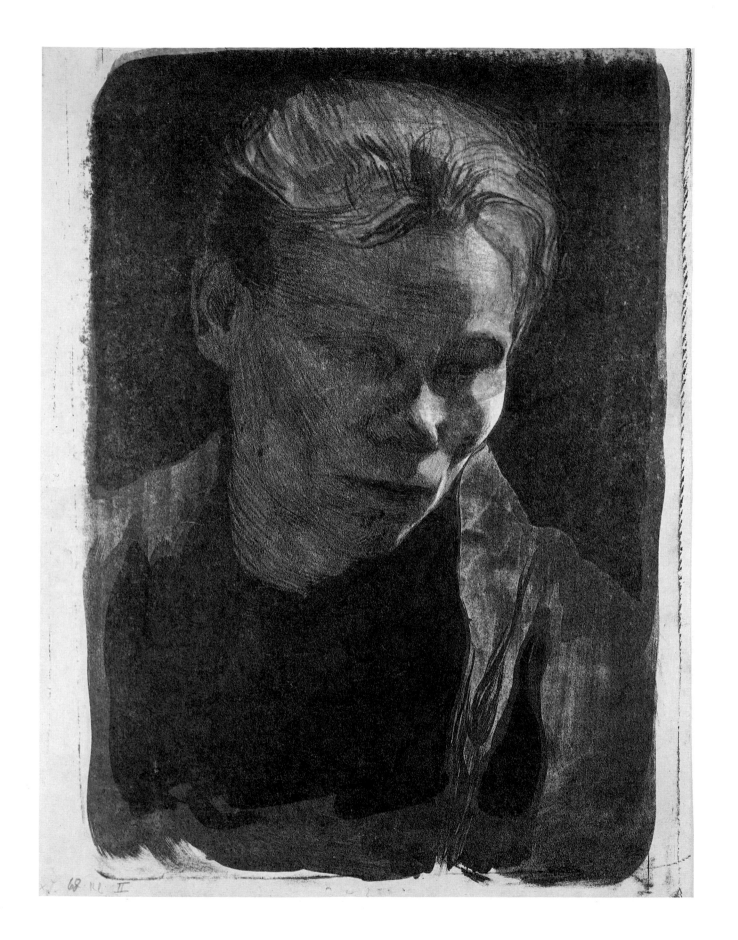

Käthe Kollwitz

ELIZABETH PRELINGER

with essays by

Alessandra Comini and
Hildegard Bachert

NATIONAL GALLERY OF ART, WASHINGTON
YALE UNIVERSITY PRESS, NEW HAVEN AND LONDON

The exhibition is made possible by Robert Bosch GmbH, Daimler-Benz, The Deutsche Bank Group, Mannesmann AG, Miles Inc., Siemens, Thyssen AG, and the Federal Republic of Germany, which have provided support for the Tribute to Germany festival.

The National Gallery is grateful to Lufthansa German Airlines for its transportation support of the exhibition.

Käthe Kollwitz is supported by an indemnity from the Federal Council on the Arts and the Humanities.

Exhibition dates
May 3–August 16, 1992

Produced by the editors office, National Gallery of Art
Frances P. Smyth, editor-in-chief
Edited by Jane Sweeney
Designed by Chris Vogel
Typeset in Janson by
BG Composition, Baltimore;
Printed on Leykam
by La Cromolito, Milan
PRINTED IN ITALY

FRONT COVER/JACKET: cat. 45. *Female Nude with Green Shawl Seen from Behind*, 1903. Kunsthalle Bremen

FRONTISPIECE: cat. 44. *Working Woman with Blue Shawl*, 1903. Private collection

BACK COVER/JACKET: cat. 98. *Self-Portrait in Profile Facing Left, Drawing*, 1933. National Gallery of Art, Washington, Rosenwald Collection

Note to the Reader

Dimensions are given in millimeters followed by inches in parentheses.

Kollwitz' prints are identified with the reference code *K.* and a numeral followed by a Roman numeral indicating state and/ or a letter indicating particular version as in the catalogue raisonné of her prints by August Klipstein, *Käthe Kollwitz. Verzeichnis des graphischen Werkes* (Bern/New York), 1955.

Drawings are identified by the reference code *NT* followed by a numeral as in the catalogue raisonné of her drawings by Otto Nagel and Werner Timm, *Käthe Kollwitz. Die Handzeichnungen* (Berlin, 1972, 1980).

Library of Congress Cataloging-in-Publication Data

Prelinger, Elizabeth.
Käthe Kollwitz / Elizabeth Prelinger; with essays by Alessandra Comini and Hildegard Bachert.
 p. cm.
Catalog of an exhibition held May 3– Aug 16, 1992 at the National Gallery of Art, Washington, D.C.
Includes bibliographical references (p.) and index.
ISBN (paperback) 0-89468-170-2
ISBN (clothbound) 0-300-05729-6
1. Kollwitz, Käthe, 1867–1945— Exhibitions. I. Kollwitz, Käthe, 1867–1945. II. Comini, Alessandra. III. Bachert, Hildegard. IV. National Gallery of Art (U.S.) V. Title.
N6888.K62A4 1992
709'.2—dc20 91–46307
 CIP

Contents

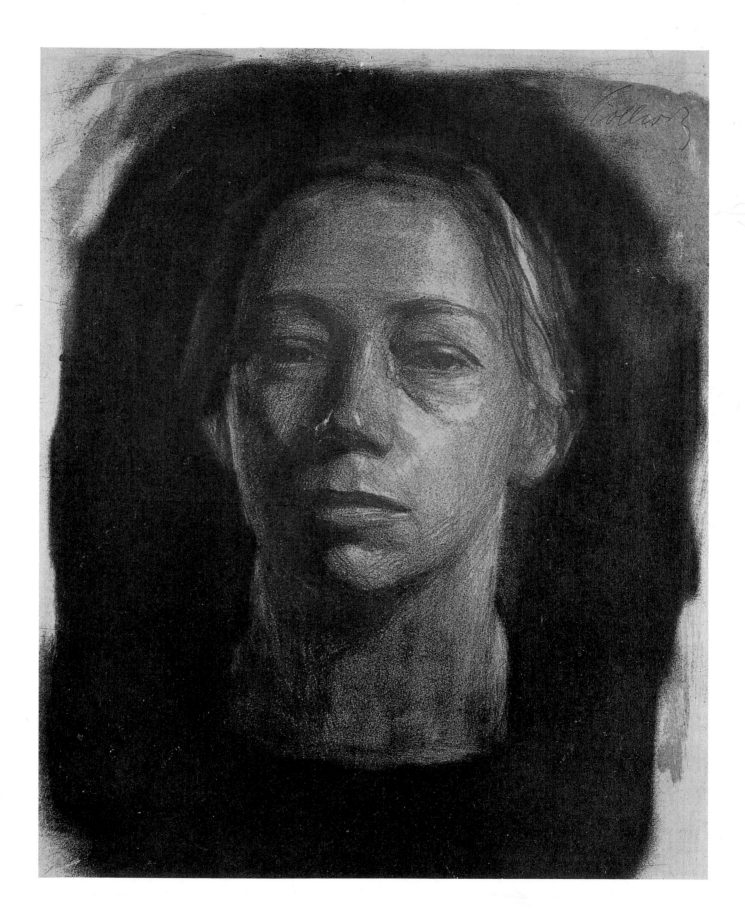

Foreword

Few artists have as devoted a following as Käthe Kollwitz. She has been celebrated throughout her native Germany, and her work has been the subject of numerous exhibitions worldwide. Kollwitz is largely known in this country through political posters and restrikes of her prints. Her reputation has to some extent been dominated by an emphasis on the social content of her work, often at the expense of her remarkable artistic skills. The present exhibition aims to challenge and augment that view by focusing on the artistic aspect of her achievement. Included in *Käthe Kollwitz* are a wide range of the artist's moving self-portraits, significant examples of her sculpture, and exquisite works in color that counter her reputation as a monochromatic artist. Also presented are preparatory drawings and working proofs, many never before exhibited in America. We expect that these rare works will lend valuable insight into the artist's inventive means of mastering her media.

This is the third exhibition of Kollwitz' work at the National Gallery of Art over the past three decades. In 1963 a selection of her prints from the Rosenwald Collection was shown in commemoration of Human Rights Week, followed in 1970 by an exhibition of the artist's prints and drawings, all but one of which came from the Gallery's collection. The present exhibition is nonetheless distinctive for highlighting some of Kollwitz' most significant works in all the various media in which she worked. It includes a substantial number of international loans, in particular works from Germany that are critical to a balanced and clear understanding of Kollwitz the artist.

Käthe Kollwitz follows a succession of exhibitions at the National Gallery devoted to the art of Germany. In addition to its prominent role in many of our general or survey exhibitions in recent years, German art has been the focus of no fewer than five exhibitions ranging from work of the sixteenth century to that of the twentieth. It is fitting that the present exhibition takes place at the time of "Tribute to Germany," a Washington-area cultural festival organized by the John F. Kennedy Center for the Performing Arts under the patronage of the Federal Republic of Germany. This promises to be an enlightening celebration of German culture in all its various forms: theater, music, dance, film, literature, and of course the visual arts. We hope that at this auspicious time it will also serve as a salute to a unified Germany.

The National Gallery is grateful to Lufthansa German Airlines and the Federal Republic of Germany, which together provided support for the

LEFT: cat. 58. *Self-Portrait en face*, 1904. Museum of Fine Arts, Boston, Frederick Brown Fund

exhibition as part of the "Tribute to Germany" festival. Lufthansa, in particular, provided essential transportation assistance.

The Gallery owes its extensive Kollwitz collection to many donors, including Philip and Lynn Straus who made an outstanding fiftieth anniversary gift. However, the primary basis for mounting a major Kollwitz exhibition at the National Gallery has been the generosity and foresight of two people. First is Lessing J. Rosenwald, whose gift to the nation of his superb prints and drawings, including many by Käthe Kollwitz, continues to distinguish the Gallery's collection and form the foundation for any exhibition here. Second is Richard A. Simms, today's preeminent private collector of Kollwitz' work and the major lender to this exhibition. He has also donated one of his fine prints to the Gallery, and it is our hope that others from his remarkable collection may follow. Dr. Simms' enthusiasm for this project has never faltered, and we are enormously grateful to him.

Many others have given invaluable assistance to this exhibition. The original proposal came from our Mellon Senior Curator, Andrew Robison, a specialist in German art. Elizabeth Prelinger, assistant professor of fine arts at Georgetown University, served as curator and author of the catalogue. Alessandra Comini, University Distinguished Professor of Art History at Southern Methodist University, and Hildegard Bachert, an expert on modern German art, both contributed insightful essays to the catalogue. And at the National Gallery Judith Brodie made a key contribution in her role as coordinating curator. To them we extend our warmest thanks.

Finally, we wish to recognize the many museums and private collectors throughout the world who gave freely of their time and expertise, especially those lenders who have shared with the American capital their superb works of art.

J. Carter Brown
DIRECTOR
NATIONAL GALLERY OF ART

List of Lenders

The Art Institute of Chicago

The Baltimore Museum of Art

Trustees of the British Museum, London

The Galerie St. Etienne, New York

Hirshhorn Museum and Sculpture Garden,
Smithsonian Institution, Washington

Käthe-Kollwitz-Museum Berlin

Käthe Kollwitz Museum Köln, Kreissparkasse Köln

Dr. Eberhard Kornfeld

Kunsthalle Bremen

Museum of Fine Arts, Boston

National Gallery of Art, Washington

Dr. August Oetker Zentralverwaltung

Chris Petteys

private collections

Richard A. Simms

Sprengel Museum Hannover

Staatliche Graphische Sammlung München

Staatliche Kunstsammlungen Dresden

Staatliche Museen zu Berlin-Preussischer Kulturbesitz,
Kupferstichkabinett

Staatsgalerie Stuttgart, Graphische Sammlung

Mr. and Mrs. Philip A. Straus

Mr. and Mrs. David S. Tartakoff

Zedelius Family

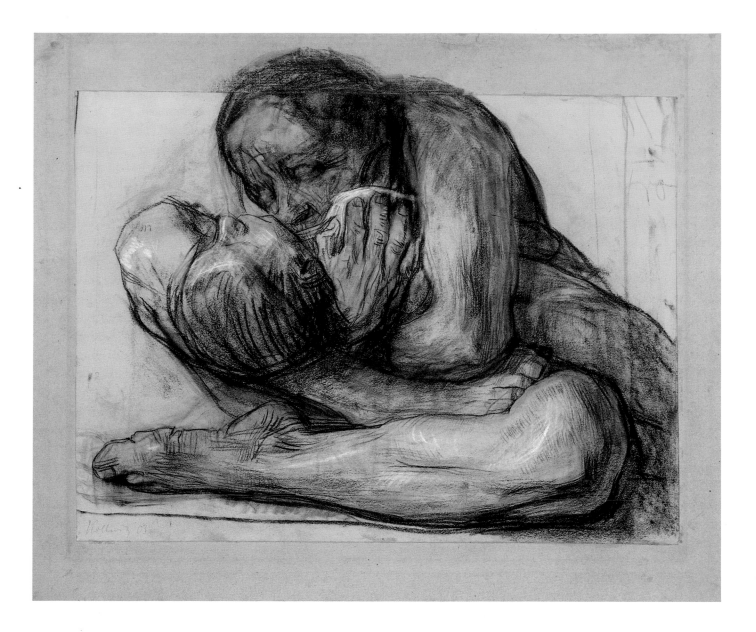

Kollwitz Reconsidered

ELIZABETH PRELINGER

Few artists are as universally loved as Käthe Kollwitz. Throughout the Western world, China, and the Soviet Union, her name conjures up powerful images of mothers and children, of solidarity among human beings, and of protest against social injustice and suffering. Many German towns have named a street, place, or riverbank in her honor, and the cities of Berlin and Cologne are home to museums dedicated entirely to her art. Aspects of her work are also familiar to Americans, though this has happened only relatively recently and largely as a consequence of World War II.[1] Critics and the public appreciated Kollwitz' art from the moment she was "discovered" in an exhibition in 1893; its accessible style and humanitarian themes ensured a wide audience that remained faithful during her lifetime and afterward.

Because Kollwitz steadfastly adhered to a figurative style in the era of abstraction, because she was a woman in a field dominated by men, and because she depicted socially engaged subject matter when it was unfashionable, critics have focused on those issues and have rarely studied the ways in which the artist manipulated technique and resolved formal problems. The literature tells too little of the artist as a gifted and technically inventive printmaker, draftsman, and sculptor, a virtuosic visual rhetorician who, in her best work, achieved a brilliant balance between subject and form. Such was Kollwitz' mastery of means and attachment to her subjects that the images seemed to flow spontaneously from the heart. However, the number of preparatory works, rejected trials, and evidence of extensive technical experimentation, in addition to ccaseless reflection on media and techniques in diaries and letters, portray an artist intensely involved in process and the act of making. As late as 1968, her son Hans Kollwitz acknowledged that she was highly talented in her work, a master of her craft ("eine Könnerin"), communicating through a command of visual devices that came only after long, hard effort, and that this purely artistic portion of her work was often neglected by commentators.[2] By contrast, this essay will examine the implications of Kollwitz' choice to become a graphic artist and, by studying not only finished works but also preparatory drawings and experimental proofs, will explore the means by which she created the rhetoric of her powerful images.

"Kollwitz Reconsidered" also addresses the tension that existed between the reception of Kollwitz' art and the artist's own attitude toward what she made and what she believed. It has served the interests of critics to present Kollwitz as a figure of unwavering resolu-

LEFT: cat. 50. *Woman with Dead Child*, 1903. Private collection

tion, progressive in terms of politics and feminism, without heeding her consistently critical and skeptical attitude toward her work and her ambivalent ideological and artistic stances, all of which she discussed at length in the diaries and letters. For example, although Kollwitz has been much touted as a radical artist, she was conservative stylistically, and she strenuously rejected association with any specific political party. In other words, Kollwitz' art and ideas emerge as far more problematic than is usually acknowledged, and they merit a reconsideration that restores a missing dimension to our understanding of both the person and her work.

Kollwitz as "Könnerin"— Master of Her Craft

Käthe Kollwitz' life and work may be viewed in terms of a continual interaction of oppositions. She was at once conventional and unconventional, conservative and progressive, reflecting an unresolved duel that was played out in her life and her art. These contradictory elements account for the richness of her work as well as for some of the confusions surrounding her accomplishment.

Kollwitz began her artistic career hoping to become a painter and ultimately emerged as a draftsman and printmaker. Encouraged by her family to cultivate her talents, she first studied with the engraver Rudolf Mauer (1845–1905), under whose direction and in the company of a few other girls Kollwitz drew after plaster casts and reproductions. Her first attempts at painting and drawing date from these teenage years.[3]

Kollwitz left home in 1884 at the age of seventeen to begin studies at the Zeichnen- und Malschule des Vereins der Künstlerinnen in Berlin. Barred from government-run art schools, female artists attended such academies established just for them.[4] These schools were not particularly progressive; they retained the traditional, academic instructional methods associated with the state-run academies, and bourgeois parents seem to have felt comfortable sending their daughters there.[5] Kollwitz was delighted with the academy; as she wrote in a letter to Max Lehrs (1855–1939), director of the Kupferstich-Kabinett in Dresden and one of the early collectors of her work, she felt lucky to study with the Swiss artist Karl

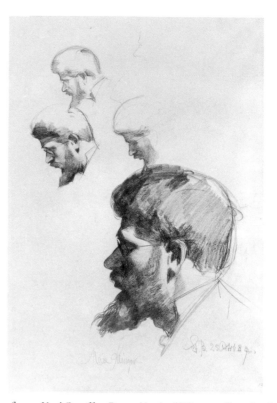

fig. 1. Karl Stauffer-Bern, *Heads of Klinger—Four Studies of Max Klinger*, 1883–1884, graphite on paper. Staatliche Kunstsammlungen Dresden

Stauffer-Bern (1857–1891), who encouraged her efforts and, with counsel that would prove decisive, steered her away from painting to cultivate her extraordinary talent for drawing (fig. 1).[6] "I wanted to paint," she later wrote, "but he kept pointing me back to drawing."[7]

During Kollwitz' first year in Berlin in 1884, Stauffer-Bern introduced her to the work of his friend Max Klinger (1857–1920). She went to see Klinger's etched cycle, *A Life* (fig. 2), at an exhibition, and was greatly excited by his virtuosic, hyperreal technique combined with his dual concern with social issues and fantastic allegory.[8] She did not abandon the study of painting immediately after her contact with Klinger's work; a sojourn in Munich from 1888 to 1889, where she studied with Ludwig Herterich (1856–1932), allowed her to pursue her lessons in color. Nevertheless, in a letter to Paul Hey, a school companion from Munich days, she ruefully observed that "With my eyes, I always paint very well but with my hands I'm deficient."[9] Realizing that her true talents lay in the graphic media, she took up etching in 1890 and abandoned oil and canvas for good.

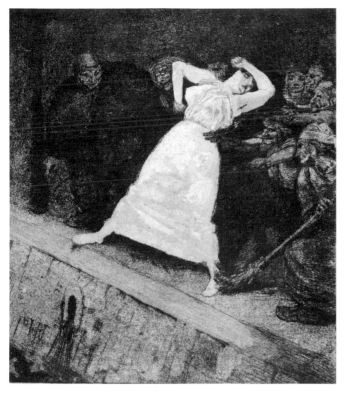

fig. 2. Max Klinger, *Into the Gutter*, from *A Life*, 1884, etching and aquatint. Los Angeles County Museum of Art

Klinger's example, as theoretician, as technician, and as creator of visual narratives, was crucial to Kollwitz' decision to become a graphic artist. Indeed, the history of modern printmaking in Germany has been viewed as beginning with Klinger.[10] Though very different in other respects, the two principal German surveys of nineteenth- and twentieth-century graphic art, published in 1914 and 1922, both concurred on this point.[11] Klinger became the "first major German artist for decades who made his own prints (in his case etchings) a fundamental and unignorable part of his work."[12] Instead of leaving the creation of the actual matrices to professional craftsmen, he learned how to etch, creating fourteen major print cycles that are generally considered to surpass his painting and sculpture.[13] In so doing, the artist established for succeeding generations the status of the graphic arts as equal in worth to other media.[14]

In addition to creating works of remarkable thematic invention and technical ingenuity, Klinger published a theoretical treatise, *Malerei und Zeichnung*, which originally appeared in 1891.[15] Here Klinger outlined

his views on the role of the print as opposed to that of oil painting with color, establishing a unique agenda for the graphic arts in Germany. In this highly influential work, Kollwitz found validation for the direction she would eventually choose.[16]

Under the concept "drawing" Klinger included the arts he understood as monochromatic, prints in particular. To drawing he opposed oil painting with color, understanding this medium in terms of highly realistic nineteenth-century academic styles. Whereas the print stood "in a freer relationship to the representable world," painting, through its dependence upon color, was so bound to the natural world and the world of appearances that it was less successful as a vehicle for conveying imaginative issues or approaches to the real world that extended beyond the sensuous apprehension of material things. Painting was related more to decoration and to the creation of "pictures" than to the world of fantasy and the idea. Drawing, as Klinger defined it, was far more programmatic. It had more in common with poetry in its potential for the expression of ideas; less complete and concrete in details, perhaps, than painting, drawing was therefore more suggestive in its scope. Unlike painting, a so-called "pictorial" art, which provides "pure enjoyment," drawing, a so-called "reporting" art,[17] whose most salient characteristic is the subjectivity of the artist,[18] could confront the unbeautiful and the repugnant.[19]

Klinger perceived the graphic arts to be uniquely suited to the creation of a monochromatic cycle of images, within which a piece of life might be unfolded, might expand itself in "epic" fashion, intensify itself dramatically, and look us in the face with dry irony. The images produced by drawing, which are only "shadows," could therefore seize the monstrous without giving offense.[20] Klinger explained that "there are fantasy images which are not, or merely in a limited way, artistically representable through painting, but which are accessible to representation by drawing without losing anything of their artistic value. It turned out that these images spring from a world view [*Weltanschauung*], I would like to say from the world-feeling [*Weltgefühle*], just as the images in painting spring from the form-feeling [*Formgefühle*]."[21]

Liberated from the necessity of defining every detail, a task that Klinger regarded as intrinsic to the

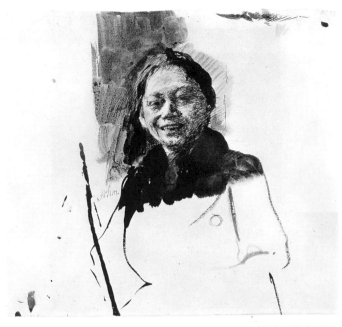

cat. 1. *Self-Portrait en face, Laughing*, c. 1888–1889. Käthe-Kollwitz-Museum Berlin

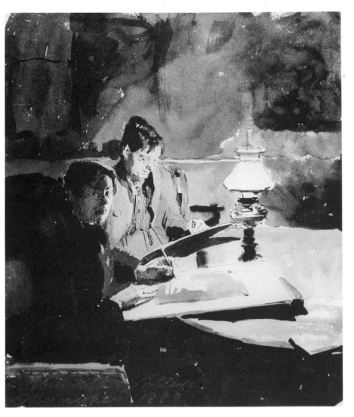

cat. 3. *Self-Portrait with Student Colleague*, 1889. Private collection, courtesy Galerie St. Etienne, New York

medium of painting, drawing could pursue its purpose of representing ideas.[22] Instead of attempting to beautify things, the print became a critical tool.[23] "All masters of drawing, " observed Klinger, "develop in their works a conspicuous trend of irony, satire and caricature. They prefer to emphasize weakness, sharpness, hardness, and evil. Out of their works bursts almost everywhere a basic tone: The world should not be like this! They practice criticism with their stylus."[24]

Finally, the print was by nature reproducible, which permitted it to find a wide audience and not to disappear, like a drawing, into a library. It could thereby achieve as much recognition as a painting and stand on its own as an independent art, not as a secondary and lesser art.[25]

These arguments simultaneously influenced Kollwitz and confirmed her sense of artistic mission. They reveal that, in pursuing graphic art, Kollwitz opted not only for certain media, but also for particular kinds of subject matter. The scope of "drawing," as defined by Klinger, provided Kollwitz with license to

explore social issues as well as mystical allegories; since both remained within the realm of the idea, the two concerns were less antagonistic than might be supposed. Further, unlike Klinger and other famous contemporaries of the 1890s such as Munch and the Nabi group, Kollwitz was not a painter-printmaker, but exclusively the latter. It was of crucial importance to Kollwitz that her work be moderately priced and widely accessible, features intrinsic to the graphic arts.[26] Related to this was the fact that, as Kollwitz became more socially engaged over the course of her career, she progressively distanced her art from involvement with laborious techniques and embraced the stark purity of the "reporting" art of "drawing." Klinger's notion of the tasks of the graphic arts would remain with her for life.

Kollwitz' gift for drawing emerged early in her striking self-portraits, executed in all media (cats. 1–5, 7, 8 [see p. 104], 10). But the artist's choice of ideas that appealed more to "poetic apprehension" than to the eye[27] and her most significant experimentation, both

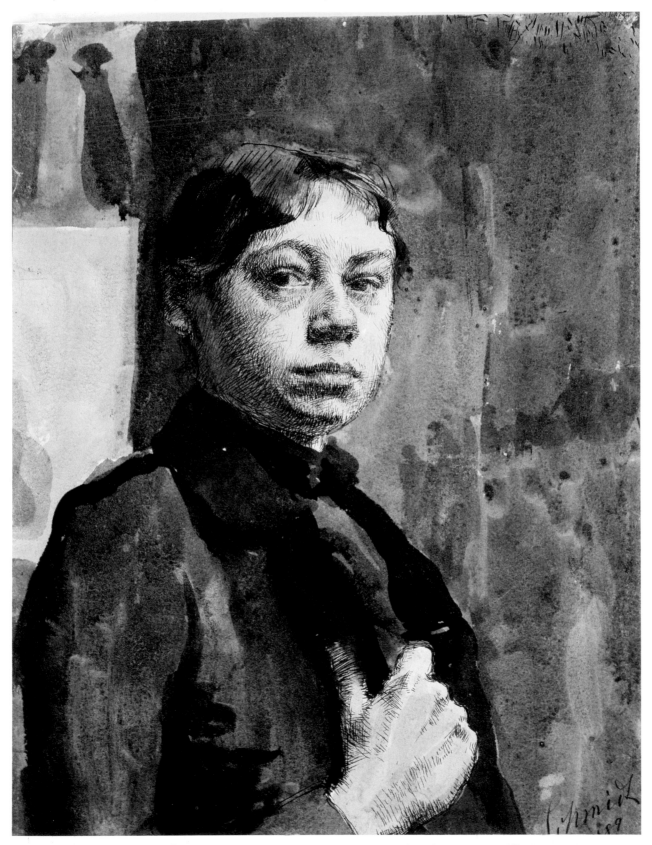

cat. 2. *Self-Portrait*, 1889. Käthe Kollwitz Museum Köln, Kreissparkasse Köln, on loan from a private collection

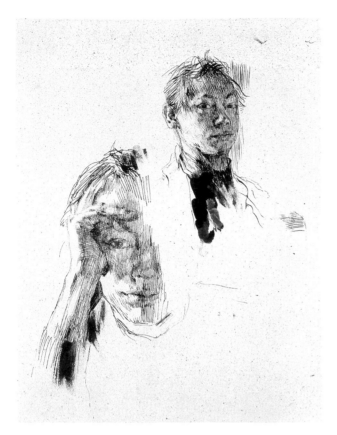

cat. 4. *Two Self-Portraits*, 1891. Staatliche Museen zu Berlin, Kupferstichkabinett

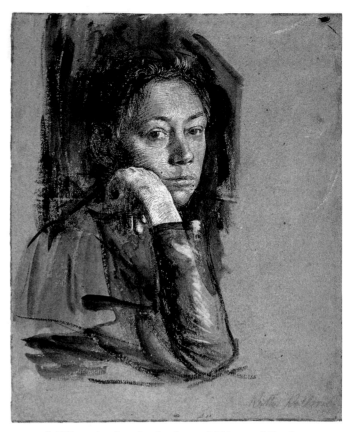

cat. 5. *Self-Portrait*, 1891. Art Institute of Chicago, Gift of Mrs. Tiffany Blake, Mr. and Mrs. Alan Press, and the Print and Drawing Fund

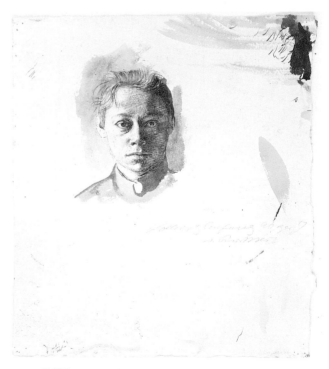

cat. 7. *Self-Portrait en face*, 1892. Käthe Kollwitz Museum Köln, Kreissparkasse Köln, on loan from a private collection

with technique and the creation of a forceful rhetoric, may be traced in her five graphic cycles and in a number of single-sheet works that treat themes of particular emotional or ideological import.[28] These works afforded her the opportunity to explore in depth the interrelationship of media, pictorial organization, and rhetoric, or, in a more general sense, to find an appropriate visual form for the ideas she wished to realize in her art.

The artist's first sustained involvement with the print media not coincidentally overlapped with her decision to create a visual narrative based on Emile Zola's naturalist mining novel, *Germinal*, which had appeared in 1885. The idea derived from a single drawing that she made during 1888/1889, while she was studying in Munich under Herterich's direction. One evening she joined a gathering of women artists in the company of the well-known artists Otto Greiner, Alexander Oppler, and Gottlieb Elster. A theme was chosen and each participant was required to produce a drawing illustrating it. That night, the theme was a

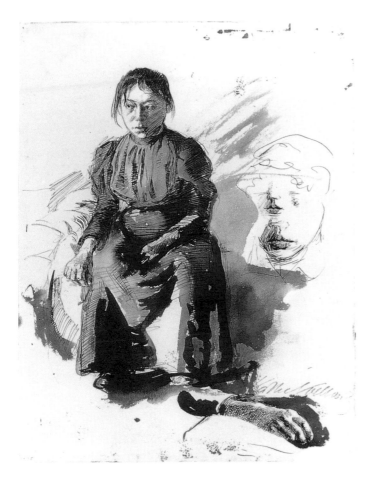

cat. 10. *Self-Portrait Full-length, Seated*, 1893. Dr. Eberhard Kornfeld

"fight." Kollwitz chose the scene from *Germinal*, "where, in a smoky tavern, the young Catherine is being fought over by two men."[29] To her delight, the composition was greatly praised, marking a turning point in her conception of her career. "For the first time I felt established in my path, great perspectives opened themselves to my fantasies and the night was sleepless with happy expectation."[30]

That particular charcoal drawing, which has never been precisely identified, became a preliminary study for the richly realized scene depicted here, made when Kollwitz decided to pursue the theme further (cat. 6).[31] In order to render the setting as convincing as possible, Kollwitz exercised good naturalist practice, carrying out actual studies of a sailors' bar when she returned to Königsberg after her stay in Munich.[32] She made friends with the proprietor of the bar and sketched the interior in the morning when it was empty.[33]

The choice of rendering Zola's novel in pictures was significant for several reasons. First, she initially conceived the project as a painting, and then, after becoming stuck, realized, perhaps from Klinger's example, that the format of a print cycle would be most effective. She outlined her plans in a letter of 1891, mentioning that the preliminary drawings were almost finished and that she would begin to convert them to prints as soon as she had more practice with etching.[34]

Second, Kollwitz' choice of *Germinal* reflected her long-time interest in the lives of workers as opposed to the bourgeoisie. Workers of the rural and, later, urban proletariat fascinated her from the time she was a child. At the outset, however, Kollwitz' portrayal of such subjects did not stem from social engagement. According to the artist herself, the proletariat laid claim to her imagination through literary sources, often recommended to her by family members, and from observation of her surroundings in Königsberg. Direct contact with the poor and the misery of their

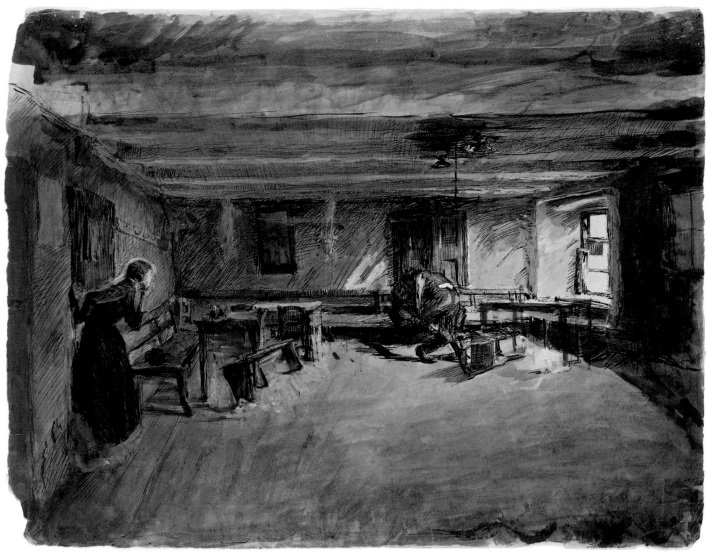

cat. 6. *Scene from Germinal*, 1891. Private collection

lives came only later, well after she had moved to
Berlin in 1891 and become acquainted with her hus-
band's patients at his clinic, most of whom were mem-
bers of the industrial proletariat and who became the
subject of much of her art. Nor did her depictions of
the poor originate entirely from sympathy or her con-
viction to provide them with a voice through her art.
Kollwitz admitted that she initially chose these subjects
because, simply, she found them to be beautiful.[35]

During the time she was working with the scene
from *Germinal* and pursuing the idea of a cycle,
Kollwitz attended a private opening performance of
Gerhart Hauptmann's play *The Weavers* on 26 Feb-

ruary 1893 in Berlin. Based upon a historical uprising
of Silesian workers in 1844, *The Weavers* made an
enormous impact when it was produced, to the extent
of being temporarily banned by the government for
subversiveness. In Hauptmann's version of the events,
the weavers collectively agree that their lot is intoler-
able. They descend upon the mansion of their employ-
er, who calls in the military. In the melee that results,
an old man who had strenuously opposed the uprising
is killed by a stray bullet that flies in his window. The
play ends on this ironic and inconclusive note.

Kollwitz was so moved by the performance that
she decided immediately to abandon Zola's novel as

the subject of her graphic series and to substitute Hauptmann's play. The choice of this infamous work guaranteed her an audience and established her reputation as an advocate for the downtrodden. Moreover, in this role she found good company in the Germany of Emperor Wilhelm II. Max Liebermann, Fritz von Uhde, and Wilhelm Leibl were only three of a number of contemporary painters who embraced this kind of subject, sharing the notion of art as a means of communicating everyday truths rather than art for art's sake. While aiming "for realism without the sentimental or anecdotal additions that traditionally rendered lower-class motifs agreeable," they also avoided overt commentary that might lead to problems with the emperor.[36]

In creating the cycle, which would occupy more than four years of her life, Kollwitz effectively accepted Klinger's challenge to develop an epic suite of images linked by ideas, which confronted difficult themes of poverty, infant mortality, violent rebellion, and retaliatory slaughter. The story would not be beautified by being rendered in color; rather, as Klinger had advocated, Kollwitz found the materials for the depiction of the weavers' environment in the monochromatic graphic techniques she cultivated specifically for this purpose. Her apprenticeship in the graphic arts, launched here, would later come to fruition in the series *Peasants' War*.

Our precise understanding of Kollwitz' training in etching, the first graphic medium she essayed, remains somewhat cloudy and contradictory, and we must depend upon her own remarks as well as the evidence of her early work. She claimed in several places that the etching technique gave her much difficulty at the outset and that she was essentially self-taught and not very successful. In a letter of 1901 to Max Lehrs, she wrote that before her move to Berlin with her new husband in 1891, she asked the copper engraver Meurer (sic) to show her "how one grounds a plate and what kind of acid one uses— there was not sufficient time for more instruction— and then in Berlin I sought with laborious study to come at the etching technique by myself." She noted later that, with two children, she had even less time to study the procedure.[37] In the same letter, Kollwitz related that, on the strength of her success with her first cycle of printed

images, *A Weavers' Rebellion*, which appeared in 1898, the director of her alma mater in Berlin, Margarete Hönerbach, asked her to teach the class in etching. She was reluctant to teach since "[my] knowledge of the etching technique was so weak . . . that I could hardly take charge of any instruction." Kollwitz noted in her memoirs that, indeed, Hönerbach, who had studied with the eminent Berlin teacher Karl Köpping (1848–1914), on one occasion stepped in and tactfully offered an alternative method for grounding a plate, sparing the artist considerable embarrassment in front of her students.[38]

These anecdotes to the contrary, Kollwitz' early attempts appear extremely successful technically.[39] From her first sheet of studies (K. 1), dating from 1890, and her early nudes (K. 3–4), to her first etched self-portrait in 1891 (K. 8), one can trace her increasing ambition and mastery. It thus seems unlikely that the artist experienced problems with line. Perhaps the difficulties to which she referred arose from the tonal and textural processes that were so crucial to her compositions for *A Weavers' Rebellion*. These most certainly were experimental and troublesome, yielding results that were not always quite what she had expected. She later wrote that "I was often very discouraged, that what was good as a drawing came off the plate in such a completely unsatisfying manner."[40]

Lithography, on the other hand, presented no such problems for Kollwitz. To Max Lehrs she observed that she had been doing lithography along with etching and that she actually planned to mix the two techniques. It was not hard for her to experiment, she related, because she had a press at her disposal, and she acknowledged how straightforward the lithographic technique could be.[41] Her earliest works on stone date from the later 1890s, just as the centennial of the process was being commemorated.[42]

Kollwitz began work on *A Weavers' Rebellion* in 1893, exhibiting it five years later at the Women Artists' Exhibition at the Gurlitt Gallery before receiving national critical and popular success at the Grosse Berliner Kunstausstellung. An examination of some of the numerous trials she made for the motifs illustrates the importance of experimentation to the artist and her search for the most expressive compositions. Although Kollwitz did not intend that these preliminary studies

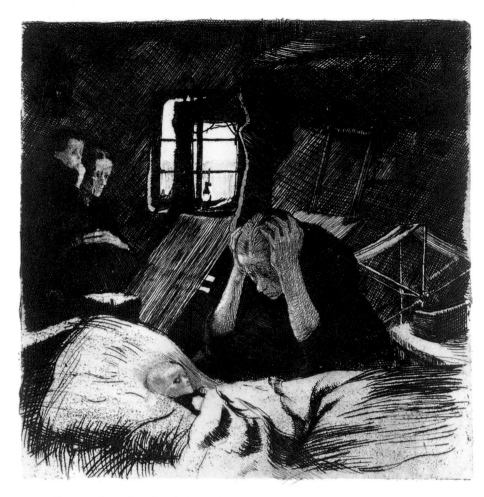

cat. 12. *Poverty*, 1893–1894. Staatliche Kunstsammlungen Dresden

be exhibited or sold, they are distinguished for their beauty and technical interest and provide invaluable documentation of her aesthetic preoccupations.

The series consists of six images: *Poverty, Death, Council, March of the Weavers, Storming the Gate,* and *End.* They caused Kollwitz much difficulty as she struggled with her newly acquired knowledge of printing techniques. In her reminiscences, she related how, once she had seen the play and decided to produce a cycle of images about it, "[her] technical ability in etching was still so weak that the first attempts failed." This is why the first three *Weavers* sheets were lithographed and the last three were etched, an unusual situation for a single cycle.[43]

The etchings for the first plates were in fact extremely successful. Kollwitz proceeded in the conventional fashion of making preparatory drawings and

trial proofs, seeking out the most expressive configurations. The first one, *Poverty*, was carried out in four separate versions (к. 22; к. 23; к. 26; к. 31), over about three years, with two distinct compositions. The Dresden proof (cat. 12), acquired by the print cabinet from the artist herself, represents a rejected trial for the final image, which she ultimately reworked in similar fashion as a lithograph (к. 34).[44] The scene appears nowhere in Hauptmann's play and may instead have had an artistic source, for example Edvard Munch's *Sick Child*, which appeared in drypoint form in 1894 (fig. 3).

With etching needle and drypoint, Kollwitz set the stage for her drama by depicting a dark low room filled with weaving tools. One window illuminates a woman bent with despair over the bed of a dying infant. This dark and menacing second state enmeshes the triangu-

lar form of the woman with the echoed forms of the looms in the background, suggesting that they are bound together inexorably in an unbreakable cycle. The diagonal lines and patches of light and dark (extolled by Klinger as crucial to the language of the graphic arts), which emphasize the deathbed, create a spiraling movement around the image as the eye circulates like the endless rotations of the spinning wheel. On the impression reproduced here, Kollwitz added notes reminding her where to etch further, and she touched certain areas, such as the child's face and the mother's arms, with tiny pencil scratches to indicate where more work would be needed. The sheet combines delicate handling with a movemented linear vigor, particularly in the rendering of the architecture, and results in a bold and chilling conception. The fine-drawn treatment of the dying infant's face is simultaneously gruesome and heartrending. So accomplished is the technique that it is unclear why she rejected this version, especially when the final lithograph is so similar. She evidently concluded that the slightly rougher lithographed effect was more appropriate than the intricacy of the etching, which perhaps asked to be treated like a "belle épreuve," something to be appre-

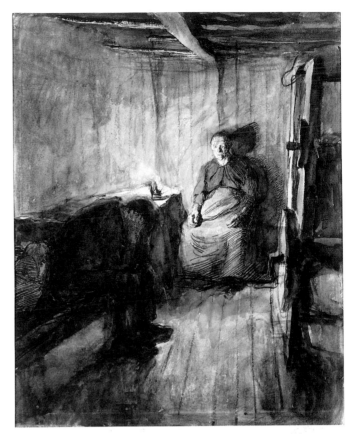

cat. 14. *Poverty*, 1895. Sprengel Museum Hannover

ciated too much for the technique at the expense of the subject.

Some two years later Kollwitz experimented with another composition for *Poverty* (cat. 14). In this drawing, which recalls van Gogh's *Potato Eaters* (1884), she lodged the figures within a deeper space. The arrangement is similar to the one Kollwitz chose for the second sheet of the series, *Death*, and she may have decided that the compositions resembled each other too closely and needed more variation. In the drawing Kollwitz worked with pen and ink, smudging chalk for atmosphere and adding yellow highlights and a purplish wash. Her chalk lines pick up the tooth of the paper and acquire a rough texture that mimics the splintery boards of walls and floor. The obscurity heightens the hopelessness, a correlative to the grim-faced woman as she sits with her enormous, work-deformed hands temporarily idle.

Death (cat. 19) seems to have posed fewer problems for the artist. It is the first of the *Weavers* cycle sheets

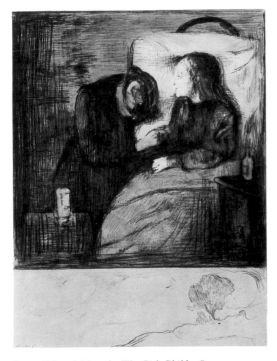

fig. 3. Edvard Munch, *The Sick Child*, 1894, drypoint. National Gallery of Art, Washington, Rosenwald Collection

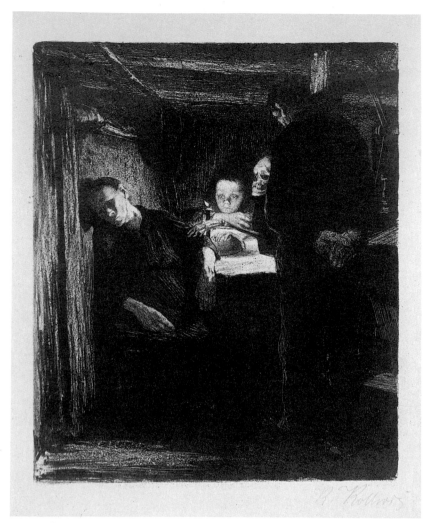

cat. 19. *Death*, 1897. Private collection

that she seems to have rendered immediately in lithography without first exploring it as an etching. The advantage was that the technique imitated the effects of an intaglio print but bypassed the difficulties of the copper plate. Here Kollwitz adopted the general configuration of the second trial for *Poverty*, the dark, low-ceilinged room with figures facing us as if on a stage. The viewer is directly confronted by the woman who, leaning against the wall, has slipped out of life in response to the gently menacing brush on her arm of the skeletal fingers of Death. Only the recoil of the candle's flame intimates that an alien presence intrudes upon the silent watchfulness of the man and the boy. More than the other *Weavers* sheets, *Death* refers to Kollwitz' acquaintance with contemporary symbolist art, underscoring her penchant for combining naturalism with symbolism in a single work. This blend, which formed the basis for much of Max Klinger's work as well, reflects the ability of the graphic arts to bridge two worlds credibly. By means of the skeleton, the artist also managed to evoke the way in which the simple weavers might conceive of death and made the situation obvious to her viewers in the most direct manner possible.

Kollwitz adhered to traditional academic practice in producing the cycle, making preparatory studies of individual elements, assembling them into a finished compositional sketch, and reworking it onto the copper plate, which she built up over a series of states. The preparatory drawings for *Storming the Gate* (cat.

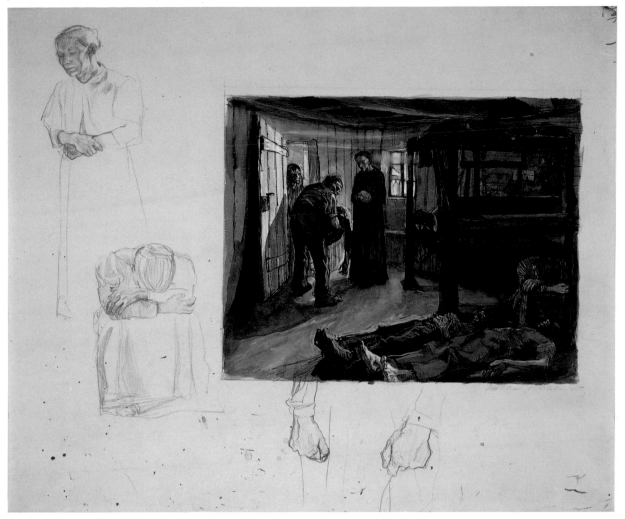

cat. 20. *End*, 1897. Staatliche Kunstsammlungen Dresden

17, p. 143) and for *End* (cat. 20) are among the most finished in Kollwitz' extant oeuvre. In *End*, the treatment of line, for example in the crosshatching of the seated woman's skirt, indicates that Kollwitz was thinking directly in terms of etching. She touched in white gouache markings to signal where on the print she would burnish away a ground of aquatint, such as in the strange shafts of light entering from the doorway. Accents on the corpses lying on the floor refer to later burnishing, or, as in the case of the feet, seem to indicate lighter biting of the plate.

For the etchings, however, Kollwitz dispensed with the feeling of smoothness and finish that distinguish the preparatory drawings. By deliberately seeking a gritty and corroded effect on the surface of the plates

she shaped the viewer's apprehension of the scene, removing the possibility of aestheticizing the event and forcing the beholder into the hovels of the destitute. Through manipulating the graphic procedures, Kollwitz created meaning and promoted feelings of empathy.

In the process of transferring *End* to the plate for the final etching (fig. 4), Kollwitz altered her interpretation of the cycle and the lesson it was intended to convey. In the study the standing woman clasps her hands together, resigned, as the men carry in the slain strikers. In the etching, however, she clenches her fists; a study of the gesture is already visible at the bottom of the drawing. Whereas Hauptmann had been criticized at the time of the play's production for not pro-

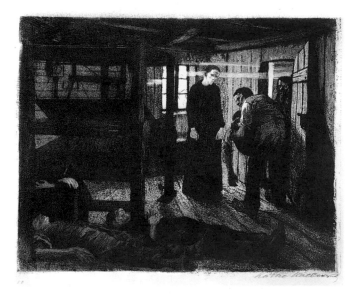

fig. 4. Kollwitz, *End*, 1897, etching and aquatint. National Gallery of Art, Washington, Rosenwald Collection

viding a plan for further action on the part of the weavers (and by extension the workers of the world),[45] Kollwitz' small alteration engendered a large change in meaning — from resignation to militant anger — suggesting that in her version these deaths would not go unavenged. With this rhetorical gesture, Kollwitz reformulated the message of the play.

Kollwitz made one more sheet, which she intended as the conclusion of the series. *From Many Wounds You Bleed, O People* (fig. 5) was completed in 1896, in the

midst of her work on the cycle, and demonstrates the artist's enduring fascination with symbolic imagery within a realist project. Organized in three parts and bearing the title across the top, it resembles a traditional Christian Lamentation[46] and depicts a man with a sword[47] bending over the corpse of a nude male figure, which relates visually to the lifeless figures in *End*. On both flanks there stand nude females bound to columns. It has been suggested that these allegorical figures on either side of the central scene represent themes of Poverty and Shame[48] or suicide and prostitution, symbolizing the hopeless situation of the proletariat.[49]

The motif, which has been interpreted in different ways according to the interests of the particular observers, forms a jarring contrast to the naturalism of the other *Weavers* images. The critic Julius Elias felt that it lent a false note to the modern naturalist tragedy, a Klinger-like ending inappropriate to Kollwitz' cycle, and he successfully persuaded her to omit it from the series.[50] Nevertheless the theme and its intricate symbolic program fascinated Kollwitz, and she reprised it in 1900 in the more elaborated program of *The Downtrodden* (cats. 26, 27).

The iconography of *From Many Wounds You Bleed, O People* and *The Downtrodden* has been explicated at length.[51] Of interest in this context is the obvious attraction that Kollwitz felt for allegory and traditional Christian visual rhetoric. She departed from the grim realism of the weavers scene in the former image and

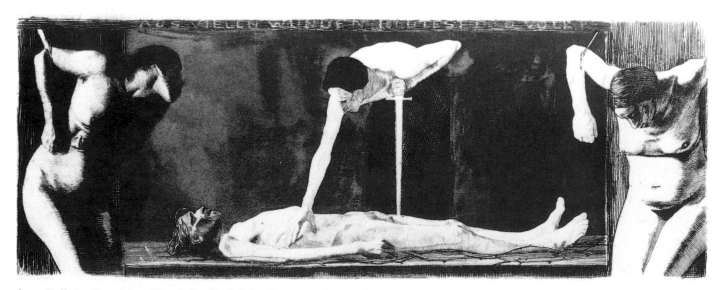

fig. 5. Kollwitz, *From Many Wounds You Bleed, O People*, 1896, etching and aquatint. Private collection

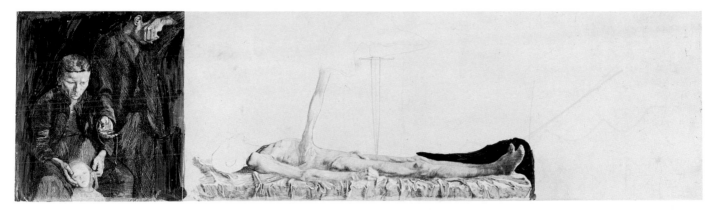

cat. 26. *The Downtrodden*, 1900. Staatliche Kunstsammlungen Dresden

then created a curious combination of the two modes in the latter, encapsulating in this single work the dichotomy of realism and romanticism that characterized German art of this era.

The preparatory drawing for the etching that Kollwitz ultimately titled *The Downtrodden* bears the inscription "Das Leben" (life) (cat. 28). Because of the notice "Zu 'Das Leben'" on the *Self-Portrait at the Window* (cat. 31), it has been proposed that the artist planned a series of that name, reminiscent of Klinger's cycle *Ein Leben*. Perhaps also it was meant to be a self-contained panorama of the condition of proletariat existence, with the inclusion of the artist's own face, which she later removed, as observer or chronicler.

Kollwitz adopted the format of the triptych, associ-ated with an altarpiece, for the image. In the center she placed the motif evoking the dead Christ, and shifted the two allegorical figures to the left side in company with a superimposed self-portrait. But on the right side of the tripartite scene Kollwitz positioned a realist image of a proletarian family, where a resigned mother, numb with grief, cradles the head of her dead child while a despairing father dangles a hangman's noose. It is a tragic recasting of the motif of the Holy Family and a sort of working-class Lamentation, not unlike that in *End* but rendered in a more overtly Christian manner.[52]

Kollwitz made many studies for *Life*, of which *Self-Portrait and Nude Studies* (cat. 34), *Sitting Woman* (cat. 29), *Child's Head in a Mother's Hands* (cat. 30), and *Nude*

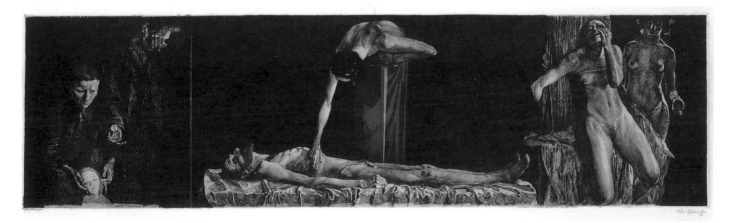

cat. 27. *The Downtrodden*, 1900. Private collection

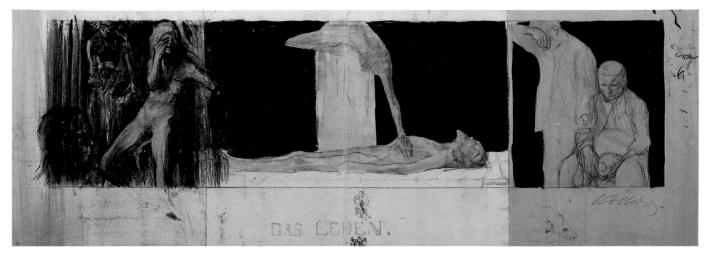

cat. 28. *Life*, 1900. Graphische Sammlung, Staatsgalerie Stuttgart

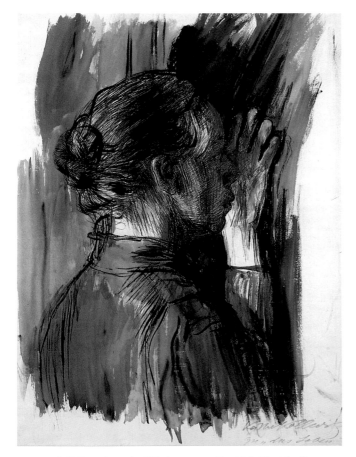

cat. 31. *Self-Portrait at the Window*, 1900. David S. Tartakoff

Study for "Das Leben" (cat. 37) are among the most delicately worked and expressive. When the artist finally turned to the plate, she constructed the image in stages based upon these works. The proof of the first state reproduced here (see cat. 26) eloquently illustrates Kollwitz' procedure. It consists of the family scene, which was printed separately and added to the other two sections, of which the rightmost has been simply lightly sketched in pencil as Kollwitz worked out the composition.[53]

The most finished state of the etching (see cat. 27) exhibits technical virtuosity and brilliant draftsmanship; the fine drawing combined with the velvety black of the aquatint background forms one of the most triumphantly polished works Kollwitz ever created in the intaglio medium. Although with this image the artist demonstrated that she could equal the technical finish and meticulous detail of her teachers and mentors, in particular Stauffer-Bern and Max Klinger, she possessed a strong sense for the appropriateness of modes. Consequently, the images finally chosen for *A Weavers' Rebellion* are looser and rougher, as befits the subject matter. Kollwitz understood that the addition of a sheet like *From Many Wounds You Bleed, O People* or *The Downtrodden* would have detracted from the power of her *Weavers' Rebellion*, not only in terms of their symbolic content but the exquisite sleekness of handling as well. Later, as she became more involved

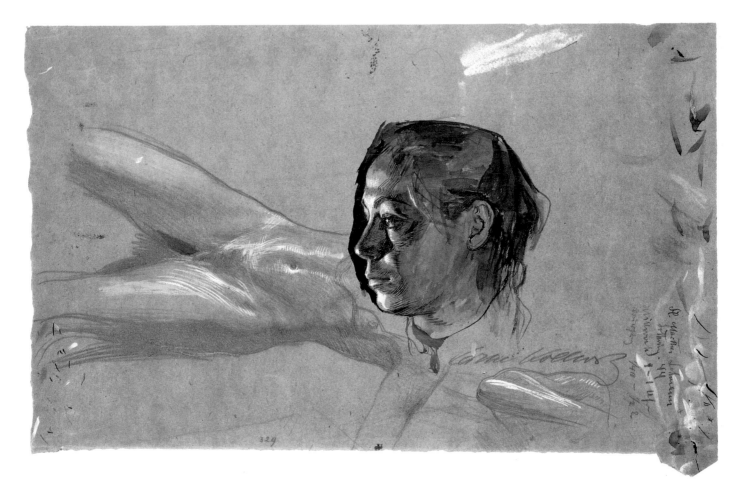

cat. 34. *Self-Portrait and Nude Studies*, 1900.
Graphische Sammlung, Staatsgalerie
Stuttgart

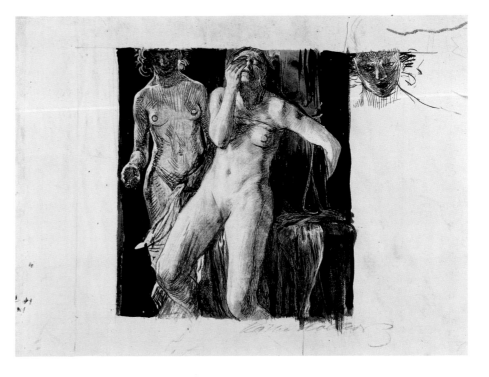

cat. 37. *Nude Study for "Das Leben,"* 1900.
Käthe-Kollwitz-Museum Berlin

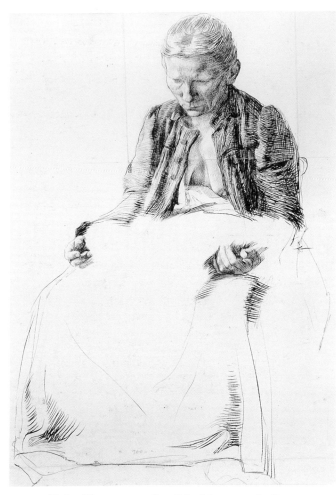

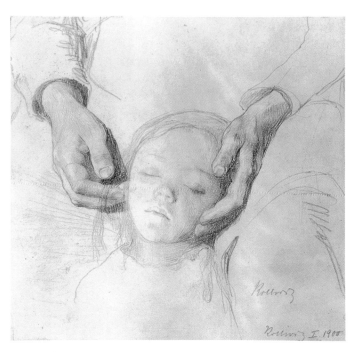

cat. 30. *Child's Head in a Mother's Hands*, 1900. Staatliche
Kunstsammlungen Dresden

cat. 29. *Sitting Woman*, 1900. Staatliche Museen zu Berlin,
Kupferstichkabinett

with socially engaged imagery, Kollwitz repudiated
The Downtrodden, with the exception of the scene of
the family. She maintained that the rest of the image
appeared sentimental, even "fatal" to her.[54]

The cycle combined academic procedure with a
topic that was considered unconventional and subver-
sive enough for the ministers advising the German
emperor Wilhelm II to prevent the artist from receiving
the Berlin Salon's small gold medal.[55] In the philistine,
repressive Prussian atmosphere, it was not just the type
of material but the subject in conjunction with its "nat-
uralistic" execution that troubled the officials, at the
same time that they admired its "technical compe-
tence" and "forceful, energetic expressiveness."[56]

Kollwitz' work represented something new; among
other things, she simply had not illustrated the play.

For *A Weavers' Rebellion (Ein Weberaufstand)*, she nei-
ther adopted Hauptmann's exact title, nor used the
definite article (*Der Weberaufstand*). This suggests,
first, that while the drama formed the basis for her
cycle, the images were not in fact intended to illustrate
the play so much as to create a parallel and self-
sufficient visual text; and, second, that it was not a
specific historical rebellion to which she was referring,
but the general intolerable and unchanging state of
these workers and the continual nature of their protest
against such conditions. New evidence and argument
have further confirmed that, despite her supposed
abandonment of *Germinal*, she may even have relied
more upon that novel than upon *The Weavers*, actually
conflating the two works as she freely devised a story
in pictures.[57]

Further, the cycle drew upon Klinger's notion that works in black and white, prints in particular, provided the ideal medium for treating ideas, but it did so in an unconventional fashion. The use of two media in a single cycle was highly unusual and creates a disjunction, however subtle, between the flow of the story and the mode of realization. Whether intentional or not, the resulting disruption of the narrative forces the viewer to consider the tools by which it was realized, a surprisingly modern and antiliterary device.

The narrative is further subverted because the episodes are not linked causally. Klinger also used this strategy of forging indeterminate relationships between the scenes, but mainly for his symbolist series such as *The Glove* (1883), in which a dream logic unites the sequence of images. Kollwitz selected the most dramatic or psychologically compelling events for *A Weavers' Rebellion*, allowing the viewer to fill in the spaces between them. According to Julius Elias, just the first impulse, the spark, came from Hauptmann's powerful drama and he recorded that Hauptmann himself admitted that, when he first saw the images, he was "a little disappointed" at not finding a faithful rendering of his play. He had the right as author, Elias observed, to expect a kind of "congenial illustrational handwriting." But as artist Kollwitz too had rights, as she detached herself from the literary subject of the work and, in free discovery, could "write" from "things seen and experienced from the soul."[58] Clearly, the creation of a convincing narrative comprised only one aspect of Kollwitz' complex agenda as she worked through the implications of Klinger's treatise.

The success of *A Weavers' Rebellion* was encouraging to Kollwitz, and in the period following its appearance, from 1897/1898 to 1910, she produced some of her finest images. The wide range of themes explored during these years was matched by extensive technical experimentation. Kollwitz' most inventive graphic procedures date from this time; they include complex soft-ground processes for etching as well as some instances of photo-etching and experiments in intaglio and lithographic color printing.

During these years as well, the size of the images and the scale of the motifs grew along with the artist's ambition and with her desire to convey a message that was even more insistent than that of the *Weavers* cycle. The

small sheets with detailed anecdotalism, relatively speaking, that characterize *A Weavers' Rebellion* evolved into works larger not only in their dimensions but in the way the motif appropriated the page and acquired an iconic presence. This is true for all her major subjects of this time: scenes of workers (cat. 21, p. 102), nudes (cats. 35, 36), the extraordinary images of mothers holding dead children, and her next cycle, *Peasants' War*.

Peasants' War was based on a historical event, the peasants' revolt of 1522–1525. Related to the Reformation in Germany, it nevertheless was catalyzed, like the weavers' rebellion, by the intolerable conditions under which the peasants labored. It has been thought that Kollwitz' own direct relationship with this series also derived from a literary source, in this case the *General History of the Great Peasants' War* (1841–1842) *(Allgemeine Geschichte des grossen Bauernkrieges)*, written by the Schwabian theologian and historian Wilhelm Zimmermann. However, the artist's procedure with *A Weavers' Rebellion* constitutes clear evidence of her

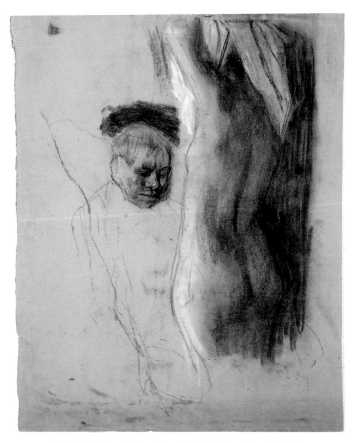

cat. 35. *Man Kneeling before a Female Nude Seen from Behind*, 1900. Graphische Sammlung, Staatsgalerie Stuttgart

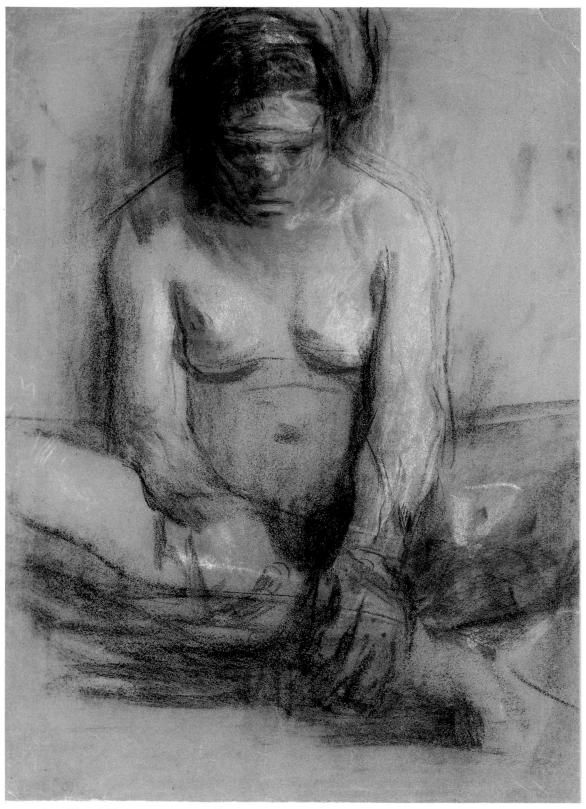

cat. 36. *Seated Female Nude*, 1900. Private collection

unwillingness to illustrate anything directly. She wrote to Arthur Bonus, husband of her friend Jeep, that "the motifs of the sheets from *Peasants' War* are not taken from some or other literary source. After I had made the small sheet with the woman flying above, I became further involved with the same theme and hoped that I would be able to portray it once and for all so that I would be finished with it. At that time I read Zimmermann's Bauernkrieg, and there he tells of 'Black Anna,' a peasant woman who incited the peasants. I then made the large sheet with the swarms of peasants breaking out. Based on this I received the commission for the cycle. Everything followed from this already finished plate. Six sheets are ready. . . ."[59]

The "small sheet" to which Kollwitz referred is *Uprising* (cat. 24). Directly related to the eventual genesis of *Peasants' War*, this etching and its vivid preparatory study (cat. 23) depict a mass of defiant peasants following a standard-bearer who marches resolutely forward, leading the people. The prelimi-

nary drawing for this sheet stands out as one of the artist's most dynamic and illustrates her forceful pictorial rhetoric. Exceptionally, Kollwitz added color: the red-orange flames and touches of pink, green, and white on a brownish sheet are startling and unexpected. Kollwitz delineated every individual so that one may reflect upon the involvement of each and not see them as a single undifferentiated mass. In the etching, an allegorical female nude, the personification of Revolution, flies above their heads, inciting the crowd. She wields a torch which, in the rare first-state impression illustrated here, has been handcolored by the artist with a red ink flame that seems to have ignited the burning building. By the time she commenced work on *Peasants' War*, however, Kollwitz resolved to capture the plight of the people without resorting to such explicit allegory.

Peasants' War consists of seven images that were made out of order and later arranged to create a rough narrative sequence. Except for the figure of Black Anna,

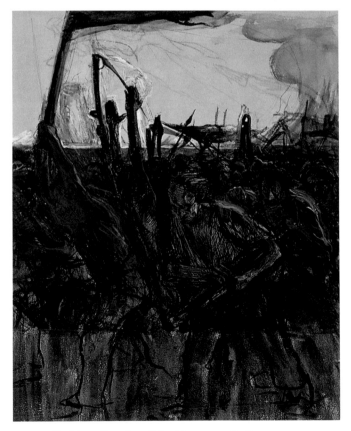

cat. 23. *Uprising*, 1899. Staatliche Museen zu Berlin, Kupferstichkabinett

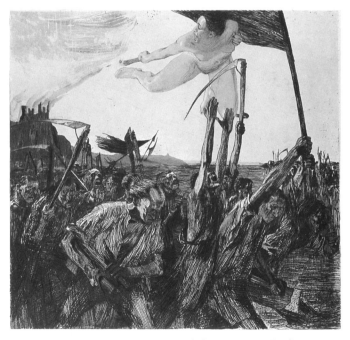

cat. 24. Kollwitz, *Uprising*, 1899. Staatliche Museen zu Berlin, Kupferstichkabinett

cat. 61. *Plowers and Woman*, 1905. Private collection

which appears in *Outbreak*, the cycle was not based upon historical events or personages but on imagined stages in a revolution. As in *A Weavers' Rebellion*, there is no strict narrative or literary thread; rather, the cycle is episodic. Kollwitz began by focusing upon crimes committed against the peasantry, showing humans treated like animals plowing the land (*Plowers and Woman*, cat. 61); a peasant woman raped by a feudal lord (*Raped*, fig. 6); the peasants preparing for revolt (*Whetting the Scythe*, cat. 60; *Arming in a Vault*, cat. 62); charging into battle (*Outbreak*, cat. 43); their defeat (*Battlefield*, cats. 63, 64) and the taking of prisoners (*The Prisoners*, fig. 7). Not once did the artist depict the perpetrators of injustice, concentrating instead on the sufferings of the victims. Having learned from Julius Elias, she rejected the allegory manifested in *Uprising* and focused on "real" events. She also specified no particu-

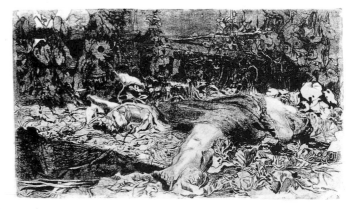

fig. 6. Kollwitz, *Raped*, 1907, etching and soft-ground etching. Private collection

cat. 60. *Whetting the Scythe*, 1905. Sprengel Museum Hannover

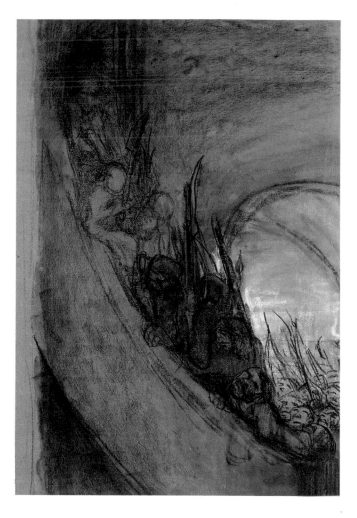

cat. 62. *Arming in a Vault*, 1906. National Gallery of Art,
Washington, Rosenwald Collection

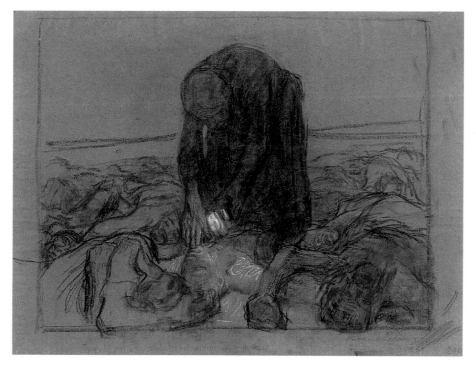

cat. 63. *Battlefield*, 1907. Staatliche
Graphische Sammlung München

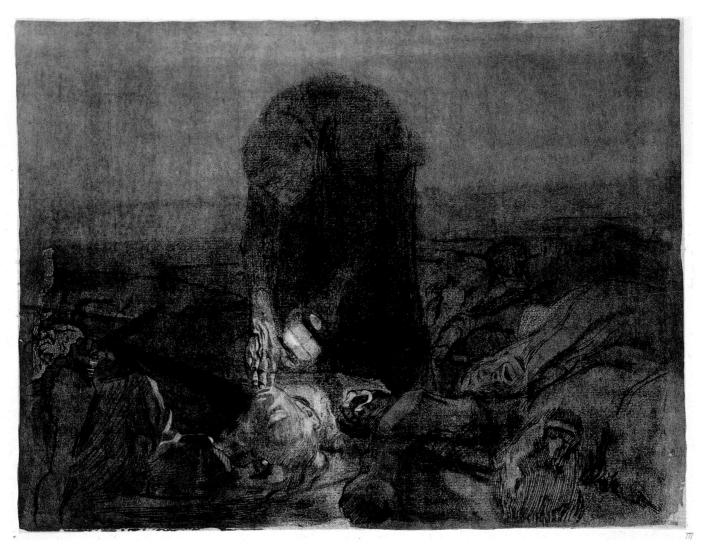

cat. 64. *Battlefield*, 1907. Private collection

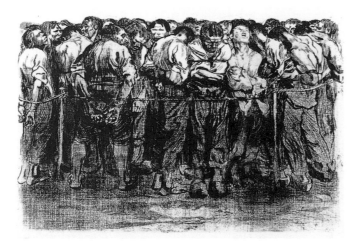

fig. 7. Kollwitz, *The Prisoners*, 1908, etching and soft-ground etching. Private collection

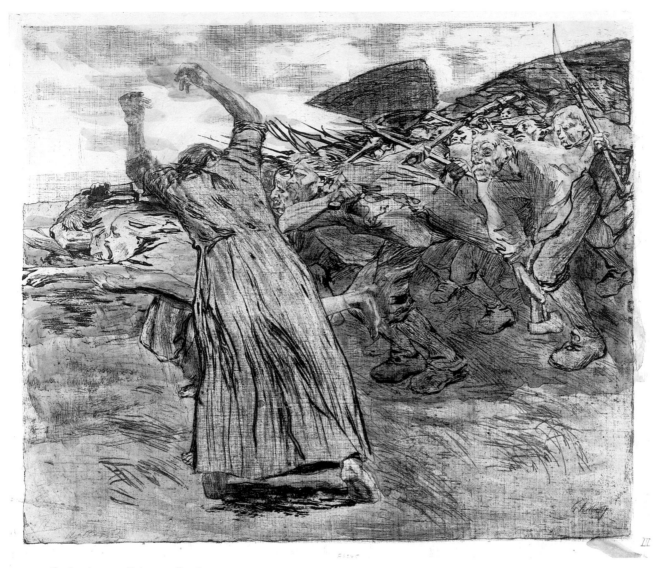

cat. 43. *Outbreak*, 1903. Private collection

lar time or place for the series, aiming for a universalized expression of the themes.

Kollwitz devoted much thought to the configuration of *Outbreak*, in which the rhetoric of the uprising reaches its most strident and dramatic exposition. She made a series of compositional studies, along with sketches for the figure of Black Anna, but according to Klipstein did not assemble them into an etching until after she had made three attempts at lithographs in 1902 for *Arming in a Vault* and *The Plowers* (K. 59, 60, 61). Kollwitz then produced studies for *Outbreak*, both in etched form (K. 63, 64, 65) and in many graphite,

chalk, and charcoal sheets. One of the finest of these preparatory drawings (cat. 57) depicts the figure of Black Anna from the rear, arms upraised in a gesture of furious excitement. She is surrounded by sketches of the set of the head, along with an unfinished view of Kollwitz' own face and three additional poses of the hand and forearm. Since the gestures are crucial to the expressivity of the composition, the artist experimented with various possibilities. The figure seen from the back was decided upon in the course of making studies; among them is one where Black Anna is drawn from the side (NT 194).[60]

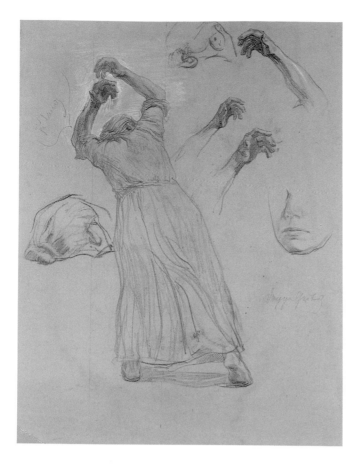

cat. 57. *Black Anna*, 1903. Staatliche Museen zu Berlin, Kupferstichkabinett

For several reasons, the rear view was clearly the most effective. The fact that Anna stands with her back to us serves to universalize the figure rather than have us identify with an individual; although she was a historical personage and is portrayed thus, she nonetheless duplicates the role of the nude in *Uprising* without the sentimentality of such an allegorical device. The figure's vertical orientation, its proximity to the picture edge, and the fact that it stands apart yet catalyzes the action serve to engage the viewer. In this sense, the configuration of the scene is highly meaningful and appears to represent the artist's own ideological stance.

The expressive compositional format of *Outbreak* reflects the degree to which Kollwitz' pictorial rhetoric was carefully calculated. In *Outbreak*, which the artist based on the earlier *Uprising*, Kollwitz pictured a mass of peasants lunging across the picture space from right to left. Directly in front of the viewer, her back to us, stands Black Anna, pitched forward with revolutionary zeal as she urges the crowd onward. One critic has suggested that the "mass of their bodies forms a wedge

shape: they are a spearhead. . . . In the West we are used to reading print from left to right. The fact that the movement of the peasant wedge runs counter to our perceptual habits makes concrete the reversal of terms, the uphill struggle, which their revolt represents socially."[61] The idea of the spearhead is buttressed by the shape of the flag, whose perspectival rendering echoes the form of the mass.

The plates of *Peasants' War* exhibit a complicated array of techniques for creating the drawings and for producing the tone and texture that were so crucial to Kollwitz' compositions in these and other contemporaneous works. First, instead of making her drawing directly on the prepared copper plate, she used soft ground to transfer a drawing made on laid paper.[62] The procedure most often consisted of laying a sheet of paper over the copper plate, which had been covered with soft ground, and then drawing lines over it with a hard pencil. This action would remove the corresponding ground, allowing the plate to be bitten in those areas. When printed, the lines produced would

be softer and grainier than the usual etched ones. Kollwitz extended the potential of this procedure even farther by creating entire backgrounds of texture, often transferring by means of the sensitive soft ground the grain of the laid paper on which she made the original drawing. This is visible in all the *Peasants' War* prints and in *Woman with Dead Child* as well.

The second technique Kollwitz used during this period to create large expanses of texture and tone was the addition of a so-called "mechanical grain," described as exhibiting "unmistakable rows of tiny parallel dots."[63] This grain, "only added in later states," has been observed on every sheet in *Peasants' War* except for *Outbreak*.[64] Its striking regularity and fineness and similarity to reproductive prints has activated a debate that turns on whether or not Kollwitz used some kind of photomechanical process to transfer the tone created in this way.[65] Careful study corroborates the suggestion that she did.[66] Most likely, Kollwitz laid a half-tone screen over a copper plate grounded with a light-sensitive emulsion, transferred the dot pattern from the screen by means of exposure to light, possibly the sun itself, and then etched the pattern into the plate. The rest of the image was obtained from soft-ground procedures, stopping out, and direct etching.

In *Outbreak*, reproduced here in a crisp, overworked, early impression, Kollwitz used yet another method for creating texture.[67] At the time that she was working on the image, the painter Sella Hasse visited the "etching magician" and recounted the following: "I was helpless, so unreservedly was [Kollwitz] forthcoming with her counsel. She could not share enough about her method, about her 'tricks.' 'See the sky on this plate,' (it was 'Outbreak' from the Peasants' War cycle), 'here I applied Vernis mou [soft ground]. Laid a piece of canvas over that and wound it through the press and then etched the impression.'"[68]

Despite the obvious fascination that the process of making held for the artist, she experimented for reasons other than the mere exercise of technical virtuosity. The cloth texture, which covers much of the image, serves a variety of functions. It literally represents the homespun material of Black Anna's dress and the garments of the peasants. In a larger sense, it stands metaphorically for roughness and for the rural

environment. It also unifies the image visually, linking different areas of this large print.

The choice of canvas is even more telling in that the material so closely identified with painting is here deployed in a graphic context. By providing either a canvas or some other grained background in the *Peasants' War* sheets, whose dimensions are the equivalent of easel-size paintings, Kollwitz has subtly illustrated the visual and philosophical gap between the different media while claiming equal importance for the graphic work. Moreover, the canvas pattern does not represent the fundamental surface of the object, as in painting. Instead, the paper, which emerges from below the printing, affirms the truth to materials and represents the essence of graphic art as a technique of reproducibility. In conjoining the sense of touch with the sense of vision and in distancing the work from the "real" world while simultaneously emphasizing its objectness, Kollwitz' approach to making becomes far more advanced than her style.

By exploring these new surface textures, Kollwitz sought to enhance the expressiveness of the image and to create her own graphic vocabulary. In his treatise, Klinger discussed at length the potential of the graphic arts for particularly subtle handling of light and dark and for the creation of surfaces unknown to painting, and Kollwitz evidently continued to perceive his comments as a challenge for her own creative endeavors. A measure of the effort that went into fashioning unusual surfaces is reflected in the numerous states undergone by the plates until Kollwitz found the effect she desired. Kollwitz thus incorporated in the *Peasants' War* sheets the distinctions postulated by Klinger, not just between drawing and painting, but between drawing and printmaking.

Kollwitz employed some of the same inventive intaglio procedures for *Woman with Dead Child*, which, like *Outbreak*, was executed in the extraordinarily productive year of 1903. The theme of a mother cradling a dead child became one of the artist's most powerful ones, and it was reprised in different ways throughout her career. Although Kollwitz portrayed the motif in *A Weavers' Rebellion*, for example in the image *Poverty*, in 1903 she removed it entirely from the sphere of narrative, isolated it, and made it the single focus of a large-scale composition. It is likely that the image was

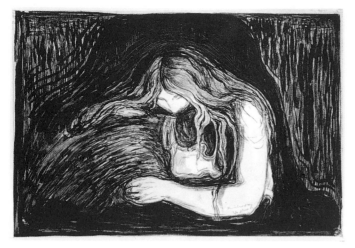

fig. 8. Edvard Munch, *Vampire*, 1895/1902, lithograph and wood-cut. National Gallery of Art, Washington, Ailsa Mellon Bruce Fund and Gift of Lionel Epstein

influenced by Munch's famous symbolist work *Vampire*, which he made first as a painting in 1893 and then as a series of mixed-media prints, blending lithography and woodcut (fig. 8).[69] Both Munch and Kollwitz effected a

shocking reversal of the usual tender, often sentimental portrayals of mothers and children that flooded turn-of-the-century iconography.

Kollwitz first confronted the theme in more traditional fashion in a work she called *Pietà*. In a colored-chalk study (cat. 48), unusual in her oeuvre, she turned again to Christian rhetoric, appropriating the Christian motif of the Madonna mourning the dead Christ. She transformed it into a universalized statement about motherhood, abolishing the grace and ethereal tenderness associated with the work of Michelangelo or other southern representations. The dark blues, browns, turquoises, and hints of yellow are far from decorative in their effect, but rather form an angry tangle of menacing hues around the figural group in order to augment the sense of uncontrolled emotion. The sketch served as the basis for a color lithograph that she printed in a few combinations (cats. 47, 49), altering the mood through the choice of different hues.

Woman with Dead Child (cat. 55) captures even more forcefully the notion of grief and loss, and is perhaps

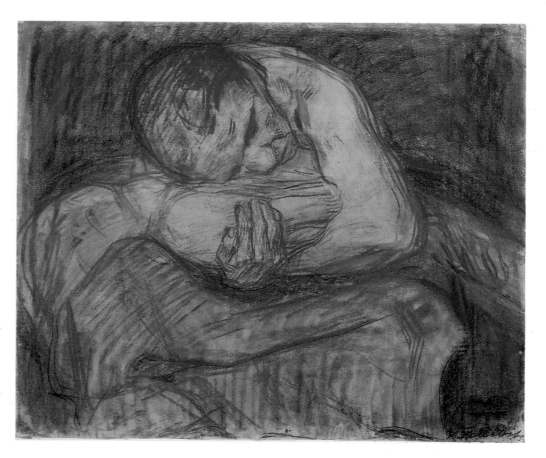

cat. 48. *Woman with Dead Child—Pietà*, 1903. Käthe Kollwitz Museum Köln, Kreissparkasse Köln

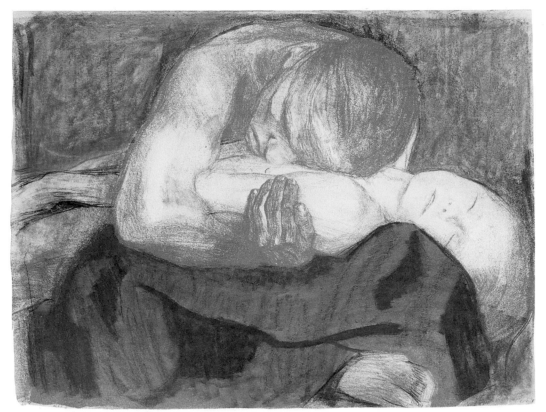

cat. 47. *Pietà*, 1903. Staatliche Museen zu Berlin, Kupferstich-kabinett

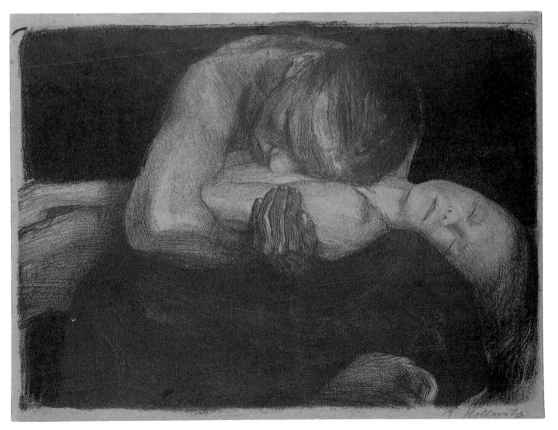

cat. 49. *Pietà*, 1903. National Gallery of Art, Washington, Rosenwald Collection

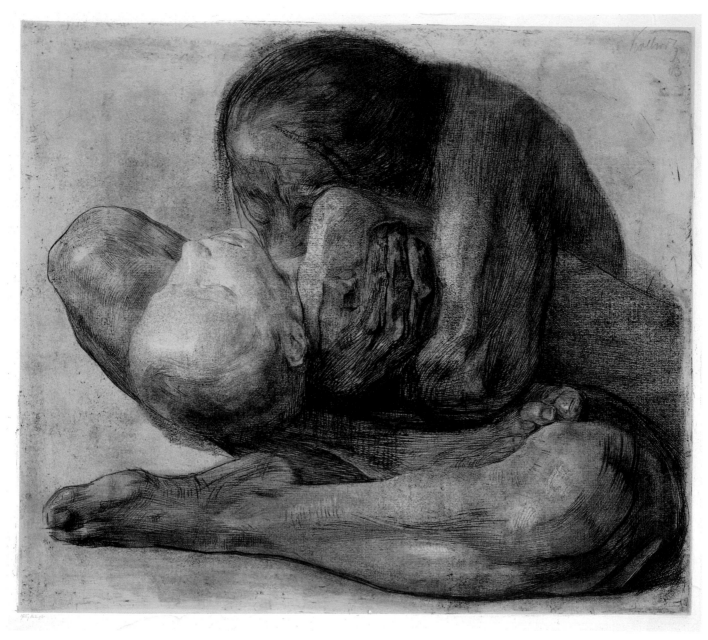

cat. 55. *Woman with Dead Child*, 1903. Private collection

the strongest image Kollwitz ever made. Of all the woe-stricken pictures, and there were many, this was so devastating that her lifelong friend Beate Bonus-Jeep was shocked when she saw it. "Jeep," as Kollwitz called her over their sixty-year friendship, later recorded her reaction.

A mother, animal-like, naked, the light-colored corpse of her dead child between her thigh bones and arms, seeks with her eyes, with her lips, with her breath, to swallow

back into herself the disappearing life that once belonged to her womb. When I saw the sheet, by chance we had not heard from each other for a long while. In the exhibition I suddenly found myself in front of the etching and turned quickly out of the room in order to compose myself: "Can something have happened with little Peter, that she could make something so dreadful?" No! It was pure passion itself, the force, sleeping contained in the mother animal, that yielding itself to the eye, is fixed here by Käthe Kollwitz, someone to whom it is given to reach beneath the ultimate veils.[70]

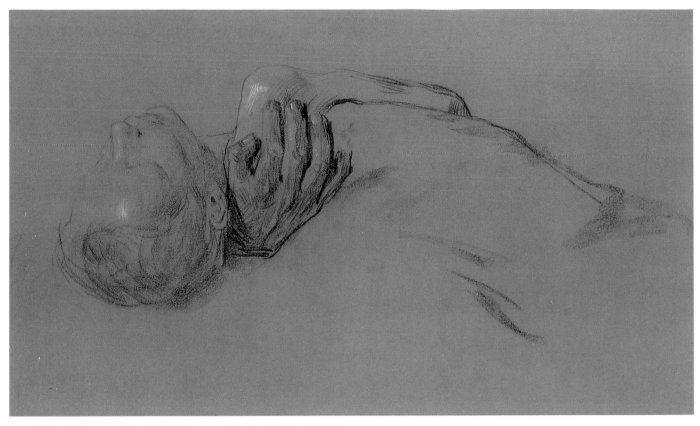

cat. 56. *Dead Boy*, 1903. Staatliche Museen zu Berlin, Kupferstichkabinett

Jeep's words capture the primal nature of *Woman with Dead Child.* Her characterization of the figure as "mother animal" strips away in words, as Kollwitz stripped away in the image, any vestige of "civilized" or rational mourning. In the bestial pathos of this motif, Kollwitz laid bare the savage force of the deepest human emotions.

Using her son Peter as a model, poignantly foreshadowing his death at age twenty-one in World War I, the artist made a number of studies for the child, of which the sheet reproduced here (cat. 56) represents one of the most sensitive. Weaving it into a compositional study, she intensified her stroke, abandoning the finely wrought style that constituted an aspect of her earlier draftsmanship. Instead, befitting her concept, Kollwitz transformed the delicacy of the preparatory sketch of Peter into a deliberately coarse, passionate handling,

defining the strong contours and rough features with vigorous lines.

The violent handling is mirrored in the composition. Kollwitz rejected the blocky frontality of the *Pietà*, here placing the figures at a slight slant. Rather than relying upon facial expressions, Kollwitz made the entire formal configuration expressive: she exaggerated the hunched-over pose and robbed the body parts of any organic connection to each other in order to communicate the psychological fragmentation and emotional disintegration of the scene.

Kollwitz made several preparatory studies after the initial sketch, of which one is outstanding (cat. 50, p. 12). This black chalk study, heightened with white, exhibits the urgency of the artist's execution. The range of markings bears witness to her need to find the appropriate visual mode for each section of the image.

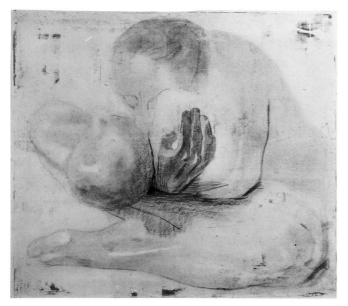

cat. 51. *Woman with Dead Child*, 1903. Private collection, courtesy Galerie St. Etienne, New York

Thus, for example, long, definite contour strokes counterpoint delicate modeling on the knee. Elsewhere she smudged the chalk to create texture and shadow, touching in white for the accents of light. So monumental was her conception that it burst from the page; the artist was compelled to add another sheet on which to expand, or revise, the top of the head and shoulder of the woman.

For the print, Kollwitz sought out new technical language that could serve as a metaphorical equivalent to the meaning of the image. As with *Outbreak*, Kollwitz built up the image over many states, enriching the surfaces by putting down layers of texture by means of soft-ground processes. She initially transferred a drawing (NT 242, now in Stuttgart), to the plate (cat. 51) and then added the texture of laid paper over the plate. In later states, she etched lines over the worked plate and pressed emery paper into more prepared soft ground. On the face of the boy, one may

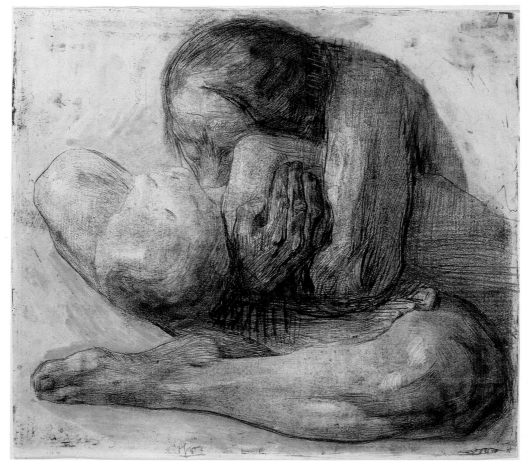

cat. 52. *Woman with Dead Child*, 1903. National Gallery of Art, Washington, Gift of Philip and Lynn Straus, in Honor of the Fiftieth Anniversary of the National Gallery of Art

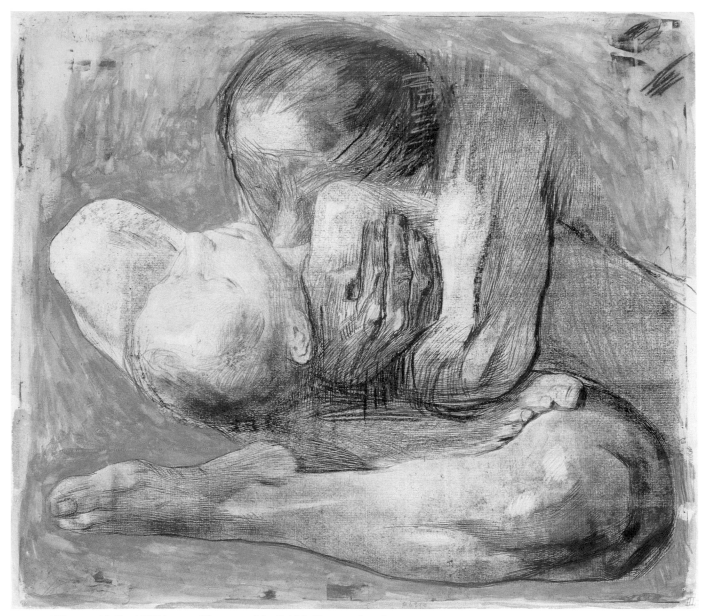

cat. 53. *Woman with Dead Child*, 1903. Trustees of the British Museum, London

also discern traces of the mechanical grain that Koll-witz would use later in the *Peasants' War* works.[71] In this way, she multiplied the densely interwoven surface effects. The final image was thus farther removed from simulating a conventional transfer of a drawing to the print medium; it became a work that could only have been manipulated graphically.

A number of rare impressions of *Woman with Dead Child* exhibit Kollwitz' method of touching in suggested changes in charcoal and graphite (cat. 52). In several of them she brushed gold wash extensively in the background, an astonishingly unexpected decorative effect for such a bleak and painful subject (cat. 53). The gold creates a haloed glow around the forms, ennobling them and raising them to the status of icon in the same way that her selection of the title "Pietà" evokes Renaissance treatments of the theme.[72]

An impression of the sixth state (cat. 54) reveals that Kollwitz finally added a lithographic stone, which she inked with a yellow-gold spritzing for a dappled tex-

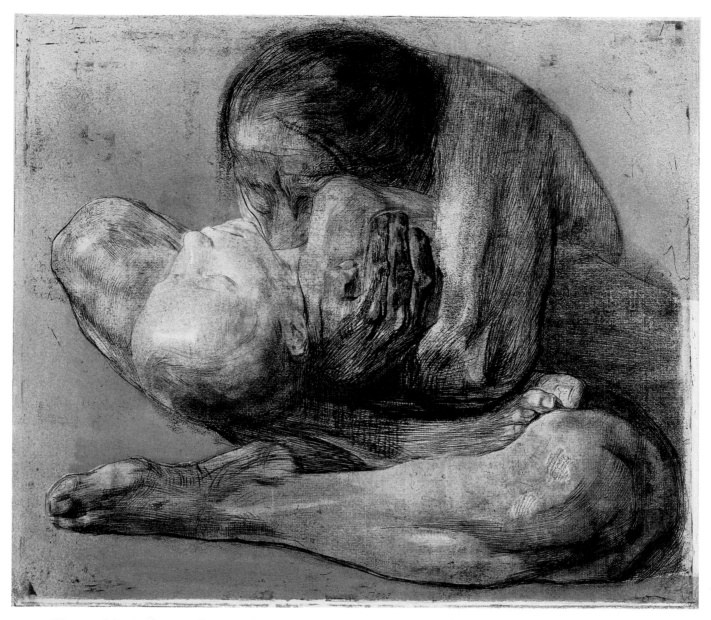

cat. 54. *Woman with Dead Child*, 1903. Trustees of the British Museum, London

ture. Two years earlier, in 1901, Kollwitz had written to Max Lehrs, explaining that she was planning to experiment with mixing lithography and etching and that she had the use of a press with which to do so.[73] Again, in a letter of 1929 to Dr. Heinrich Becker, director of the Bielefeld Kunsthalle, she responded to his implied question about whether or not the gold background had been lithographically applied, that she could not say for sure until she actually had the particular sheet before her eyes but that she had carried out "all experiments possible" with this work, even running the etching plate under the lithographic press. Later, she observed, she gave up entirely on this kind of mixed technique.[74] The combination did not even last to the edition state (see cat. 55, p. 42), in which she left the background bare. Despite the strange beauty of the gold impressions, she must have realized that the monumentality and horror of the composition would be trivialized by their rich metallic decorativeness. The stark black version that transmits the eerie radiance of green china paper captured her intention most successfully.

The combination of etching and lithography was

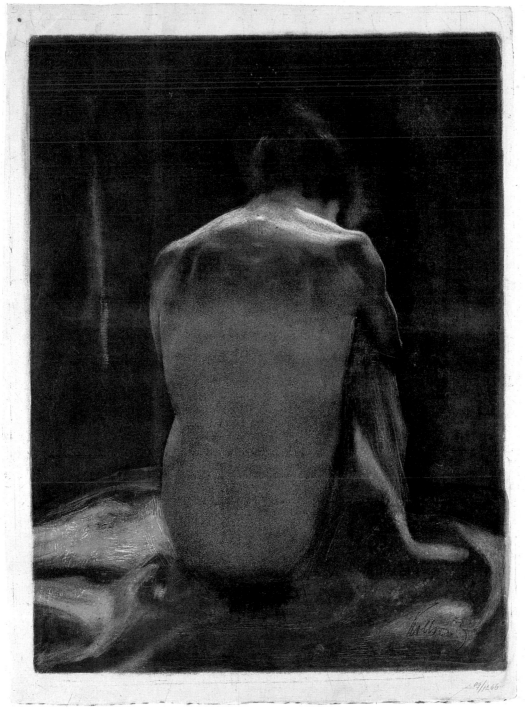

cat. 45. *Female Nude with Green Shawl Seen from Behind*, 1903. Kunsthalle Bremen

unusual for contemporary graphic art, and in this case represented a solution for printing in color. Although Kollwitz' efforts in this direction resulted in subtle, atmospheric images of remarkable eloquence and beauty, such as *Female Nude with Green Shawl Seen from Behind* (cats. 45, 46) and *Woman Arranging Her Hair* (cat. 25), like Klinger she seemed to have viewed color as an element essentially associated with painting and she pursued it for only a few years, roughly 1899 to 1903. As beautiful as the works in color are, it would

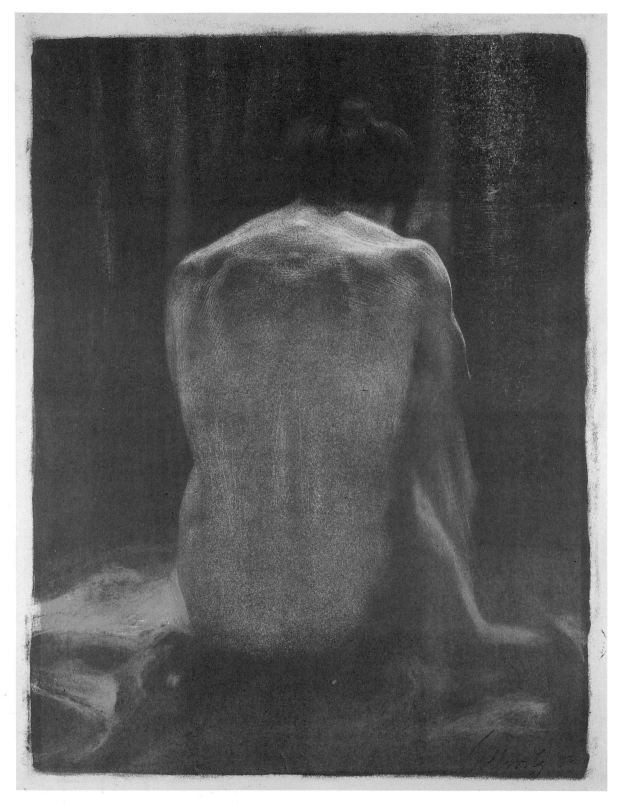

cat. 46. *Female Nude with Green Shawl Seen from Behind,* 1903. Staatliche Kunstsammlungen Dresden

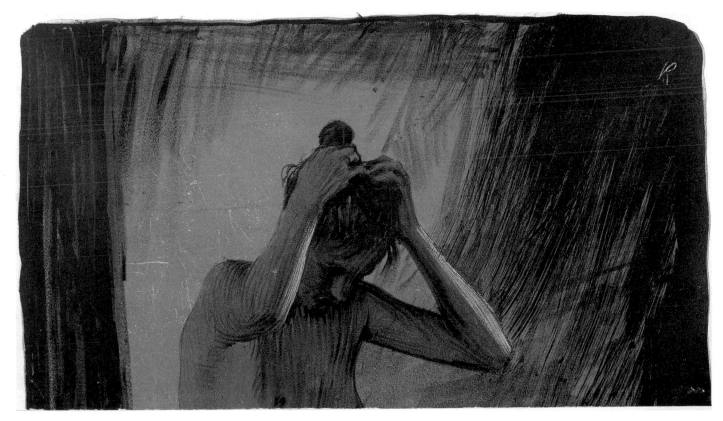

cat. 25. *Woman Arranging Her Hair*, 1900. Staatliche Kunstsammlungen Dresden

be misleading to overstate their place in the artist's career. Rather these sheets constitute a poignant reminder of her strong and seldom indulged inclination toward pure aestheticism.

The works in color, along with *Woman with Dead Child* and the sheets from *Peasants' War*, represent one of the most creative moments in Kollwitz' career, certainly from the standpoint of technique if not imagery. With regard to the intaglio medium, it was the last time she pushed it so far, carrying out a sustained exploration of its possibilities. The textural excitement and complexity she devised from the various copperplate processes would no longer seem suitable for the tasks of the next period, which required posterlike immediacy and accessibility. Although other media, in particular the woodcut and sculpture, would continue to challenge and trouble her, never again in the same way would she so fruitfully and joyfully pursue technique.

As Kollwitz became progressively committed to using her art as social commentary, lithography displaced

etching as her medium of choice. She was always most comfortable with drawing, and the process of transfer lithography as well as that of drawing directly on stone allowed her to create an image rapidly and easily with the broad, gestural quality that characterized her drawing style as it developed after about 1908. In the early lithographs included in *A Weavers' Rebellion*, Kollwitz had used the procedure to approximate the effects of etching, working in a small format with tight, small strokes and sometimes scratching highlights into the stone. Subsequently she developed the qualities more specific to the lithograph: luminous black lines generated by the lithographic crayon, draftsmanly spontaneity, and a penchant for simplification. In 1919, before she temporarily became discouraged with the technique, she noted in her diary that lithography seemed to her the only possibility, "A technique which hardly seems like one, it is so easy. It seizes only the essential."[75]

The looser, seemingly more spontaneous handling of the work of the period beginning in 1908 may be

cat. 65. *Out of Work*, 1909. National Gallery of
Art, Washington, Rosenwald Collection

seen in the drawings Kollwitz contributed for repro-
duction in the political-satirical magazine *Simplicis-
simus* (cat. 65). At the time she referred to a new
approach to her work, linking purpose to style.

> I abandon myself entirely to the art of drawing, the
> motif too, and I would probably have enough material for
> drawings for an entire year for [*Simplicissimus*]. The "Have-
> to-finish-it-quickly," the necessity of expressing something
> "popularly," and thus the possibility—since after all it is
> for "der Simpl"—of being able to remain artistic, and in
> particular the fact of being able to express repeatedly to a
> large public that which has always stimulated me and of
> which not enough has been said: the many silent and audi-
> ble tragedies of life in the big city—which all together
> make this work extraordinarily dear to me.[76]

Kollwitz' pleasure in this work was augmented
because, just at this time, she stopped relying upon a
model. She referred in her diary to this fact, noting
that she was "glad that I can work well and *easily* now.
So I could go on effortlessly making drawings for
Simplicissimus now. Through the long time of working
on studies, I finally have attained a certain background
in technique which allows me to express what I want
without a model."[77] So the years 1908–1909 mark a
turning point in Kollwitz' style, which, partly because
she abandoned the routine of making studies from life,
became one of greater simplicity and concentration of
pictorial means and design. As to her subjects, the

increase in socially oriented topics was balanced by
more "cosmic" themes of parting (cat. 68) and death.

The recurring dissatisfaction and doubts Kollwitz
experienced about the different graphic media and
their effects in large measure reflect her ambivalence
about the goals of her art. The events of World War I,
in which her younger son Peter was killed, and later
the November Revolution and traumatic formation of
the Weimar Republic forced the artist to examine her
conscience and consider the purpose of art. Although
she frequently voiced uncertainty about the direction
her art should take, she was convinced that it should
serve the people. She gradually decided that the
devices and effects possible with the intaglio processes,
which she had so avidly pursued and clearly enjoyed in
Peasants' War, no longer seemed relevant to the new
demands placed on art in time of war and drastic soci-
etal upheaval. Artistic procedures that might impede
the rapid and accessible communication of her idea
seemed a superfluous luxury, even a hindrance to the
effectiveness of an image, just as the individualistic
"studio art" of the avant-garde appeared to lack a solid
base with the people. In embracing the most straight-
forward graphic methodology with which she was
acquainted, lithography, Kollwitz sought to avoid
affectations of technique that would detract from her
message.

Yet even lithography would lose favor with the artist

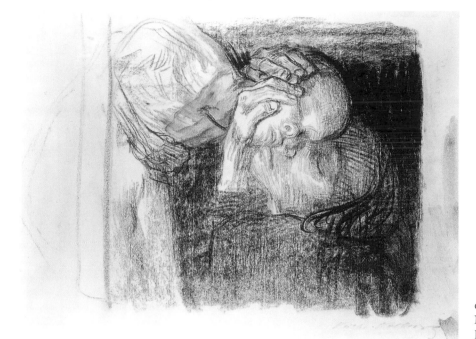

cat. 68. *Death, Mother, and Child*, 1910.
National Gallery of Art, Washington,
Rosenwald Collection

for a time as she continued to struggle with the relationship of technique to meaning in a work of art. A case in point is the *Memorial Sheet to Karl Liebknecht*, the Spartacist leader who was assassinated on 15 January 1919 in the midst of the tumultuous events surrounding the formation of the Weimar Republic. Sympathetic to Liebknecht as a person though not supportive of his leftist stance, Kollwitz was invited by his family to look at his corpse and make drawings after his face. She recounted her visit to the morgue where she saw "the shot-up forehead decked with red flowers, a proud face with the mouth slightly open and painfully distorted. . . . I then went back to the house with the drawings and tried to make a better, more comprehensive drawing."[78] Six extant sketches depict the head, each from a slightly different angle (cat. 71).[79]

Kollwitz soon conceived the idea for a print, the *Memorial Sheet to Karl Liebknecht*, based upon these drawings. It was her struggle with this image that precipitated her consciously articulated dilemma about finding a "new form for the new content of these recent years."[80] She made numerous preparatory drawings for the composition of workers paying homage to Liebknecht and taking their final leave (NT 773–790), and these are related to the printed versions with which she concurrently experimented. The group

described here includes some of the most interesting sheets and those that document the artist's discovery of the woodcut.

Probably the earliest drawing Kollwitz made for the print is one that carries some of the finest detail (cat. 72). In this charcoal study one sees the hesitation experienced by the artist over the composition. At right, several pieces of paper have been cut out and pasted, with newly drawn additions, over and under the original sheet. The sensitive, even classically inspired han-

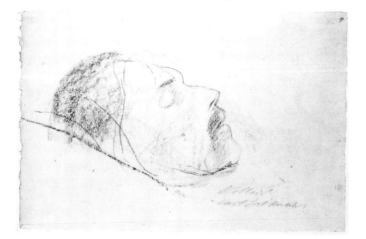

cat. 71. *Head of Karl Liebknecht on His Deathbed*, 1919. Private collection

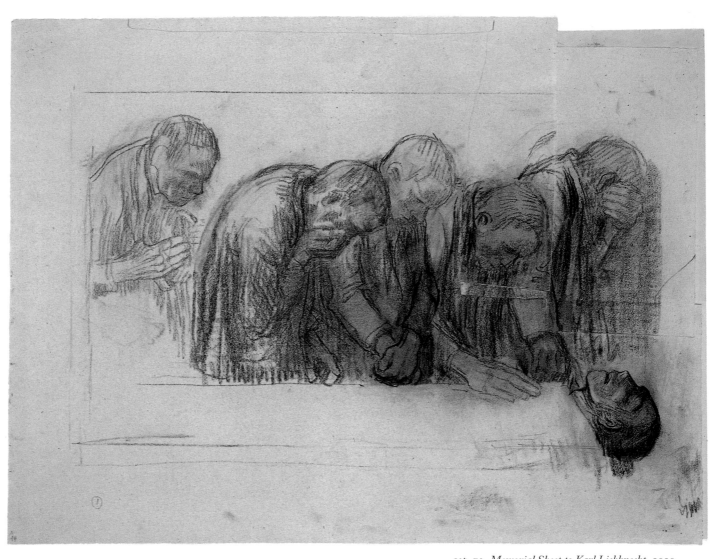

cat. 72. *Memorial Sheet to Karl Liebknecht*, 1919.
Private collection

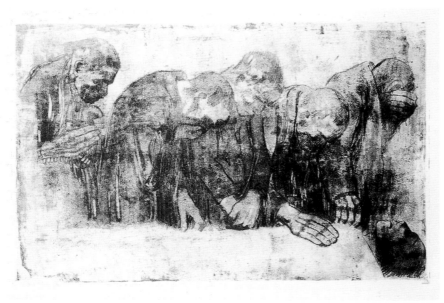

cat. 73. *Memorial Sheet to Karl Liebknecht*, 1919.
Private collection

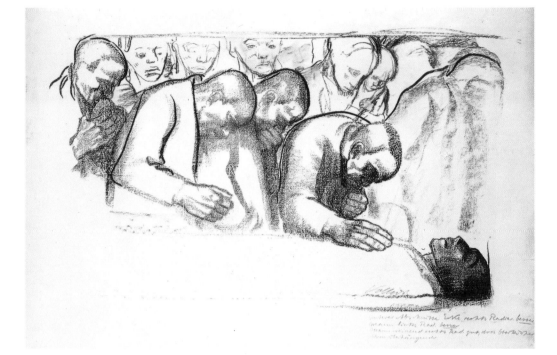

cat. 74. *Memorial Sheet to Karl Liebknecht*, 1919. Private collection

dling, with touches of fine cross-hatching, recalls her earlier style but on a larger, more monumental and iconic scale. From this rendering Kollwitz proceeded to the intaglio medium, working up the image in stages from pure soft ground to a developed etching over four states (cat. 73). The atmospheric smudging in the drawing, which picks up the texture of the paper, turned into splotchy disorder on the plate, and the artist abandoned the attempt.

Kollwitz then turned to lithography, the medium she used most frequently in her later years to condense and simplify form and thereby intensify the impact of the scene. In this unique trial proof (cat. 74) the texture of the laid paper is visible as lines on the printed areas—that is the figure of Liebknecht and the four mourners. Behind them Kollwitz drew additional participants with charcoal, filling in the empty space around the central activity. Under her signature at lower right, she noted ways to improve the various figures.

Kollwitz was not satisfied with this result. Frustration with planography had led her to consider the woodcut technique for the *Memorial Sheet* as early as April 1920,[81] and about two months later, the 24th of June to be precise, she visited the Secession and saw something that "completely knocked [me] over, this was Barlach's

woodcuts." The sculptor Ernst Barlach (1870–1938), who would become a friend, was one of the artists whom she credited as a direct influence on her work; she saw the woodcut of *The Banished Ones* (fig. 9) that day at the Secession and it directly inspired *Woman with Children Going to Death* (cat. 88).[82] His expressionist tendencies appealed to her at this time and they contributed to the shift in her work toward that style. The

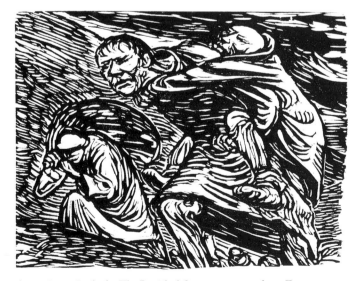

fig. 9. Ernst Barlach, *The Banished Ones*, 1919, woodcut. Ernst Barlach Haus, Stiftung Hermann F. Reemtsma

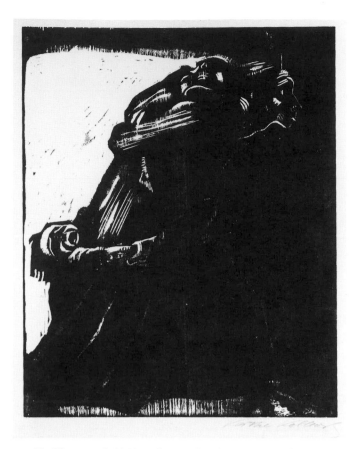

cat. 88. *Woman with Children Going to Death*, 1924. Private collection

Should I really make a completely new attempt like Barlach and begin with the woodcut?

When I considered that up to now, I said to myself that lithography was for me a given for clear and obvious reasons.

I don't want to go along with the current fashion in woodcuts, the spotted effect. *Expression is all that is important to me* and I therefore told myself that the simple line of the lithograph is best suited for that.

But the result of my work, except for the sheet "Mothers," has never satisfied me.

For years I have tormented myself. Quite apart from sculpture.

I initially began the war series as etchings. Came to nothing. Let it all lie. Then I tried with transfers. There too almost never satisfying results.

Whether the woodcut will do it? If that too doesn't, then I have proof, *that it lies only within myself.*

Then I simply can no longer do it. In the torment of all these years small oases of joys and successes![83]

Kollwitz turned to the woodcut, and her practice of the medium encouraged her adoption of some expressionist effects such as simplification and a degree of distortion. She did not lack for models; avant-garde artists including Ernst Ludwig Kirchner (fig. 10) had been using the medium as early as 1904. It was a surprising concession on her part, given her general resis-

experience came at a crucial moment for the artist and occasioned a long discussion in her diary about the relative merits of different graphic techniques.

> Today I looked again at my lithographs and saw again that almost all of them *are not good*. Barlach has found his way and I have not yet found mine.
>
> I can no longer etch, I am finished with it for good.
>
> And with lithography there are the inadequacies of transfer paper. Stones can be gotten to the studio now only with lots of money and pleading. But even on stone I can't get it to come out right. I always hide behind the many obstacles and as I saw Barlach, it dawned on me like lightning that perhaps this really was not it. But why shouldn't I be able to do better?—The prerequisites for artistic works after all are given, for example for the war series. First of all the strong feeling—these pieces come from the heart—and secondly they rest on the basis of my earlier works, therefore, upon a rather good foundation of capability.
>
> And yet the sheets are not purely artistic. What is the reason for that?

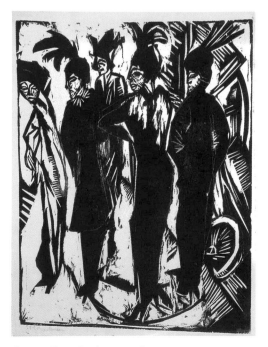

fig. 10. Ernst Ludwig Kirchner, *Five Tarts*, 1914, woodcut on blotting paper. National Gallery of Art, Washington, Ruth and Jacob Kainen Collection

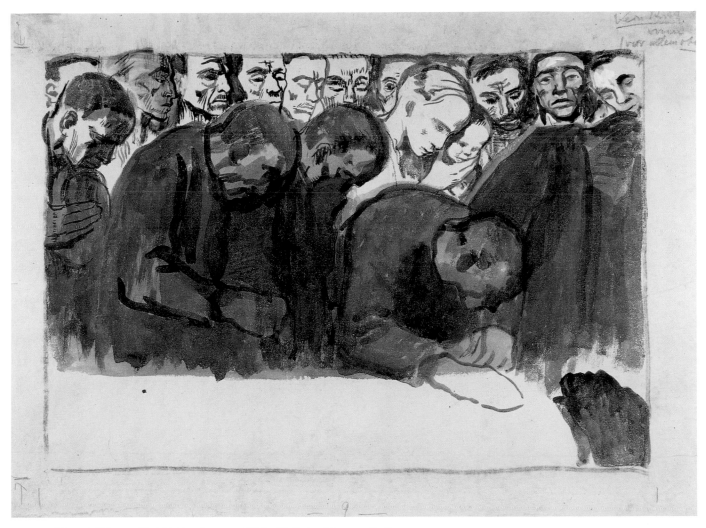

cat. 75. *Memorial Sheet to Karl Liebknecht*, 1920. Käthe-Kollwitz-Museum Berlin

tance to contemporary styles, and suggests how far she was willing to go to seek an art for the people, not realizing that she had long since found it. Nevertheless, the expressionist quality of the *Memorial Sheet to Karl Liebknecht* and the *War* series remains only a brief episode in Kollwitz' career.

Hoping to condense the Liebknecht sheet even more, she made a study in ink wash (cat. 75), selecting this medium because it could suggest the broad planes of the woodblock. Rather than using pen and ink or graphite, she hereafter executed many of the studies for her woodcuts in brush and ink wash or gouache, to approximate the relief areas of the block and the cuts of the knife in the wood.

Yet again Kollwitz based an image on a Christian Lamentation, reflecting her choice of a familiar rhetoric in which to cast the motif of a contemporary revolutionary. She could count on this format to be accessible to her viewers, who would immediately grasp the reference to Christ's martyrdom. Given Kollwitz' preoccupation with the common people and her desire to engage them through her imagery, her focus upon the mourners rather than the figure of Liebknecht is in character; his rather wooden figure is obscured amid the frieze of spectators, the subtlety of his head and facial features lost at the lower right (cat. 76). In reworking the general motif of the dead man from the early sheets, *From Many Wounds You Bleed, O*

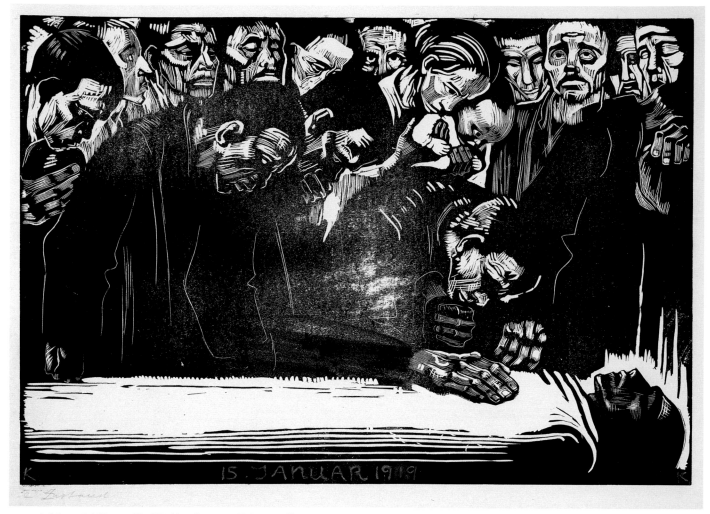

cat. 76. *Memorial Sheet to Karl Liebknecht*, 1919. Private collection

People and *The Downtrodden*, much of the stagelike and atmospheric effect, so evocative in those works, has been rejected. Kollwitz substituted a stark, broad handling, which she hoped would communicate more directly with the viewer. Accordingly, the print went into two editions, one of which was unlimited and was sold very cheaply at a Workers' Art Exhibition in Berlin in 1920.[84]

At the same time, Kollwitz was beginning to experiment with the woodcut images that would make up the *War* series, one of her most important achievements of this period. A study of the strongest sheets for this seven-image series demonstrates how far she had moved away from the style and subject of *A Weavers' Rebellion* and *Peasants' War* and of what her new concerns now consisted.

War represents one of a number of graphic cycles on this theme that were completed by different artists in the early 1920s. The cycle format, which played such an important role in German art of the late nineteenth century onward, continued to represent an effective way of communicating a set of ideas or recounting a narrative.[85] Kollwitz' series should be viewed against the background of other portfolios that were made during the war, including four by Willy Jaeckel, Frans Masereel, Ludwig Meidner, and Max Pechstein, and two, in addition to Kollwitz' own, that were made during the Weimar Republic by Otto Dix and Willibald Krain.[86] Kollwitz' work is unique because it includes no scenes of combat or of material devastation. Rather, it presents the phenomenon of war entirely from the perspective of the home front, of mothers and children

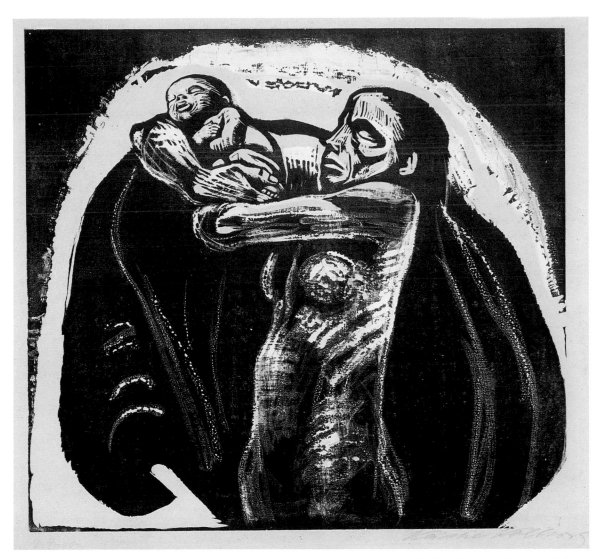

cat. 82. *The Sacrifice*, 1922. National Gallery of Art, Washington, Rosenwald Collection

fig. 11. Otto Dix, *Wounded (Fall 1916, Bapaume)*, Sheet 6 of *War*, 1924, etching and aquatint. The Los Angeles County Museum of Art, The Robert Gore Rifkind Center for German Expressionist Studies

in particular, and may in a sense be interpreted as a study of the notion of sacrifice. Unlike Dix, for example, who in a series of fifty etchings depicted grotesque scenes of physical injury and material devastation (fig. 11), she had of course not seen action, but in any case she would not have been likely to present that aspect of war. In her other cycles too, combat was always noticeably absent.

The *War* series was issued in 1924 in three editions after its completion in 1922–1923.[87] In a letter to the novelist Romain Rolland, Kollwitz reported that she had finally finished it. "I have repeatedly attempted to give form to the war. I could never grasp it. Now finally I have finished a series of woodcuts, which *in*

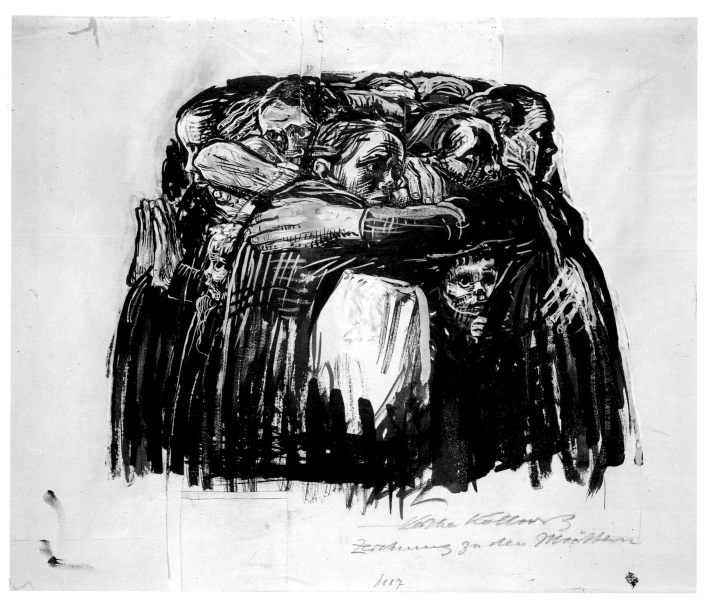

cat. 81. *The Mothers*, 1921. Museum of Fine Arts, Boston, Frederick Brown Fund

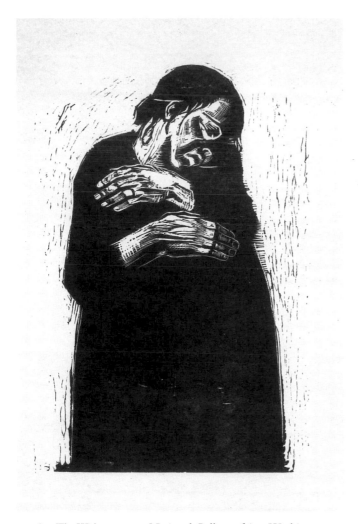

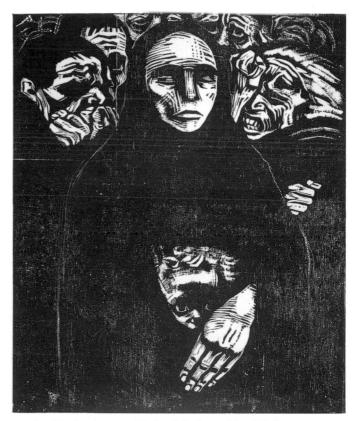

cat. 85. *The People*, 1922. National Gallery of Art, Washington, Rosenwald Collection

cat. 84. *The Widow I*, 1922. National Gallery of Art, Washington, Rosenwald Collection

some measure say what I wanted to say. There are seven sheets, entitled: the Sacrifice [cat. 82] — the Volunteers — the Parents — the Mothers [cat. 81] —the Widows [cat. 84] — the People [cat. 85]. These sheets should travel throughout the entire world and should tell all human beings comprehensively: that is how it was — we have all endured that throughout these unspeakably difficult years."[88]

The sheets for *War* were designed in large format, and are posterlike in impact. When Kollwitz made them they were the starkest and most iconic images she had yet attempted, representing a gradual trend to simplification evident in her work as early as 1903.

Whereas *Peasants' War* increased the scale from *A Weavers' Rebellion* and was less concerned with specifying places and times, *War* was drastically reductive. Here Kollwitz compressed a wealth of associations into single motifs and showed no interest in establishing a sense of place or in elaborating extraneous details. Everything is expression, gesture, and iconic form. In keeping with her wish that the series should travel the world with its message, Kollwitz adopted a stark black and white language of signs that would be universally understood. They are unencumbered by particulars that would restrict them to a specific time or place.[89]

cat. 77. *The Volunteers*, 1920. Private collection, Berlin

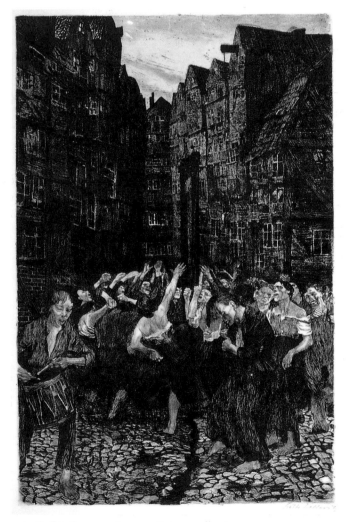

cat. 38. *Die Carmagnole*, 1901. Private collection

The Volunteers, the second and best-known sheet in the series, depicts a group of young men who have willingly offered themselves to the cause (cat. 83). Swept along by their own fervor, they follow a leader who is none other than Death himself, beating upon his drum, much like the symbolic drummer boy in *Die Carmagnole* (cat. 38). This sheet underwent a number of adjustments, demonstrated here by three preparatory drawings in addition to a trial proof of the final state. The first study was probably the pencil sketch (cat. 77) showing Death followed by three figures, eyes closed in an ecstatic trance. Death looks backward toward the chain of boys; pounding on the drum, his rhythm is echoed in the zigzag of the forms and the light, quick line.

Kollwitz chose charcoal for two further studies in which she heightened the drama of the departure for battle. She carried the sense of frenzy into the study reproduced here (cat. 78), boldly outlining the faces that evoke damned souls lamenting a descent into hell. In this drawing she added figures, filling out the chain of bodies and suggesting that it continues well beyond the framing edge. By smudging the charcoal into the paper, Kollwitz emphasized the unity of the figures in what would, in woodcut form, become one single plane printed in black. Unlike *Outbreak*, where each member of the crowd acquired a distinct, elaborated identity, here she aimed for more universality, emphasizing the

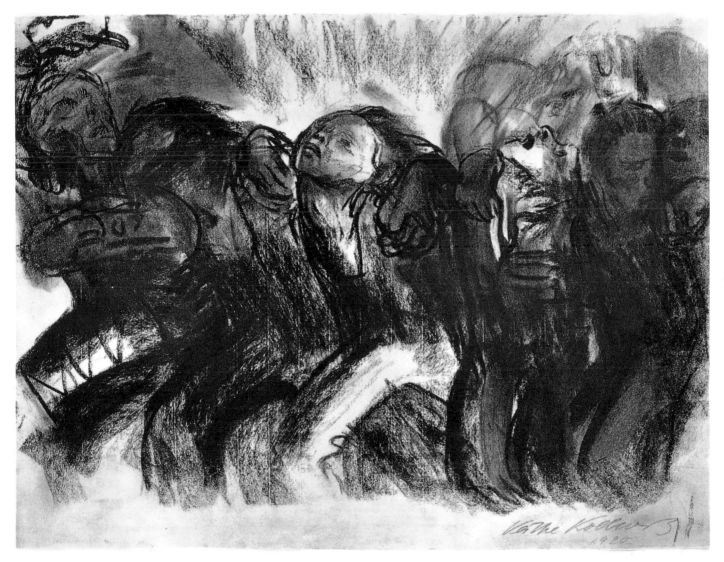

cat. 78. *The Volunteers*, 1920. Private collection, Berlin

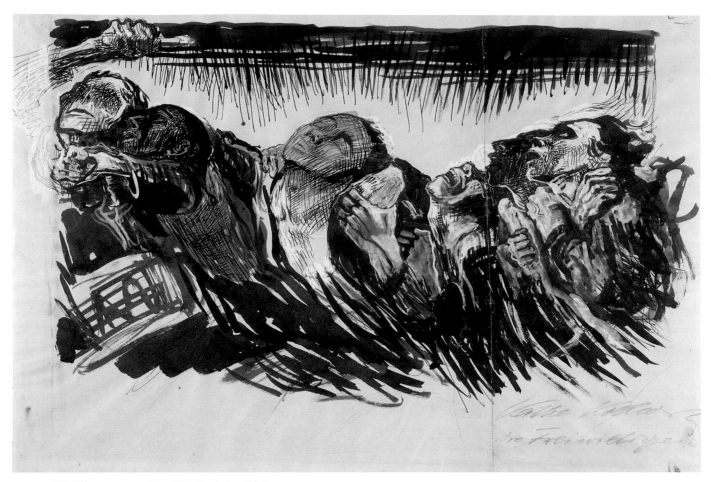

cat. 79. *The Volunteers*, 1920. Dr. Eberhard Kornfeld

action and subordinating the materials to expression. One feels that for her to have concentrated any more than she has done on the means would have been to trivialize the subject.

An extraordinary pen and ink study approaches the woodcut most closely (cat. 79). On two sheets pasted together, Kollwitz extended her composition to include five male figures who accompany Death to the field of battle. Death no longer looks backward at them but ahead, leading them inexorably forward. Working in a mixture of finely crosshatched pen strokes, which recall her early style of draftsmanship, and wider brushmarks, which refer to chisel cuts, Kollwitz set out

to imagine how these would be translated onto the pearwood blocks. Touching with white provides some indication of where she would cut into them, allowing the lines to appear white as well in the printed version. This seems to have been her method of conceptualizing a woodcut composition: to see it first in terms of the black solids and to cut away mentally on the page through the addition of white accents.

Such is the variety of line in this study—the combination of the fluid and the crisp—that the woodcut seems slightly stilted in comparison (cat. 83). But in its blend of spiky cuts with broad black masses and the disjointed play of solids and voids, particularly in pas-

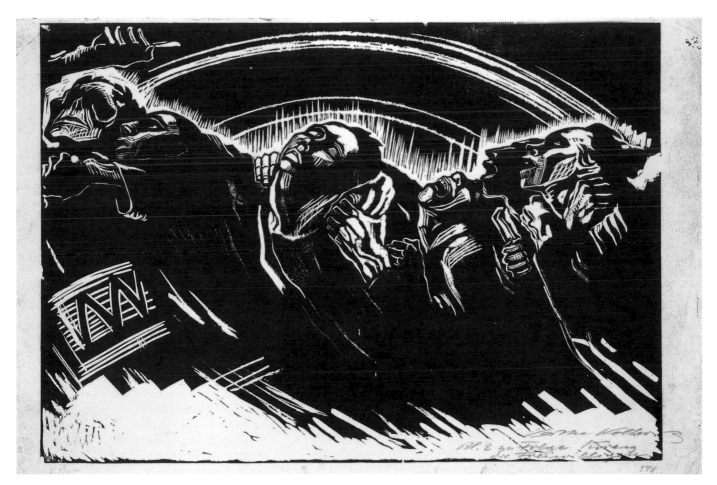

cat. 83. *The Volunteers*, 1922. Private collection

sages such as the juxtaposition of the two hands in the center, the print disallows the perception that this is a scene of total dedication, an easy march to the tune of death. The jagged, deliberately disordered flicks and jabs at the bottom, in addition to the participants' range of expressions—from the beatific to the agonized—insist upon a highly ambiguous, even ironic interpretation of the scene, an impression that even the formally unifying "rainbow" at the top, usually a symbol of hope, cannot dispel. One might even infer that this act of sacrifice took place not so much as an affirmation of the justice of a cause so much as a will to death on the part of innocent young men. In a long

entry in her diary in 1916 Kollwitz meditated on the phenomenon of volunteering, observing that not only in Germany did the young men go willingly and joyfully into war, but in all the nations. "Does youth in general want war?" she asked.[90]

These woodcuts possess a sculptural nature that to an extent is built into the handling of the relief medium, a quality that was used to good effect when Kollwitz reworked some of her motifs into three dimensions, as in *Tower of Mothers* (cat. 106), modeled some fifteen years later. This sculpture, while projecting the flat relief planes into space, possesses the same inward-turning cluster effect as the woodcut. The extent to

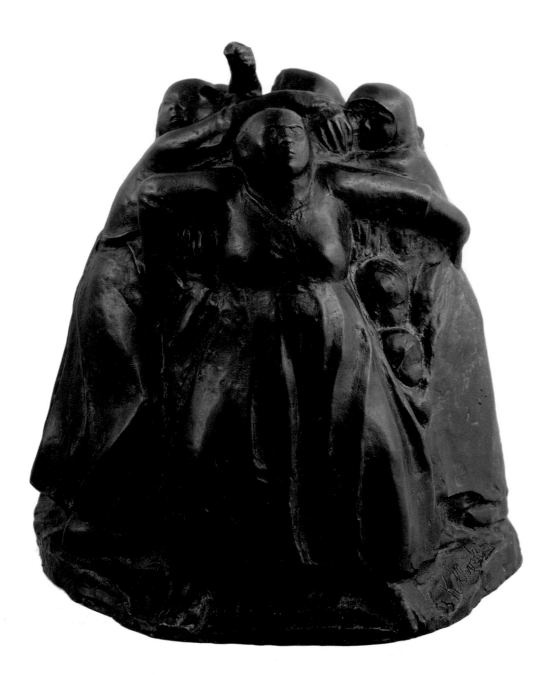

cat. 106. *Tower of Mothers*, 1937–1938. The Baltimore Museum of Art, Given in Memory of
Joseph Katz by His Children

which Kollwitz was sensitive to her materials is indicat-
ed in a diary entry of February 1922, in which, always
self-critical, she claimed that her woodcuts were a bit
boring. She observed further that "I cannot work with
the soft wood, which is more amusing to cut, because it
makes for too many accidents and mistakes. And hard
wood, the way I handle it, very easily becomes aca-
demic."[91] Such an aspect emerges most strongly in the
edition prints, which sometimes acquire a brittle and

slightly mechanical surface. At their best, as in the
rejected version of *The Parents* reproduced here (cat.
87), the woodcuts are warm and rich, enhanced by the
type of paper used for the impressions. Shimmering
japan paper seems to complement most successfully
their dense oppositions of value.

The contrast of these abstract, iconic woodcuts with
Kollwitz' lithographs is striking. It emerges with the
creation in the following year of her most famous

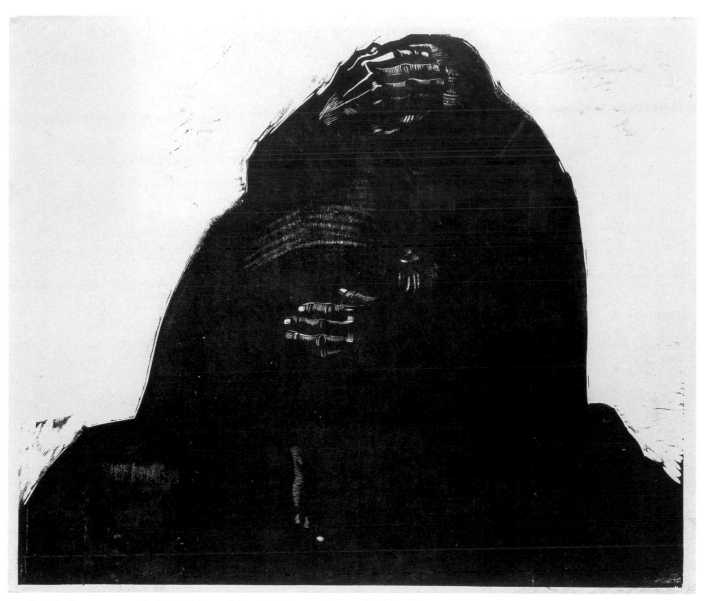

cat. 87. *The Parents*, 1923. National Gallery of Art, Washington, Rosenwald Collection

poster, *Never Again War!* (cat. 90). Streamlined down to essentials, one androgynous figure shoots an arm into the air and calls for a halt to aggression. In the background, Kollwitz' own agitated lettering cries out the simple message.

The lithographic technique persisted in troubling the artist. On the one hand, she felt that the medium was too easy and that she had not truly accomplished something. On the other, Kollwitz seems to have feared that too much preoccupation with the means would compromise the purity of the ends. So in the

most nakedly political work, where she sought to arouse emotions and, more important, to exhort to action, she called upon the simplest and quickest means of exercising her brilliant draftsmanship: lithography. During the last two decades of her life she turned to it more frequently than to any other medium. A signal that her priorities had shifted to the primacy of the subject is suggested in a letter in which she wrote that she had received the commission from the International Trade Union Congress for a poster against war and that she was delighted to accept it.

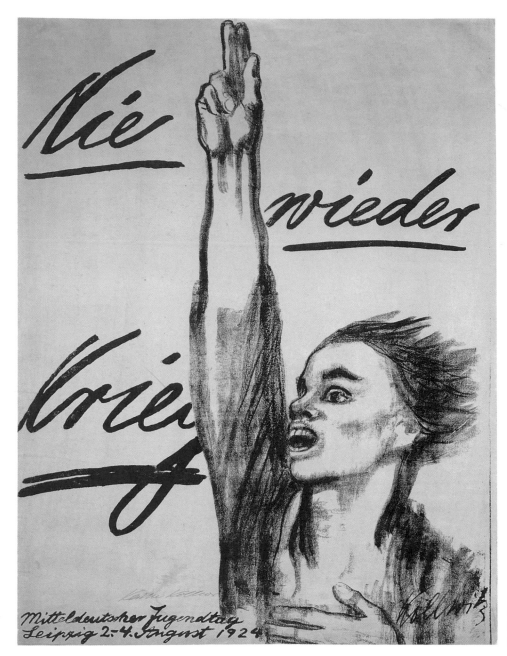

Nie wieder Krieg

Mitteldeutscher Jugendtag
Leipzig 2.–4. August 1924

cat. 90. *Never Again War!*, 1924.
National Gallery of Art, Washington,
Gift of Richard A. Simms

"One can say it a thousand times, that pure art does not include within itself a purpose. As long as I can work, I want to have an effect with my art."[92]

In the interest of "having an effect," Kollwitz was not immune to some influence of the expressionist movement, as reflected in her images of war and political posters. The intensity of the emotion relates to the concerns of the first generation of the movement, while the subject matter coincides with that of the highly politicized Weimar-era artists. But though her work sometimes became exaggerated to make a point,

at no time did it exhibit the deliberate, controlled distortion of the human figure so characteristic of expressionism, nor the cathartic ecstasy interpreted by opponents of the movement as decadent bourgeois self-indulgence. In this regard, it is useful to compare *Never Again War!* with the famous drawing by the expressionist Max Pechstein, *To All Artists!*, made in 1919 to illustrate the cover of a pamphlet for the radical artists' organization called the November Group (fig. 12). They share a similar format: a figure facing left raises the right arm skyward and presses the left

hand to the heart. Kollwitz executed her image rapidly and with spontaneous, bold strokes to convey the intensity of the sentiment. As strong as it is, the image seems restrained, even conventional compared to Pechstein's expressively distorted figure, who has been delineated with a nervous line and who clutches the flaming heart in his breast. His burning buildings situate the figure and evoke violent confrontation with society, whereas Kollwitz' figure emerges from an empty background. Kollwitz certainly knew Pechstein's image and recognized its power, but she reworked it according to her own aesthetic, which diverged significantly from that of the expressionist artist.

Despite Kollwitz' continually expressed ambivalence toward all of the graphic media, she returned to lithography almost exclusively in the period from about 1920 until her death. This choice was not without problems, however. Although there are sheets

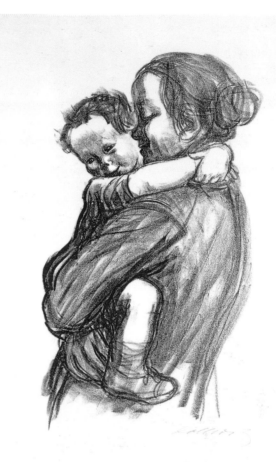

cat. 97. *Mother with Boy*, 1931. Private collection

fig. 12. Max Pechstein, *To All Artists!*, 1919, pamphlet cover, reproduction of a drawing. The Los Angeles County Museum of Art, The Robert Gore Rifkind Center for German Expressionist Studies, purchased with funds provided by Anna Bing Arnold, the Museum Acquisition Fund, and Deaccession Funds

from this period that possess great power, there are those in which she seemed to lose a certain critical distance from her subject, allowing them to hover precariously on the edge of sentimentality. Interestingly, Kollwitz professed herself glad when a reviewer found two of her works, *The Downtrodden* and a poster she made for an exhibition of home crafts (see p. 109, fig. 27), to be sentimental. Although she rationalized that her technical proficiency had been lacking at the time, one receives the distinct impression that she was somehow relieved to be checked in her production, as if aware that her deep feelings could sometimes overtake her.[93] In a revealing moment, with regard to images similar to the *Mother with Boy* (cat. 97), she posed the question of whether or not they were *"kitschig."* "I do not feel secure about them," she reported.[94]

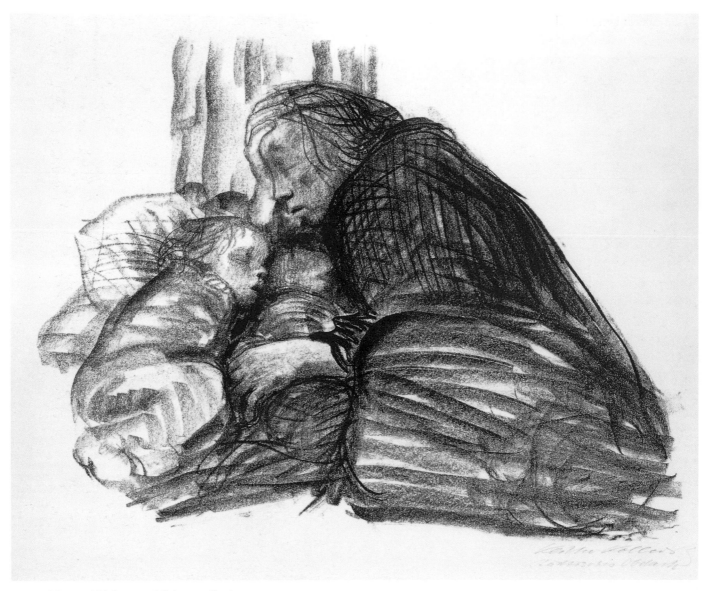

cat. 95. *Municipal Shelter*, 1926. Private collection

The best of Kollwitz' late work is characterized by large sheets in which her expansive, fluid line produces the most economical statement possible. For example, the humanity of her work in tandem with the quality of her draftsmanship raises an image like *Municipal Shelter* above the level of mere reportage or propaganda (cat. 95). The vigorously rhythmic and transparent lithographic line reveals Kollwitz at the apex of her expressive facility with that medium and shows how far she had come from the lithographs of *A Weavers' Rebellion*, which so closely imitated the effects of intaglio printing.

Although like the art of numerous other contemporary figures it mirrored social ills, *Municipal Shelter* nonetheless diverged from prevailing contemporary styles. The sharp-edged realism of the work of Berlin satirists of the 1920s such as George Grosz (fig. 13), Christian Schad, and Jeanne Mammen (fig. 14) carried an acid bite that was absent from the sympathetic, humanitarian outlook characteristic of Kollwitz' approach.[95] Her work also differed from similar working-class subjects by Secessionists like Hans Baluschek (1870–1935), whose color drawing *Homeless* from 1919 exemplifies the kind of anecdotal, sentimentalized illus-

tration from which Kollwitz sought to distance her own art (fig. 15).

The comparison of the two images reveals the urgency of Kollwitz' repudiation of techniques that, to her mind, beautified and consequently trivialized the tragic. In evocative harmonious hues, Baluschek portrayed homeless figures sitting on benches in a park. He took obvious pleasure in studying the different types, their expressions, and the details of their clothes and surroundings, even the patterns made by the trees against the evening sky. By contrast, Kollwitz focused exclusively on the large-scale figure of the distraught mother hunched over her two sleeping children. There is virtually no indication of setting, and the figures have been described just enough to communicate the essentials of the situation. In addition to the stark monumentality of the composition, whose black and white rendering signals unrelenting bleakness, the passionate handling of line expresses identification with the subject compounded by the presence of the artist's own features on the face of the mother. Overall, the image is unsentimental but sympathetic, more an admonitory chronicling of the human condition than illustration, satire, or an overt call to action.

fig. 15. Hans Baluschek, *Homeless*, 1919, mixed media on paper. Bröhan-Museum der Stiftung Bröhan

fig. 13. George Grosz, *Friedrich Ebert*, 1923, black ink over graphite. Harvard University Art Museums, Busch-Reisinger Museum, Gift of Erich Cohn

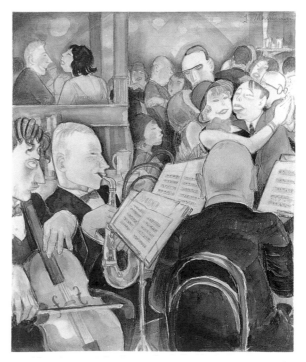

fig. 14. Jeanne Mammen, *Dance Orchestra*, 1923, watercolor. Harvard University Art Museums, Busch-Reisinger Museum, Gift of Robert Paul Mann

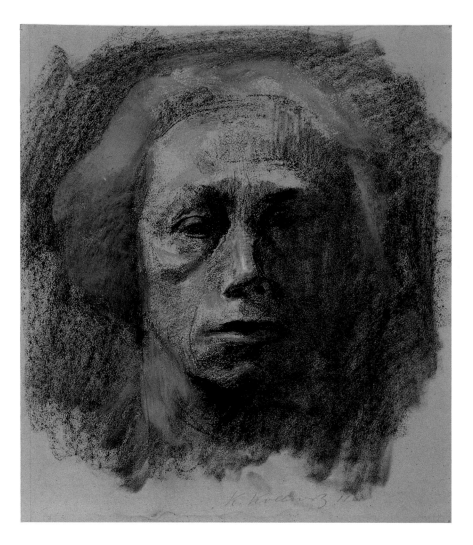

cat. 69. *Self-Portrait en face*, 1911. Staatliche
Kunstsammlungen Dresden

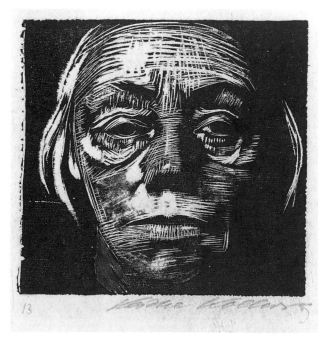

cat. 86. *Self-Portrait*, 1923. National Gallery of Art, Washington,
Rosenwald Collection

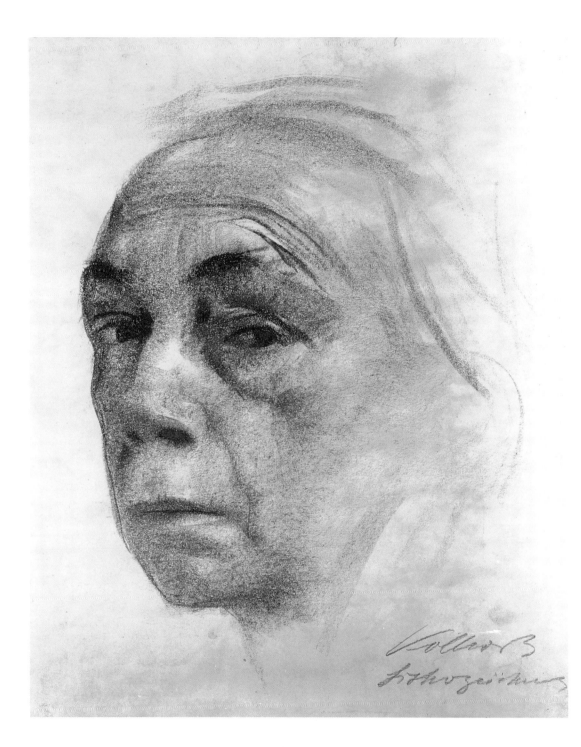

cat. 89. *Self-Portrait*, 1924.
National Gallery of Art,
Washington, Rosenwald
Collection

In addition to the sheets that document the artist's social engagement and the consistently powerful self-portraits (cats. 69, 86, 89, 92–94, 98–102 [see also pp. 168–170]), the final decades of Kollwitz' life saw the creation of her last cycle, *Death* (1934/1935). In this series of eight lithographs, Kollwitz depicted episodes linked only by the fact that each illustrates a mode of perishing. Here she reached the peak of her mastery of this process, especially in *Call of Death*. In this work (see cat. 100), the artist portrayed her own face, partially obscured by a raised forearm, eyes closed in a mask of peaceful expectation. From the left, the form of a disembodied human hand reaches out and gently taps Kollwitz on the shoulder as she instinctively raises her own hand to grasp that of Death. There is no fear, no anxiety, but rather a tranquil, weary acceptance of

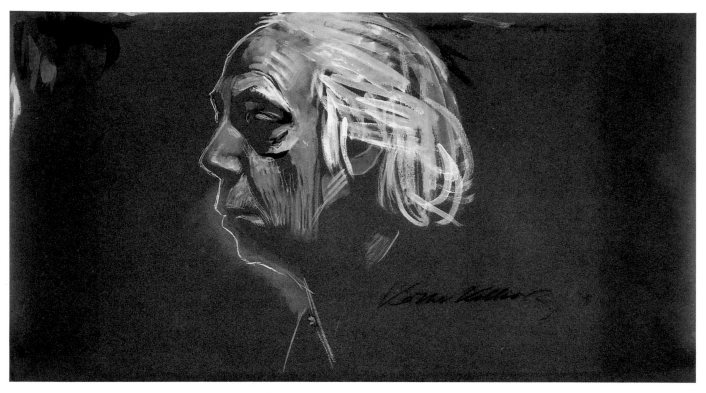

cat. 93. *Self-Portrait*, 1924. Käthe Kollwitz Museum Köln,
Kreissparkasse Köln

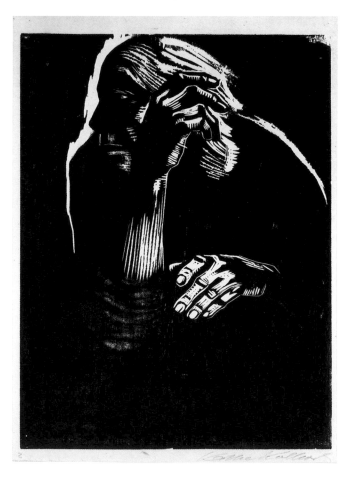

cat. 92. *Self-Portrait*, 1924. Private collection

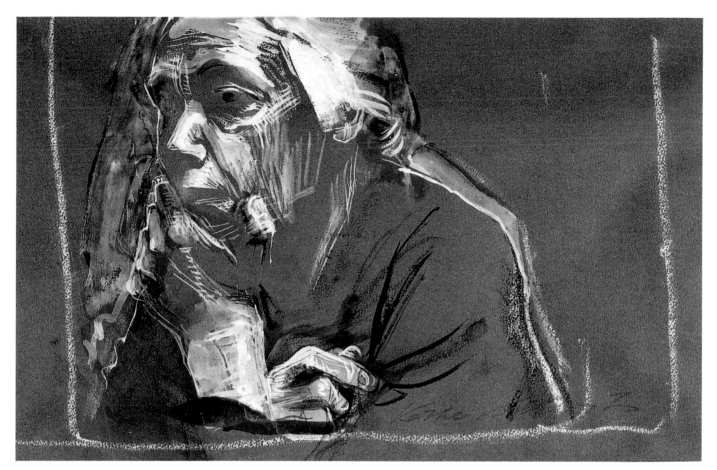

cat. 94. *Self-Portrait*, 1924. Dr. August Oetker Zentralverwaltung

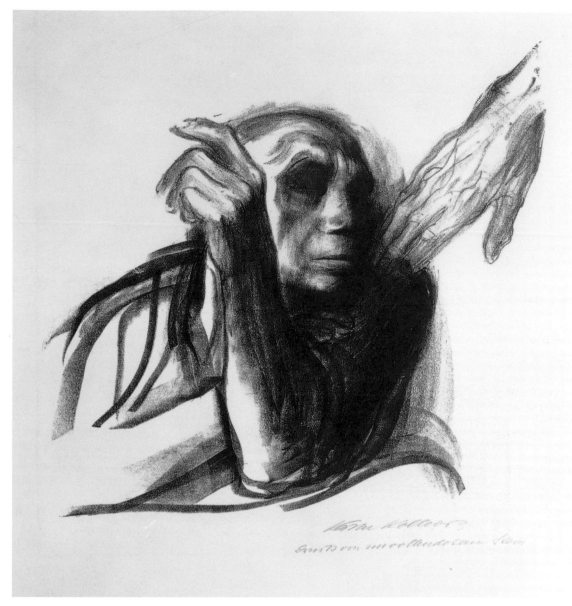

cat. 100. *Call of Death*, 1934. Private collection

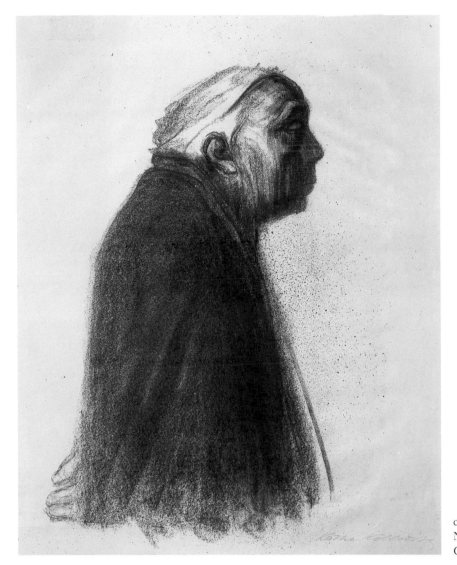

cat. 101. *Self-Portrait in Profile Facing Right*, 1938.
National Gallery of Art, Washington, Rosenwald
Collection

this long-awaited visit. The sheet is unequaled within
Kollwitz' production for its simplicity of conception
and its economy of means; the aged and resigned artist
caressed the stone with rich, sure strokes of the
lithographic crayon. The black lines possess an
unparalleled tonal richness and create a bold overall
design as well as a sensuous feeling for the grain of the
stone and the movement of the crayon on the smooth
surface. The final concrete expression of Kollwitz'
lifelong dialogue with death, *Call of Death* embodies
expressive draftsmanship and utmost economy of
means, which together account for the stark and
devastating impact of her finest late work.

Social Engagement and Ambivalence

Kollwitz' anxieties were not confined to her experi-
ments with various media. Issues such as the meaning
of art and its role in society, particularly during a time
of drastic social and political change, troubled the
artist and repeatedly forced her to confront and define
her own beliefs. The fact of her social engagement has
been taken for granted and her images appropriated to
such a degree by so many different political interests
that the artist's own stances have been obscured.
Consequently, any reconsideration of Käthe Kollwitz
must attempt to recover the private attitudes that
engendered an oeuvre of such universal and enduring
significance.

Above all, Kollwitz was a product of her background

and of her times. The well-rehearsed account of her family life describes the birth of Käthe Schmidt into a solid middle-class family in Königsberg. There she grew up in a household where literature and music played a role in everyday life and where the tone was set by her maternal grandfather Julius Rupp, a dissident Protestant minister who founded a Free Congregation that emphasized morality, the intellect, and duty. Much has been made of the family's resistance to the philistinism and repressiveness of Prussian society; among other things, the Schmidt children were educated privately in order to escape the rigidity of the public schools. So on the one hand Kollwitz' background was unconventional, and this, along with her social conscience that was deeply rooted in her childhood experiences and in the literature to which she was exposed by the family, would inform her entire life.

On the other hand, Kollwitz could not exactly be described as a rebel. From her diaries and letters as well as from the numerous accounts of her life and work, one may follow the progress of this East Prussian, who, as a young girl, had already identified her goal to become an artist. Far from having to reject the wishes of her family, Kollwitz pursued her artistic interests with the encouragement of her father; she remembered his conviction that, since she was not pretty, love affairs would not hinder her artistic progress.[96] He was partly wrong. Kollwitz became engaged at the age of seventeen to a friend of her brother, shocking her bohemian student colleagues by her adherence to middle-class conventions.[97] In spite of her marriage she persisted in her career, much to the relief of her father.

This childhood formed the backdrop for Käthe Kollwitz' choice of a topic such as the rebellion of the weavers for a print cycle. There is irony in the fact that the subject, whose success identified her in the public eye as an artist of social engagement, should have stemmed more from literary sources and an aesthetic inclination than from concrete political involvement. In one of many instances in which the artist felt compelled to clarify her point of view, Kollwitz admitted this in her memoirs from 1941:

> I would like here to say something about the characterization as "social" artist, that accompanied me from then on. Certainly my work by then already referred to socialism through the attitude of my father, my brother and through all the literature of that era. My actual motive, however, for choosing from now on the representation of the life of the worker was that selected motifs from that sphere simply and unconditionally were what I perceived as beautiful. . . . People from the bourgeoisie were entirely without charm for me. The bourgeois life seemed entirely pedantic to me. On the other hand, the proletariat had great style. Only much later, when I became acquainted, especially through my husband, with the difficulty and tragedy of the depths of proletarian life, when I became acquainted with the women, who came to my husband seeking aid and incidentally also came to me, did I truly grasp in all its power, the fate of the proletariat. . . . Unresolved problems like prostitution, unemployment tormented and worried me and acted as the origin of my attachment to the depiction of the lower classes and their repeated representation offered me a vent, or a possibility to tolerate life. Also there was probably a similarity in temperament with my father which strengthened this tendency. Occasionally my parents themselves said to me, "There are also cheery things in life. Why do you only show the dark side?" That I could not answer. It held no charm for me. Only I must repeat once again, that originally pity and sympathy were only minor elements leading me to representation of proletarian life; rather, I simply found it beautiful. As Zola or someone said, "The beautiful is the ugly."[98]

This passage, noteworthy for its straightforward and unapologetic tone, readjusts the common perception of Kollwitz as a political radical, certainly at this time during her career. The fact that her first two cycles, *A Weavers' Rebellion* and *Peasants' War*, both treat preindustrial themes from literary or historical sources suggests that it took roughly two decades after her move to the German capital before the artist seriously turned to the urban industrial life of Berlin for material.[99] During that time, Kollwitz was preoccupied with perfecting her graphic techniques. Only around 1908/1909 did her graphic art reflect more contemporary concerns and direct experiences. Concomitantly, it was at this time that she began to refine the notion of her art having "purpose" and that she slowly started to privilege subject matter over technical issues. Although the first cycles certainly display a profound sense of pathos and identification with sorrow, only later would a sense of active mission inform her imagery.

As mentioned, *A Weavers' Rebellion* was considered

subversive and was denied the Berlin Salon's small gold medal. However, denial of the medal only enhanced her growing reputation. On the strength of the portfolio's success with more progressive factions of the public and the art world, in 1898 she was invited to teach classes in the graphic arts at the Berlin School for Women Artists, where she had been a student. The following year she received the imprimatur of the establishment with an invitation to join the Berlin Secession, then under the direction of the renowned impressionist Max Liebermann. She later was appointed to the jury of this exhibition organization, becoming the first and only woman to serve in that prestigious position.

Thus began Kollwitz' immersion in the art world of her time. She was not an outsider, a rebel, or an isolated misunderstood figure, but rather was fully integrated into the establishment of the Secession group and accepted by the public. Among the reasons for her acceptance was the fact that her art fit so well into a prevailing mode of socially oriented imagery promoted by a number of her contemporaries. These artists— Menzel (fig. 16), Liebermann (fig. 17), Uhde, Leibl—

already represented an older generation of which Kollwitz was spiritually very much a part. Kollwitz pursued her own figurative style and socially engaged themes. She was surprisingly impervious to developments in art in the first decades of the twentieth century, despite the increasing visibility of the expressionists in Germany and vanguard groups like the cubists in France. Her diaries record no mention of Cézanne or Picasso, for example, but rather concentrate on examining her own views on art. In one diary entry she mentioned her acquaintance with Max Pechstein, one of the expressionist artists, viewing his work as "talented smears" that said nothing to her, and she mused upon the passing of generations of artists.[100] Nor was it solely a question of generation. Although the expressionist Emil Nolde was precisely the same age, he embraced the most avant-garde current movement with its overtones of internationalism and radicalism. Kollwitz remained resolutely the product of her formation, grounding her explorations in the naturalist tradition from which she emerged.

A measure of Kollwitz' conservatism may be discerned in her role in the so-called Vinnen affair. In 1911 she signed what became a notorious protest organized by the minor German landscape painter Carl Vinnen, directed against the purchase of modern French art by state museums in Germany.[101] As Peter Paret has observed, "Käthe Kollwitz cannot be reproached for disliking Matisse and envying his suc-

fig. 16. Adolph Menzel, *Study for Two Workers*, n.d., graphite on light brown paper. Hamburger Kunsthalle

fig. 17. Max Liebermann, *The Weaver*, 1882, oil on canvas. Städelsches Kunstinstitut, Frankfurt

cess in German exhibitions. But that someone with her political and social concerns could be blind to the implications of associating herself with a manifesto directed at the very people and organizations that were defending modern art, including her own work, suggests not only political naiveté but also how difficult it was for some early members of the Secession to tolerate the newest art."[102] In a letter to her son Hans written almost immediately after she signed, Kollwitz disavowed her association with the chauvinist and antimodernist document, realizing the implications of what she had done.[103]

The incident contributes to a more subtle reading of Kollwitz' dilemma. It affirms that the artist's open-mindedness did not automatically extend to the most progressive trends in art or art politics and that she did not have a clearly defined approach to political matters. Although a diverse range of organizations called upon Kollwitz to contribute posters to a variety of causes, she herself rejected active membership in a specific political party. Her outlook was humanitarian and universal. In the pre-war years, only one work carried true political implications until she began to make posters and her next series on war. This was *March Cemetery*, executed in 1913 (cat. 70, p. 92). Depicting workers paying homage to the dead of the revolution of the 18th of March 1848, this was a commissioned work, executed for the Free Peoples' Theater of Berlin and made available to its members. Posterlike in its firm bold draftsmanship and direct, legible style, *March Cemetery* celebrated solidarity and the continuing struggle among workers, without any overt or disturbing messages but rather with a slightly elegiac tone.

What Kollwitz did understand, unlike the artists who embraced progressive styles, was the necessity of remaining accessible to the average viewer if she were to communicate a message. At no time was she vulnerable to the misunderstanding on the part of the expressionists, among others, that avant-garde art was synonymous with progressive politics. The experience of World War I was largely responsible for Kollwitz' confrontation with this dilemma. A pivotal moment for her was the death of her son Peter in the first days of combat: on Friday, 30 October 1914, she and Karl received the news that their beloved son had died.[104] Like many young men, Peter Kollwitz had enlisted as a volunteer and had departed full of national pride and fervor. Kollwitz' own initial support for his action was severely challenged after his death, and she was torn between her mounting disgust for the endless fighting and monumental number of casualties and her fear that her son's death would be rendered meaningless.[105] Reflecting on his loss two years later, she observed that being the "granddaughter of Julius Rupp," by which she meant the strong moral training she had received, was different from being a mother, and she implied that she had been responsible for Peter's voluntary enlistment. She wondered sadly if, given another chance, she would not do things differently.[106] Spurred on by the death of her son, the artist began to comprehend the role of engaged art and its power. She began to accept the notion that, through her art, she could communicate social messages to the population and in so doing have an effect on her times.

The loss of Peter, the war, and the violent birth of the Weimar Republic precipitated a genuine shift in Kollwitz' attitude toward the function of art and contributed to her persistent dissatisfactions with media and their expressive capabilities. She was acutely sensitive to the fact that the political and social events unfolding in Germany presented situations that demanded different subjects and new pictorial strategies to realize them. A leitmotif in Kollwitz' career during the period of war and revolution was the struggle to create an art that could aspire to a high level of aesthetic achievement while responding to the needs of the people, the "average viewer," something that, with the advent of expressionism and abstract art, she realized by no means could be taken for granted. In a diary entry of 1916 she discussed the issue at some length.

> Read an article by Eduard von Keyserling "The Coming Art." He turns away from Expressionism and says that less than ever after the war will the German people be able to use high-flown "studio" art. What it needs is an art of reality.
>
> Completely my opinion. . . .
>
> This relates to a conversation I had recently with Karl concerning my little sculpture. It is true that it fails. Why? It is not popular. The average spectator does not understand it. Art for the average viewer need not be superficial. Indeed, he would still like it even if it were flat. But surely true art will please him if it's simple.
>
> It is totally my opinion that there must be an under-

standing between the artist and the people, in the best of times it has always been so.

To be sure, Genius can run ahead and seek out new paths, good artists, however, who come after genius—and I count myself among these—have to create again the connection that has been lost. A pure studio art is unfruitful and untenable, because that which does not create living roots—why should that exist?

Now for me. It is a danger for me, that I distance myself too far from the general spectator. I lose the connection with him. I am a seeker within art, and who knows whether by doing so, I might not come to what I search for. On New Year's Eve 1914, as I was thinking of my work, I vowed to myself and to Peter that more than ever before, I wanted to "honor God, that means, to be totally genuine and unembellished." Not that I sensed myself to get away from this but, in this search, one declines easily into artistic brooding and hairsplitting—affectations. . . .[107]

The debate centering on the merits of "pure art" as opposed to "reality art," in Keyserling's terms, naturally became more urgent because of the war. After 1918, avant-garde artists in Germany, the expressionists in particular, became politicized, naively equating progressive art with progressive politics. Kollwitz by contrast understood clearly that her notion of the role of art did not permit an art-for-art's-sake approach and that the styles of the avant-garde would not serve her ends. In an often quoted statement from a diary entry of 1922, she observed, "Actually my art is not *pure* art in the sense e.g. of Schmidt-Rottluff's. But still art. Each works as he can. I am in agreement, that my art has *purpose. I want to have an effect on this era*, in which humans beings are so much at a loss and so in need of help."[108]

Kollwitz understood that new situations could be the occasion for new forms, but she believed in adhering to the only mode in which she felt truly comfortable, realism. She puzzled over her relationship with the viewer as something both individual and with larger implications. For example, in the context of a sculpture she planned to commemorate Peter's death, she mulled over a conversation she had with her older son Hans on the difficulty of creating a "new" work of art.

> Peter's sculpture should be significant and simple, but the word new does not come into consideration for it. That which I always said previously: the content could be the form —where have I succeeded at that? Where is the new form for the new content of these last years?
>
> . . . I worked further on the sketch [for Peter's sculpture]. I should only execute it when I genuinely succeed in finding a form that coincides with the content. It does not have to be realistic and [yet] it cannot be other than a human form recognizable to us. To find a form like Krauskopf does is impossible for me, I am not an expressionist in that sense. Therefore there remains only the human form that is known to me, which must be completely distilled. . . not entirely like Barlach, but closer to him.[109]

It is odd that Kollwitz should have agonized about the implications of artistic styles when hers, above that of all her contemporaries, retained its roots with the people and did not, her doubts to the contrary, genuinely decline into "artistic brooding." It is reflective of her painful self-doubt and probably of a sense of pressure from the predominance of vanguard styles that she should have regarded her experiments and joy in the materials of art as self-indulgent and, in effect, counterrevolutionary. In truth, she was producing true proletarian art in the sense of remaining apprehensible to viewers of all educational and social levels. Although she had always felt responsible for communicating with her viewers and subscribed to Klinger's conception of the graphic arts as an organ of criticism, the years of the First World War advanced this to a sense of mission and occasioned the dissatisfaction with her means, which persisted from the earliest complaints about her skill at etching. Out of a sense of duty and guilt, she subordinated the pleasure of the act of making to the communication of her message. The issue had migrated from the aesthetic to the moral and, broadly conceived, ideological realm.

This is most evident in many of the late, large-scale lithographs, where Kollwitz implicitly addressed the potentially troubling disjunction between an artist's aesthetic engagement with means and materials and difficult subject matter. Kollwitz rejected the use of too much technique as incompatible with the depiction of painful topics, realizing only too well the disturbing capability of art to elevate or beautify the unspeakable. When she attended a performance of Hauptmann's play *The Weavers* again in 1921, almost thirty years after she first was overcome by the drama, she discerned the power of art to transform ugly reality into something deceptively grand. In her diary she acknowl-

edged that "I thought I was a revolutionary and was only evolutionary. . . . How good it is when reality tests you. . . . But when an artist like Hauptmann shows us revolution transfigured by art, we again feel ourselves to be revolutionaries and fall again into the old deception."[110] After direct confrontation with war and the failed revolution of 1918, Kollwitz could no longer be deceived by the transfiguring power of art, and she did not want to seduce others with her own. Consequently, in this later period she resisted artistic experimentation, concentrating on the most unembellished communication of her subject.

For this reason one must be wary of linking the *Memorial Sheet to Karl Liebknecht* and the woodcuts of the *War* series with the art of the so-called "second generation" of expressionists.[111] Although there is no question that her woodcut style, especially, evolved in the late teens and early 1920s to approach expressionism more closely, the artist herself would have been surprised to find herself grouped with artists with whom she felt she had so little in common ideologically as well as formally. In fact, Kollwitz was working much as she always had. The politicized artists of the second generation of expressionism simply caught up with her. But unlike them, and in spite of private doubts about the nature of her art, Kollwitz always retained her connection with and loyalty from the population who knew her work. She did this by adhering to the legible forms that had become her hallmark in all media and to the social commitment she had consistently manifested well before it became fashionable or expedient.

Kollwitz' quandary with regard to the role of her art was aggravated by another event of 1919. This was her appointment as professor in the Prussian Academy of Art; she was the first woman to be honored in this way. The academy, however, had actively opposed reform in the face of tremendous pressure from avant-garde artists who were associated with left-wing political movements. Kollwitz herself had initially signed a manifesto drawn up by one of the artists' groups, the Workers' Council for Art, which sought to create a new order under the Weimar Republic by eliminating elitist art institutions and creating a new antiestablishment system under which art could flourish and artists have a role in transforming society.[112] Although she

later retreated from its radicalism and, in any case, opposed the avant-garde styles of its members, there is also evidence that she was uneasy about joining the establishment: in a letter to Bonus-Jeep of the same year, she admitted that she had not wanted to accept the academy's appointment but it was made public when she was out of town and she did not want to cause trouble when it was too late.[113] The awkward situation was troubling for the artist, who yet again found herself pulled in many directions by circumstances and felt unable to resist.

Another challenge to Kollwitz' beliefs came with her involvement in the *Memorial Sheet to Karl Liebknecht*. On the one hand, she was prompted to search for a "new form for a new content," but on the other, she anguished over the ideological implications of her choice to commemorate the event. In the politically charged atmosphere of postrevolutionary Germany it was increasingly difficult to remain aloof from party politics, and Kollwitz feared being compromised against her will. A diary entry of critical significance, written in 1920, confronted these implications.

> I am ashamed that I am still not taking a stand and surmise that when I declare that I don't belong to a party, the actual reason is cowardice. Actually, I am in fact not at all revolutionary, but rather evolutionary, but since one praises me as an artist of the proletariat and of the revolution and shoves me ever tighter into that role [mich immer fester in die Rolle schiebt], so I shy away from not continuing to play that role. I *was* revolutionary, my childhood and youthful dream was revolution and barricades, were I still young I would surely be a communist, even now something yanks me over to that side, but I'm in my fifties, I have lived through the war and seen Peter die and the thousand other young men. I am horrified and shaken by all the hatred in the world, I long for the kind of socialism that lets people *live*, and find that the earth has seen *enough* of murder, lies, misery, distortion. In short, of all these devilish things. The communist state that builds on that cannot be God's work.[114]

Kollwitz feared that her obvious indecision on these political issues would be recognized and she wished she could be left alone. In a remark that tempers claims about her feminism, she wrote, "After all, one cannot expect of an artist, who on top of it all is a woman, that she finds her way in these insanely complicated circumstances."[115] Rather, "*I have the right as an artist to extract*

*the emotional content from everything, to let things take
their effect on me and to give them external form.* And so
I also have the right to portray the working class's
farewell to Liebknecht, even dedicate it to the workers,
without following Liebknecht politically. Or not?!"[116]

Nowhere else does Kollwitz so clearly illuminate
her ambivalence toward her art and toward the role
that she perceived herself as being compelled, by out-
side forces, to take on. The artist who began by finding
themes from the working class beautiful and whose
orientation was broadly humanitarian became tangled
in the political realities of a complex historical
moment. Although she developed a commitment to
providing a voice for the common person, the poor,
and the suffering, she nevertheless felt troubled by a
task she felt had been thrust upon her and which she
could fulfill only at the expense of certain facets of her
art. This is not to say that she was insincere. The
desire to use her art to help was quite in character,
which the powerful rhetoric of her many posters of the
period amply confirms. In a diary entry of early 1920,
the artist discussed her poster to save Vienna's starving
children (see p. 121, fig. 6). "While I drew, and wept
along with the terrified children I was drawing, I really
felt the burden I am bearing. I felt that I have no right
to withdraw from the responsibility of being an advo-
cate. It is my duty to voice the sufferings of people, the
sufferings that never end and are big as mountains.
This is my task, but it is not at all easy to fulfill."[117]

The difficulties of fulfilling the role were expressed
again in an entry from the diary of Kollwitz' son Hans
some months later. He was discussing with his mother
a review in the Communist party newspaper *Die Rote
Fahne* of an exhibition for workers, which divided her
oeuvre into two periods. According to the review, the
first was a revolutionary period and the second was
devoted to imagery depicting the proletariat only in its
oppression and hopelessness. According to the artist,
that was only half true. Not only was the differentia-
tion not so sharp, but she now was interested in essen-
tial human concerns such as death as well. And yes, she
was no longer revolutionary, her interests had become
more "cosmic," and even when she was making *Out-
break,* for *Peasants' War,* she could not have made it
more revolutionary than she did at the time.

Further, she admitted to Hans that she might have

moved entirely away from political issues and toward
purely human experiences had events not led her back
again. Earlier she would have depicted the Liebknecht
sheet quite differently, but she did not know if the
workers would have understood it as well. When, on
the strength of the *Memorial Sheet to Karl Liebknecht,*
young people came to her as their "standard-bearer,"
she always felt that there was something false, that
what they saw in her she no longer saw in herself, the
earlier "hating and fighting Käthe Kollwitz."[118] These
are revealing and rather poignant remarks on the part
of an artist who was adopted by so many groups as a
model for their causes. They underline the extent of
her ambivalence and show how she apparently was
unable to prevent herself from adopting positions,
artistically if not emotionally, that under other circum-
stances she might not have chosen herself. Ironically,
critical reception of her art had assigned her the role of
political engagement long before she finally adopted it
out of a sense of duty. Even then she wished the public
to be aware of the range of her subjects: in 1942, she
observed to a correspondent, "when you characterize
me exclusively as a portrayer of the proletariat, I say
that you know my work only very incompletely."[119]

In this context, Kollwitz' trip to the Soviet Union
cannot be ignored since it further emphasizes the
ambiguity of her political stance. On the occasion of
the tenth anniversary of the Russian Revolution, the
artist and her husband accepted the invitation of the
Soviet government to visit Moscow, where an exhibi-
tion of her works was mounted. From 9 to 12 Novem-
ber the city hosted a World Congress of Friends of the
Soviet Union, of which the German delegation was the
largest. Kollwitz attended not only as a major artist but
as a representative of the Society of Friends of the
New Russia.[120] This was a much-anticipated voyage;
Kollwitz had long loved Russia because of Tolstoy and
Dostoyevsky and, like many intellectuals, she initially
viewed developments in that country as full of promise
for the creation of a new kind of society. "A new world
was hammered out. . .," she observed.[121]

Although Kollwitz remained steadfast in her refusal
to join the Communist party and published a statement
to that effect shortly before her trip,[122] her art was
greatly admired on its own merits in the Soviet Union,
where its style and content were perceived to be com-

patible with the goals of the revolutionary society. Anatoly Lunacharski, the people's commissar for culture, discussed her work at some length in his essay, "An Exhibition of the Revolutionary Art of the West."

> This truly admirable "apostle with the crayon" has, in spite of her advanced years, altered her style again. It began as what might be described in artistic terms as *outré* realism, but now, towards the end of her development, it is dominated more and more by a pure poster technique. She aims at an immediate effect, so that at the very first glance one's heart is wrung, tears choke the voice. She is a great agitator. It is not only through her choice of subject that she achieves this effect, nor by exceptional, indeed, one may call it the physiological accuracy with which she evokes an event—no, it is mainly by the exceptional economy of her means. As distinct from realism, her art is one where she never allows herself to get lost in unnecessary details, and she says no more than her purpose demands to make an immediate impact; on the other hand, whatever that purpose demands, she says with the most graphic vividness.[123]

Kollwitz found the Moscow trip to be stimulating; a photograph shows her comfortably ensconced among a group of artists and actors (see p. 122, fig. 7). She was, however, curiously noncommittal on the subject, and her diaries recount only her impressions of the hanging of her works in the exhibition.[124] A month later, on New Year's Eve, in summarizing the events of 1927, she acknowledged how different and refreshing she had found the atmosphere in Moscow, noting that "Karl and I returned thoroughly aired."[125]

Kollwitz' imagery was so universal that, to her disgust, some of her work was appropriated by the National Socialists under the name of another artist for use in their own propaganda campaign. She declined to protest, noting that it could make trouble for her and, further, that it would be worse if they then apologized for the mistake and offered to restore her name to the image.[126] The incident was even more ironic since she had been forced to abandon her post at the Prussian Academy of Art and was forbidden to exhibit under the Third Reich. Because of her passionate anti-fascist stance and because of her forthright depiction of social misery, which the Nazis considered subversive, her work was initially included in the first showing of the exhibition of "degenerate art" that traveled to the major cities of Germany in 1937.[127] Yet

again, Kollwitz was shoved into a role out of her control while her images, with their puissant universality of message and pictorial language, moved into the public domain to be used at will in service of strikingly divergent interests.

Reconsidering Käthe Kollwitz has required another look at an artist and a body of work that have been the object of extensive comment. It is remarkable, in an age dominated by the phenomenon of the avant-garde, that an artist who so resolutely resisted its call should have escaped marginalization and occasioned such concentrated attention and debate. Whereas the acute individualism or abstract style of the greatest modern masters hampered a general understanding, even toleration of their achievement, no such obstacles impeded Kollwitz' acceptance, even if, by her own admission, she did not advance the cult of originality.[128] Nor is it a question of Kollwitz experiencing great popularity in the eye of the public at the expense of being seriously considered by art historians. They too have found in her work a level of achievement and a depth of purpose that demand consideration.

Behind Kollwitz' finished work are sheets that reveal the artist searching to satisfy herself artistically, according to inner need as well as to a sense of duty both self-generated and imposed by outside causes. It is important to acknowledge the equivocal nature of this person, who despite her socially engaged imagery was an artist first and foremost, above all a "master of her craft." Kollwitz' gift for handling materials and for fashioning an idea into potent visual rhetoric raised her work above that of simple illustration or propaganda, as persuasive as it could be. While the evidence provided by her extensive technical experimentation amply illustrates her concern for her art, her writings demonstrate that, although she brilliantly and conscientiously fulfilled the dictum of her grandfather Julius Rupp—"a talent is a duty"—she accomplished it at the price of much private anguish and ambivalence. To overlook this is to deny a critical facet of an artist whose achievement, and indeed self, are far more complex than is often supposed.

Notes

1. In 1937, Elizabeth McCausland noted that Kollwitz was little known in the United States. See "Käthe Kollwitz," *Parnassus* 9, no. 2 (February 1937), 20–25. One of the earliest American exhibitions of Kollwitz' work took place at the Jake Zeitlin Gallery and Bookshop in Los Angeles in 1937.

2. Hans Kollwitz, "Einleitung," in Hans Kollwitz, ed., *Ich sah die Welt mit liebevollen Blicken: Käthe Kollwitz, Ein Leben in Selbstzeugnissen* (Wiesbaden, 1988), 6.

3. For reproductions of early oil paintings, see Tom Fecht, ed., *Käthe Kollwitz Works in Color*, trans. A.S. Wensinger and R.H. Wood (New York, 1988), nos. 2-5.

4. J. Diane Radycki, "The Life of Lady Art Students: Changing Art Education at the Turn of the Century," *Art Journal* (Spring 1982), 11. This article provides a good overview of the situation for women in Germany at the turn of the century, with reference to Paula Modersohn-Becker and Kollwitz in particular.

5. Radycki 1982, 11.

6. Kollwitz, letter to Max Lehrs, 29 August 1901, in Käthe Kollwitz, *Briefe der Freundschaft und Begegnungen* (Munich, 1966), 22. Translations are mine unless noted otherwise. I thank Dr. Ernst Prelinger for his advise in interpreting these texts.

7. Kollwitz, in "Rückblick auf frühere Zeit" (1941), reprinted in Käthe Kollwitz, *Die Tagebücher*, ed. Jutta Bohnke-Kollwitz (Berlin, 1989), 737.

8. See Kollwitz, letter to Herr and Frau Zimmerman, 1 September 1930, in Kollwitz 1966, 25. To Klinger's daughter and son-in-law, she acknowledged that the artist was "the strongest influence of [my] youth." For a discussion of the early influences on Kollwitz and clarification of where and when she began to etch, see Werner Schmidt, "Zur künstlerischen Herkunft von Käthe Kollwitz," *Staatliche Kunstsammlungen Dresden Jahrbuch* (1967), 83–90.

9. Kollwitz, letter to Paul Hey, 22 September 1889, Kollwitz 1966, 16.

10. This rapid overview of the state of printmaking at the time of Kollwitz' introduction to the art is indebted to the discussion of modern German printmaking in Frances Carey and Antony Griffiths, "Introduction," in *The Print in Germany 1880–1933. The Age of Expressionism* [exh. cat. The British Museum] (London, 1984), 11–28.

11. Hans W. Singer, *Die moderne Graphik* (Leipzig, 1914); Curt Glaser, *Die Graphik der Neuzeit* (Berlin, 1922).

12. Carey and Griffiths in London 1984, 11–12.

13. See J. Kirk T. Varnedoe and Elizabeth Streicher, *Graphic Works of Max Klinger* (New York, 1977), xiii.

14. Carey and Griffiths in London 1984, 11–12.

15. Max Klinger, *Malerei und Zeichnung* (Leipzig, 1899), 28.

16. Although the actual moment at which she read the treatise is a matter of some dispute, what seems significant is that, in hindsight, Kollwitz assigned that artist and his theories so much importance for her own development. See Schmidt 1967, 83–90.

17. Klinger 1899, 30–31.

18. Klinger 1899, 33.

19. Klinger 1899, 30–31.

20. Klinger 1899, 32.

21. Klinger 1899, 33–34.

22. Klinger 1899, 42.

23. Klinger 1899, 44.

24. Klinger 1899, 44.

25. Klinger 1899, 48.

26. Klinger 1899, 46–48.

27. Klinger 1899, 29–30.

28. *A Weavers' Rebellion* appeared in 1898; *Peasants' War* in 1908; *War* in 1922–1923; *Proletariat* in 1925; and *Death* in 1934–1935.

29. Kollwitz 1989, 738.

30. Kollwitz 1989, 738–739.

31. This work, along with another charcoal sketch reproduced in Alexandra von dem Knesebeck, "Die Bedeutung von Zolas Roman «Germinal» für den Zyklus «Ein Weberaufstand» von Käthe Kollwitz," *Zeitschrift für Kunstgeschichte* 3 (1989), 402–422, nos. 1 and 2, was unknown to Otto Nagel and Werner Timm, authors of the catalogue raisonné of Kollwitz' drawings. They appeared at auction in the 1970s.

32. Letter to Hanna Löhnberg, 29 July 1919, in Kollwitz 1966, in which the artist wrote of her eventual realization that nature study needed to be combined with the exercise of working from memory.

33. Letter of 26 February 1891 to Paul Hey in Kollwitz 1966, 20–21. See also Otto Nagel and Werner Timm, *Kathe Kollwitz: Die Handzeichnungen* (Berlin, 1972; 1980), nos. 51 and 52, for studies made at the bar.

34. Letter of 26 February 1891 to Paul Hey, in Kollwitz 1966, 20.

35. Kollwitz 1989, 741.

36. Peter Paret, *The Berlin Secession. Modernism and Its Enemies in Imperial Germany* (Cambridge, Mass., London, 1980), 86.

37. "An Max Lehrs," in Kollwitz 1966, 23. Hans Kollwitz was born in 1892, his brother Peter in 1896.

38. "Rückblick auf frühere Zeit," in Kollwitz 1989, 742.

39. See also the discussion in the section on Kollwitz by Carey and Griffiths in London 1984, 61–62.

40. Letter to Arthur Bonus, August 1921, cited in Kollwitz, '*Ich will wirken in dieser Zeit*' (Frankfurt-Berlin-Vienna, 1952/1981), 102.

41. Letter to Max Lehrs, 29 August 1901, in Kollwitz 1966, 24.

42. The first was a portrait of her son Hans, (K. 30), dating from 1896. Klipstein lists only one impression.

43. "Rückblick auf frühere Zeit," in Kollwitz 1989, 740. The final proofs were not made in the order in which they were ultimately configured, but were completed as follows: *March of the Weavers; Storming the Gate; Poverty; Death; Council;* and *End.*

44. See also Nagel-Timm 1980, 105, for a preparatory study for this composition.

45. See Knesebeck 1989, 402–422. Knesebeck observed that Kollwitz' connection to the Social Democratic party placed her in opposition to Hauptmann's more conservative politics. Young intellectuals of the party criticized the play. Knesebeck quoted from an article of 1894 in *Vorwärts*, which claimed that the playwright should have used the tragedy as an introduction to warfare against oppression, leading ultimately to the liberation of mankind (421).

46. For a discussion of the Lamentation motif see Renate Hinz, " 'Beweinung'— Transformation eines christlichen Motivs," in *Käthe Kollwitz* [exh. cat. Frankfurter Kunstverein] (Frankfurt am Main, 1973), part II.

47. Some sources have assumed that this figure represents a woman. See Knesebeck 1989, 417.

48. See Gunther Thiem, *Die Zeichnerin Käthe Kollwitz* [exh. cat. Staatsgalerie Stuttgart] (Stuttgart, 1967), no.16, 31.

49. Knesebeck 1989, 416–417.

50. Julius Elias, "Käthe Kollwitz," *Kunst und Künstler* 16 (1917), 546.

51. For the most recent and extensive treatment, see Knesebeck 1989.

52. For an intensive examination of the theme, see Renate Hinz in Frankfurt 1973, n.p.

53. In an entry on this proof, Glaubrecht Friedrich noted that the two sheets were acquired by the Dresden Kupferstich-Kabinett from the artist over two years, so they were subsequently placed together. It is clearly the same stroke of the brush, seen at the lower right of the left side, which encroaches upon the middle section; so one may assume they were made at the same time, separated for some reason, and then later reunited in the print room. See Werner Schmidt, ed., *Die Kollwitz-Sammlung des Dresdner Kupferstich-Kabinettes. Graphik und Zeichnungen 1890–1912* [exh. cat. Käthe Kollwitz Museum Köln] (Cologne, 1988), no. 57,

185.

54. Letter of August 1921 to Arthur Bonus, reproduced in Kollwitz 1952/1981, 102.

55. See the discussion in Paret 1980, 21–24.

56. Minister of culture Robert Bosse to Wilhelm II, 12 June 1898; cited in Paret 1980, 21 n. 24.

57. See Knesebeck 1989, 415. One is tempted to wonder why, after all the intensive work on the series, she simply did not call the series *Germinal* as she had originally planned. Clearly it still loomed large in her imagination and presented a richer mine to excavate than Hauptmann's drama. With his passion for naturalistic detail, Zola provided more elaborated descriptions of settings and events than the playwright, and Kollwitz might also have seen French illustrations to *Germinal* that influenced her own renderings.

58. "Sich Angeschautes und Durchlebtes von der Seele schrieb." Elias 1917, 546.

59. Letter to Arthur Bonus, August 1921 (1907?), in Kollwitz 1952/1981, 102–103.

60. Thiem suggested that the Bremen preparatory study for Black Anna (NT 193) is the one from which she transferred the figure to the plate. (Stuttgart 1967, no. 22, 37).

61. John A. Walker, "Art & The Peasantry 2," *Art & Artists* 154, vol.13, no. 10 (February 1979), 15.

62. The process was described in a contemporary handbook that Kollwitz was known to have used: Hermann Struck, *Die Kunst des Radierens* (Berlin, 1908), 36. See also 115. There Struck explained the process, noting its "less melodic" name in German, the "Durchdruckverfahren" (through-printing technique).

63. Carey and Griffiths in London 1984, 68.

64. Carey and Griffiths in London 1984, 68.

65. It has been alternatively suggested that Kollwitz obtained this texture through the Crayon- or Kreide-Manier, described in Struck 1908, 34–35. However, it would not have been pos-

sible for her to create such extensive and even tonal areas with this process.

66. I am grateful to B. G. Muhn of Georgetown University, who studied these works at great length with me, to Judith Brodie of the department of prints and drawings, National Gallery of Art, and to Shelley Fletcher and Connie McCabe, conservators in the paper laboratory at the National Gallery, for their help with this matter. A number of prints were examined in depth to make this determination.

67. According to August Klipstein, *Käthe Kollwitz, Verzeichnis des graphischen Werkes* (Bern, 1955), before Kollwitz turned to the large plate for *Outbreak* she completed a study for two of the raging peasants, one who brandishes a sword like an avenging angel (K. 65). On one of the extant impressions of the study, entitled *Technical Trial: Two Charging Figures*, Kollwitz helpfully appended an explanation of her procedure: "Drawn with a mixture of gum arabic with Kremser white with a brush on the blank copper plate. The plate was then overlaid with a hot ground and laid in water after cooling. The ground lifted off the worked-up parts and remained uncovered for etching. Thereafter etched. Liftground process. Käthe Kollwitz." cited in Klipstein 1955, no. 65, 81. Lines of this description occur repeatedly in *Outbreak*, lending the feeling of a drawing to an image that could only have been generated through treatment of the copper plate. When compared to the description of the same process in Struck's handbook, they sound very close and it is probable that the artist heard about it in printmaking circles as Struck was preparing his book. Struck observed that this "lift-ground process," also called "Reservage," produces prints that look like reed pen drawings. See Struck 1908, 124.

68. Sella Hasse, "Begegnung mit Käthe Kollwitz " in Kollwitz 1966, 152.

69. Judith Brodie, "Woman with Dead Child," *Art for the Nation* [exh. cat. National Gallery of Art] (Washington, 1991), 268.

70. Beate Bonus-Jeep, cited in Catherine Krahmer, *Käthe Kollwitz* (Reinbek bei Hamburg, 1981), 56.

71. In this case, Kollwitz almost certainly did not use a photomechanical process. The areas of mechanical grain are so few that it is more likely that she pressed a screen into a soft ground laid over the plate.

72. I am indebted to Charles W. Haxthausen for these suggestions.

73. Letter to Max Lehrs, 29 August 1901, in Kollwitz 1966, 24.

74. Letter to Dr. Heinrich Becker, 1 June 1929, in "Käthe Kollwitz an Dr. Heinrich Becker. Briefe," brochure (Städtisches Museum Bielefeld, 1967), 3. I thank Dr. Gunther Thiem for the loan of this material.

75. Entry of the beginning of October 1919, in Kollwitz 1989, 439.

76. Käthe Kollwitz, from a letter to Bonus-Jeep, 1907 (?); cited in Kollwitz 1988, 275. See also Nagel-Timm 1972/1980, 545, 294. To *Out of Work* as well as to the other seven single sheets, the editors of *Simplicissimus* affixed a title, "The Only Good Thing" (Das einzige Glück), and a legend: "If they didn't need soldiers, they would also tax the children."

77. Entry of 18 September 1909, in Kollwitz 1989, 52.

78. Entry of Sunday, 25 January 1919, in Kollwitz 1989, 402–403.

79. See Nagel-Timm 766–771.

80. Entry of 6 November 1917, in Kollwitz 1989, 340.

81. Entry of 8 April 1920, in Kollwitz 1989, 467.

82. See Elmar Jansen, *Barlach Kollwitz* (Berlin, 1989), 58–59. I thank Dr. Jansen for the gift of his book.

83. Entry of 25 June 1920, in Kollwitz 1989, 476–477.

84. Klipstein 1955, 188. See also Ida Katherine Rigby, *An alle Künstler! War—Revolution—Weimar* [exh. cat. San Diego State University] (San Diego, 1983), 47–48. Rigby noted that Kollwitz "donated the proceeds from the sales of this print to help support further similar exhibitions."

85. On the cycle, see Gerhard Pommeranz-Liedtke, *Der graphische Zyklus von Max Klinger bis zur Gegenwart* (Berlin, 1956).

86. These works are discussed in an excellent catalogue: Gudrun Fritsch, ed., *Zwischen den Kriegen. Druck- graphische Zyklen von Kollwitz, Dix, Pechstein, Masereel u.a.* [exh. cat. Käthe-Kollwitz-Museum Berlin] (Berlin, 1989). I am grateful to Dr. Gudrun Fritsch for the gift of this publication.

87. Klipstein recorded a letter from the artist to the painter Erna Krüger from the end of December 1922, in which she noted that the work on the series was almost finished. See Klipstein 1955, 236. See also entries of November–December 1922, and 30 December 1922 in Kollwitz 1989, 545.

88. Letter of 23 October 1922 to Romain Rolland in Kollwitz 1966, 56. In a letter to Dr. Heinrich Becker, Kollwitz noted that she had begun the *War* series on copper, but nothing came of it. See Letter of 1 June 1929, in "Käthe Kollwitz an Dr. Heinrich Becker. Briefe" (brochure, Bielefeld, 1967), 3.

89. Their relevance to other cultures is suggested by the fact that *The Sacrifice* was the first sheet by Kollwitz published in China in 1931, where it contributed to the renaissance of the Chinese woodcut. See Krahmer 1981, 83–84.

90. Entry of 10 October 1916, in Kollwitz 1989, 279.

91. Entry of the beginning of February 1922, in Kollwitz 1989, 524.

92. Letter to Erna Krüger of 29 December 1922, in Kollwitz 1966, 95.

93. Letter to Arthur Bonus, August 1921, in Kollwitz 1952/1981, 102.

94. Letter to Dr. Heinrich Becker, 31 January 1933, in Kollwitz Bielefeld brochure 1967, 10. "Ob die Steine zu den beiden jungen Müttern erhalten sind, kann ich Ihnen augenblicklich nicht sagen. Es geht mir nämlich mit diesen Blättern so, dass es mir nicht ganz klar ist, ob sie nicht kitschig sind. Ich habe kein sicheres Gefühl ihnen gegenüber."

95. See Carol O. Selle and Peter Nisbet,

German Realist Drawings of the 1920s [exh. cat. Harvard University Art Museums, Busch-Reisinger Museum] (Cambridge, Mass., 1986).

96. Käthe Kollwitz, "Erinnerungen" (1923), in Kollwitz 1989, 725–726.

97. See Beate Bonus-Jeep, *Sechzig Jahre Freundschaft mit Käthe Kollwitz* (Bremen, 1963), 10.

98. Kollwitz 1989, 741.

99. At this time Kollwitz made the drawings of scenes of contemporary misery for reproduction in the satirical magazine *Simplicissimus*.

100. Entry of April 1910, in Kollwitz 1989, 67.

101. For a discussion of this matter see Paret 1980, 182–199.

102. Paret 1980, 189.

103. The contents of the letter are reproduced in Kollwitz 1989, 778–779.

104. A diary entry inserted later confirms that Peter actually died on 22 October 1914.

105. Entry for 6 October 1915 in Kollwitz 1989, 200.

106. Entry of 27 August 1916 in Kollwitz 1989, 270–271.

107. Entry of Monday, 21 February 1916, in Kollwitz 1989, 226–227. The exact source of the article remains unknown.

108. Entry of 4 December 1922 in Kollwitz 1989 542.

109. Entry of 6 November 1917 in Kollwitz 1989 340. Bruno Krauskopf (1892–1960) was a painter and printmaker who showed at the Berlin Secession. Ernst Barlach (1870–1938), sculptor and printmaker, was a friend of Kollwitz' For a study of the relationship between the artist and Barlach, see Jansen 1989.

110. Entry of 28 June 1921 in Kollwitz 1989, 503-504.

111. See Stephanie Barron, "Introduction," in *German Expressionism 1915–1925. The Second Generation*, ed. Stephanie Barron [exh. cat. Los Angeles County Museum of Art] (Los Angeles, 1988), 24.

112. For discussions of art politics during the Weimar Republic see Stephanie

Barron, ed., *"Degenerate Art": The Fate of the Avant-Garde in Nazi Germany* [exh. cat. Los Angeles County Museum of Art] (Los Angeles, 1991); Helga Kliemann, *Die Novembergruppe* (Berlin, 1969); Rigby in San Diego 1983; Peter Gay, *Weimar Culture. The Outsider as Insider* (New York and Evanston, 1968).

113. Letter to Bonus-Jeep, 1919, in Kollwitz 1988, 195. See the discussion of the issue in Joan Weinstein, *The End of Expressionism. Art and the November Revolution in Germany, 1918–19* (Chicago and London, 1990), 82–83.

114. Entry of October 1920 in Kollwitz 1989, 483.

115. Entry of October 1920 in Kollwitz 1989, 483.

116. Entry of October 1920 in Kollwitz 1989, 483.

117. Entry of 5 January 1920 in Kollwitz 1989, 449.

118. Paraphrased from Hans Kollwitz, diary entry of 12 October 1920 in Kollwitz 1966, 135–136.

119. Cited in Gunther Thiem, "Vorwort," in *Die Zeichnerin Käthe Kollwitz* [exh. cat. Staatsgalerie Stuttgart] (Stuttgart, 1967), 10.

120. See annotation in Kollwitz 1989, notes, 898.

121. See Kollwitz' statement in the *Workers' Illustrated Magazine* (Arbeiter-Illustrierte Zeitung) 6 Jg., nr. 43 (26 October 1927); reproduced in Kollwitz 1989, notes, 900.

122. See note 121.

123. Anatoly Lunacharski, "An Exhibition of the Revolutionary Art of the West," in *Die Revolution und die Kunst* (Dresden, 1962), 105 ff.; cited in Otto Nagel, *Käthe Kollwitz* (Greenwich, Connecticut, 1971), 58.

124. Kollwitz 1989, 632. The artist's granddaughter Jutta noted that the trip seems to have overpowered Kollwitz, who did not want, or perhaps even feared to analyze her experience. See Kollwitz 1989, notes, 899.

125. Kollwitz 1989, 634.

126. See letter of 6 February 1938 to Gertrud Weiberlen in Kollwitz 1966, 66.

127. See Christoph Zuschlag, "An 'Educational Exhibition: . . . ,'" in Los Angeles 1991.

128. By 1919, Kollwitz was already lamenting that her art was part of the past. See diary entry of 28 September 1919 in Kollwitz 1989, 438.

Kollwitz in Context

The Formative Years

ALESSANDRA COMINI

The bewildering disarray in the Berlin of Käthe Kollwitz during the opening months of the ill-fated Weimar Republic was perhaps most dramatically summed up not by a representative of Kollwitz' generation—which had suffered the most during World War I—but of the generation that had resented Germany's senseless war the most, Hannah Höch (1889–1978). With compositional slyness, the twenty-nine-year-old Dada artist paid bittersweet homage to the fifty-one-year-old Kollwitz, whose images of compassion seemed so obsolete in a world of postwar greed, by pasting a small photograph of her unsmiling face at the center of a large and busy "photomontage" collage (fig. 1). Höch's caustically titled melange of society at cross purpose was prominently hung in the irreverent First International Dada Fair in Berlin during July and August 1920, but few noticed this discombobulated salute to the city's newly named member of the Prussian Academy of Arts, and certainly not Professor Käthe Kollwitz. Her diary entry on the date of the Dada show's opening is concerned instead with the death of a neighbor's son from lung complications suffered dur-

ing the war: "with this the last family in our house that had sons in the field has paid its tribute."[1]

Höch's placement of the prematurely white-haired "revolutionary" and "pacifist"—as the Dadaists understood her to be—within the vortex of competing political ambitions reminds the modern museum visitor, encountering the compelling works of Kollwitz firsthand, that, in spite of the fundamental gravity of her work, the artist was not always "old," and that she was witness to not one but three important epochs of German history. Kollwitz' long life (she was born in 1867, just four years before Bismarck's forging of the new German Empire under Kaiser Wilhelm I) spanned the birth and collapse (1918) of the Wilhelminian Reich, the stillbirth and disintegration of the Weimar Republic (1919–1933), and the rise and folly of the Third Reich (she died at seventy-seven in 1945 just eight days before Hitler committed suicide in his Berlin bunker). In the face of such radical social change, the extraordinarily steadfast character of Kollwitz' will to respond can best be apprehended by exploring the context within which her character and her art were formed.

This voluntary chronicler of the human condition who, in her own words, had slowly changed from "revolutionary" to "evolutionary" in her desire for world reform,[2] stubbornly persevered as an artist through marriage, motherhood, the losses in two wars of her

LEFT: fig. 1. Hanna Höch, *Cut with the Kitchen Knife DADA through the Last Weimar Beer–Belly Cultural Epoch of Germany*, 1919–1920, collage. Staatliche Museen zu Berlin, Kupferstichkabinett

fig. 2. Map of Königsberg, c. 1935

son and grandson, and political ostracism. But everything she experienced was revelatory, and her self-imposed mission, chosen when she was in her twenties, was not just to hold up a mirror to contemporary reality but, anticipating Bertolt Brecht's technique, to use her art as a hammer with which to shape reality. Her blows were directed against a hardening of the heart, as one contemporary critic said of her.[3] The artist did not just suffer, she fought—at first infusing scenes of the past with implications for the present (as in her two cycles of revolt, *A Weavers' Rebellion*, 1893–1897, and *Peasants' War*, 1901–1908), and later ever mindful of the past in her poster exhortations to the present (*Never Again War!*, 1924, see cat. 90, p. 66).

But Kollwitz the advocate was not necessarily always Kollwitz the inspired artist, or loving wife and family member, or equitable colleague. Dejection, self-recrimination, and even envy formed part of the fabric of the artist's inner life as recorded in the ten black oilcloth notebooks she used to write down her thoughts. In April 1921 she recorded in rapid sequence:

> Deep. Deep. Deep depression. . . . recently my work has been bad and I can not see things correctly. . . . Now my work nauseates me so that I cannot look at it. At the same time failure in being a total human being. I no longer love Karl, nor Mother, hardly even the children. . . . I am indifferent to everything. Yesterday in the theater saw Barlach's *Die echten Sedemunds*. A deep feeling of jealousy that Barlach is so much more powerful and profound than am I.[4]

This litany of failure is suddenly and characteristically interrupted by the memory of a pungent chance experience—one as ephemeral as it was germane to the particular impress of the artist's reservoir of imagery:

> In the Tiergarten I saw a nursemaid with two children. The older boy, two and a half, was the most sensitive child that I have ever seen. Just as the nursemaid said, like a little bird. . . . on his little face and in his thin little body were constantly reflected impressions from the outside. A great deal of fear, uneasiness, hope, almost blissful joy, then immediately again anxiety, etc. Like a butterfly whose wings quiver continuously. Never have I seen a little child more touching, more in need of protection, in need of love, more moving, more helpless.[5]

Such a receptive, sensuous passage, written in the privacy of a diary, gives us in one sweep the essential Kollwitz. Her great heart, so prey to setbacks, was constantly strengthened and stimulated by contact with the humblest inhabitants of her world, her Berlin.

And yet this sensitive scribe of the Prussian capital was not a native Berliner. The famous searing wit of those born and bred in Berlin, such as the gifted impressionist Max Liebermann (1847–1935), or of artists who precociously adopted Berlin ways to the point of incarnation, personified by Heinrich Zille (1858–1929), had no place in Kollwitz' psychological makeup. Although a *gemütlich* south German might see urbane, industrialized Berlin as representing the "north" (and all its attendant *ungemütlich* evils), Kollwitz had descended upon Berlin from the real north—from Königsberg, a thriving port city bathed by Baltic fogs in the furthermost reaches of East Prussia. The artist's hometown, ancient coronation site of the Prussian kings and girdled with austere fortresses, was a place so full of architectural grimness and Nordic melancholy that it makes Kollwitz' dark sensibilities, grave earnestness, and intense need to love become all the more comprehensible.

The artist's earliest memories are of the flat barges on the River Pregel that flowed past her parents' house on the Weidendamm (fig. 2). She and her siblings played among the piles of bricks unloaded from those barges for her father's building contracting business. Once the corpse of a young girl was washed up on the levee used for doing laundry. Writing about the event some forty years later, Kollwitz could "still see the

terrifying hearse and coffin."[6] When Käthe was nine, her father, Carl Schmidt, moved his family out of this gloomy neighborhood and into a handsome new house on the Königstrasse. This broad street, close to the Konigsgarten with its newly built Italian Renaissance-style university building (destroyed, like most of the city, by bombs in 1944), was the starting point for countless unsupervised strolls through the town that Käthe took with her younger sister Lise ("rambling," they called it). These aimless wanderings past the forbidding Gothic castle and cathedral always ended up at the commercial waterfront (fig. 3), with its wooden drawbridges, steamers and barges, colorful foreign crews, sailors' taverns, longshoremen, and vocal female fish vendors. Kollwitz had fond memories of the long and drawn-out syllables of the Königsberg accent: "Flundere, scheene frische Flundere!" (Flounder, beautiful fresh Flounder!). In later life the artist was very aware that her predilection for the world of workers had been shaped by this romantic early experience: "beautiful to me were the Königsberg longshoremen . . . beautiful was the bold outline of the movements of ordinary folk."[7] It would take years of honing her drawing technique to achieve on paper the trenchant silhouettes that had so early caught the young girl's appreciative eye.

Of all the many Königsberg impressions, one of the most influential for the artist as a person was that of Sunday mornings in the home of Käthe's maternal grandparents. Julius Rupp (1809–1884), the founder of a liberal Protestant religious community that had

fig. 3. Fish market along the Pregel River in Königsberg, with the royal palace and its Gothic tower in the background, 1900, postcard

defied the state-controlled church of King Friederich Wilhelm IV, spoke to his small congregation not only about religious matters but also about social heroes such as the *Märzgefallenen* (March dead), who had been slaughtered in Berlin during the uprising of 18 March 1848. Käthe's father, her brother, Conrad, and his boyhood friend, the medical student Karl Kollwitz, to whom she became engaged at the age of seventeen, were all committed social democrats, and the concern for social injustice voiced by Grandfather Rupp was quite naturally shouldered by the younger generation, including Käthe. The artist was later able to honor the memory of her grandfather by designing a bronze portrait relief for the memorial slab erected on the one-hundredth anniversary of his birth. This, her public debut as a sculptor, took place in Königsberg in August 1909, and it must have pleased her to think that, in the same city where a monument to Kant had been unveiled (Christian Rauch's standing figure of 1864), a second one had been raised to no less devout a thinker.

The same liberal upbringing that inspired the Schmidt children to play at defending noble causes behind homemade barricades was also supportive of Käthe's burgeoning artistic talent. At fourteen she was sent to study with respected Königsberg teachers of painting and engraving. When she was seventeen, her mother took her on an introductory trip to the art centers of Berlin and Munich. The next year, 1885, Käthe Schmidt was allowed to return to Berlin, where her brother and older married sister were already living, as a full-fledged art student at the Women Artists' School.

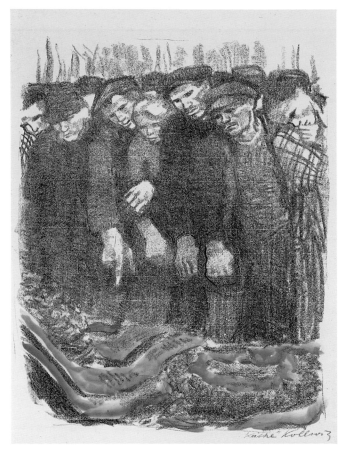

cat. 70. *March Cemetery*, 1913. Private collection

The day of her arrival happened to be the eighteenth of March, and Conrad, who met his sister at the train station, bypassed the boarding house where she was to live and led her straight out to the northern district of Friedrichshain and the Märzgefallenen Cemetery (fig. 4), where the dead of 18 March 1848 had been buried. On this anniversary hundreds of Berlin workers had come to lay wreaths and pay tribute to the 183 martyrs of thirty-seven years before. Among them, as the list of names on a memorial stone overlooking four long rows of graves revealed, were seven women. This unusual entry into Berlin left its mark on the artist. In future years she would often be among those who visited the cemetery on the anniversary date, and in 1913 she would devote a lithograph to the subject (cat. 70), concentrating thematically not upon the graves and memorial wreaths but upon the solid rank of reverent men and women who file past them.[8]

fig. 4. "In Remembrance of the 18th of March," cemetery of the March dead at Friedrichshain, Berlin, c. 1912, postcard

fig. 5. Adolph Menzel, *The Lying in State of the Fallen of the March Revolution*, 1848, oil on canvas. Kunsthalle, Hamburg

The "bold outline of movement of ordinary folk" that the artist had so admired in Königsberg is now masterfully rendered by means of a broad compacting silhouette that welds together yet differentiates the intensely gazing figures. Seeds planted in Königsberg yielded an impressive artistic harvest.

How did Kollwitz achieve such sculptural succintness, in which figures are both particularized and universalized? Certainly not all at once. Many were the prototypes she studied and varied the pictorial influences she freely acknowledged. Michelangelo and Rodin were among her favorites. Two artists to whose works she was exposed that first year of study in Berlin clearly stimulated her imagination. The ubiquitous images by Adolph Menzel (1815–1905), Berlin's beloved old realist depicter of Prussia past and Prussia present, had set a precedent for detailed individualization within easily surveyable swaths of volume and space: how remarkable, for example, are both the crowd and the clarity of his great unfinished on-the-spot painting of 1848, *The Lying-in-State of the Fallen of the March Revolution* (fig. 5). Kollwitz' version, by contrast, moves from neutral panorama to poignant close-up, from narration to gesture. And yet in the immediacy of both works there is a filtered kinship. The same holds true for Kollwitz' great discovery of 1885, the highly original Leipzig-born painter, sculptor, and graphic artist Max Klinger. Kollwitz would emulate

Klinger's laconically generic titles (suggestive of more situations than the ones shown) and serial approach to themes. His fifteen-print cycle on society's double standards for women, *A Life* of 1883, was on view in Berlin for the young artist to devour firsthand in 1885 after she heard her own work likened favorably to his by her teacher. Even more important, she was to find justification for her attraction to the graphic arts over oil painting—that is the intensity of black and white versus distracting variety in the world of color—in Klinger's 1891 pamphlet in favor of using drawing and the graphic arts to express certain serious themes, *Painting and Drawing*. Klinger's riveting visions of possible future urban revolution, titled ambiguously *March Days* (fig. 6), also of 1883, particularly excited Kollwitz. The age-old feral mood of an agitated and looting mob assembled within a disturbingly contemporary setting—telephone wires, a familiar rooftop advertisement for the Parfümerie Joop, and the sign for a bathing establishment near Berlin's Jannowitz Bridge—delivered a potent mix. It took years of reductive experiments before the enthralled Kollwitz would completely abandon the lure of Klinger's com-

fig. 6. Max Klinger, *Dramas: March Days I*, 1883, etching

pelling specificity, a hint of which can still be observed in the almost legible banners to which the workers point in her *March Cemetery* of 1913.

Further studies during the years 1888 and 1889 in Munich, where her father, determined to make a professional woman of his talented daughter, had sent her in hopes that the engagement to Karl might lapse, gave the artist a tantalizing taste of high-spirited bohemian life and personal freedom in addition to growing technical prowess. Her reading at this time reached beyond the classics to Zola, whose 1885 *Germinal*, a novel about the plight of striking coal miners, triggered pictorial responses (see cat. 6, p. 20), Björnson, and Ibsen. Whether or not at this time she read Bertha von Suttner's best-seller of 1889, *Die Waffen nieder! (Lay Down Your Arms!)*, deploring militarism and the European arms race, she was certainly as alert to pacifist arguments as she was to the issue of women's emancipation, as recently taken up by Germany's social democrat leader August Bebel in his writings and public lectures. It is interesting that even though the artist would opt for marriage, the inclination for independent existence acquired during her student days remained strong. She would twice leave her family for study periods abroad: Paris in 1904 (where she visited Rodin), Florence (as carefree recipient of the Max Klinger Villa Romana prize) in 1907. Although not a feminist in the modern sense, Kollwitz forged a hard-won if at times uneven coexistence of career and marriage ("Marriage is work," she wrote[9]), both of which endured for half a century.

Marriage to the twenty-eight-year-old physician Karl Kollwitz actually fit in nicely with the artist's growing ambition to live and work in Germany's capital city. It was Berlin where, she felt, "a very exciting circle of artists and literary people"[10] existed. And it was in the hardworking Prussian metropolis of almost two million souls that, in contrast to easygoing Munich, the artist could experience the stimulating hustle and bustle of big-city life. Karl's social democrat convictions had led him to accept a position in Berlin as doctor for a health insurance group that served the city's tailors and their dependents. This meant living in the same neighborhood as the patients, Prenzlauer Berg (fig. 7). Prenzlauer Berg was a recently built-up district just north and east of the city's government and cultural section, the Mitte—that famous neighborhood dominated by Unter den Linden, a street that extended eastward from the Brandenburg Gate to the royal palace and included the academy of art, university, state library, opera house, arsenal, royal theater (commanding the square depicted in Menzel's painting), Lustgarten, and handsome museum island.

No greater contrast could be imagined than that between the city's cultural and political center and Prenzlauer Berg, just across the Spree River to the north. As late as 1923 a Baedeker description tersely dismissed the area: "the North-East quarter is the seat of the woolen and clothing industries, and contains little that is worth seeing." What this does not tell us is that Kollwitz' new neighborhood was one of *Mietskasernen* (rental barracks), the cheap housing solution to Berlin's mid-nineteenth-century population explosion after hundreds of thousands of workers migrated to the city to find employment in the new factories springing up in the northern districts of Wedding and Prenzlauer Berg. As little as possible was to be spent on streets and parks to accommodate these workers (so directed Friedrich Wilhelm IV, the same king whose troops had squashed the workers' rebellion of March 1848 and whose church Grandfather Rupp had opposed), and the result was a grid, repeated over and over again, of narrow streets that quadrangulated huge housing complexes of four to seven stories with as many as five successive dark and damp inner courts, later termed human warrens by Christopher Isherwood. By the time Kollwitz' future *bête noir* Wilhelm II came to the throne in 1888, even Bismarck had noted an increase in the health and sanitation problems in these breeding traps of tuberculosis. The Kollwitz family would not be immune to this danger: as boys both Hans and Peter suffered from lung infections and Peter did indeed come down with tuberculosis.

It was to this gloomy, densely populated[11] working district of Berlin that Dr. Karl Kollwitz brought his bride in the middle of 1891. No complaint ever escaped the lips of the young woman who had known the austere but comfortable home on Königsberg's elegant Königstrasse. And in fact Karl did manage to find lodgings in a desirable corner building overlooking one of the few open places in Prenzlauer Berg— the Wörther Platz, a triangular park and traffic hub,

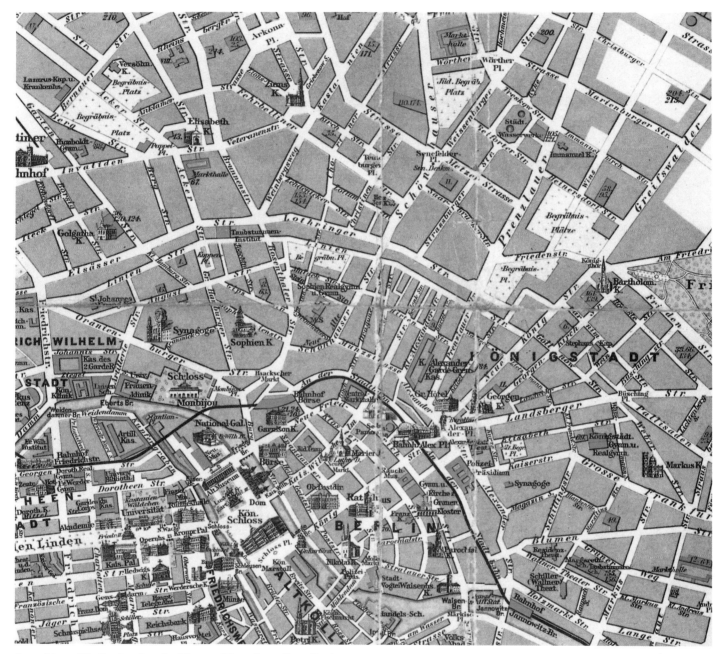

fig. 7. Map of Berlin showing the Mitte and Prenzlauer Berg districts, c. 1900

the point of convergence of no fewer than seven streets. The artist's address for the next fifty-two years was Weissenburgerstrasse 25.[12] The couple's street, down which at first horse-drawn, then electric street-cars ran, was a particularly lively thoroughfare, and their small third-floor corner balcony afforded a glimpse of the one other open space near them, the Jewish cemetery fronting the Schönhauser Allee, where Käthe Kollwitz' colleague Max Liebermann would be buried in 1935. A large market hall stood one block to the north, and one block to the south rose the round brick tower of the district's water reservoir, built in the 1850s and still in use through World War II.

One nearby sight worth seeing that escaped Baedeker's peremptory sweep was the narrow little square just beyond the Jewish cemetery to the south, Senefelder Platz, named after the inventor of lithography, Alois Senefelder (1771–1834). A year after the Kollwitzes' settling in Prenzlauer Berg, the no-nonsense district that had little room for fancy public memorials made an exception. A life-size marble figure of Senefelder gazing thoughtfully at the lithographic stone plate in his hand was set up on a tall base in front of which two marble children play, one of them reaching up to touch the appropriately reversed letters of the artist's name on the pedestal (fig. 8). How gratified Kollwitz, the master lithographer, must have been in later years, whenever she passed this one monument to art in her drab neighborhood.

In 1892 she pictured herself (fig. 9) on her balcony over Berlin, silhouetted against the row of apartment

fig. 8. Rudolph Phole, *Alois Senefelder Monument* at Senefelder Platz, Prenzlauer Berg, Berlin, c. 1895, postcard

houses on the far side of Wörther Platz, a view she would contemplate for half a century (fig. 10). She partly stands against, partly sits on the balcony, precariously and unceremoniously raising her left knee up to her chest so that her foot rests on the railing. Will she fall? No, certainly not. Frau Dr. Kollwitz is not contemplating suicide; she sits in the fading evening light, her attention directed outward across the square as lights begin to appear in the windows opposite. This was now her Berlin. What would she be able to contribute? How could she live up to Grandfather Rupp's axiom, "every gift is a responsibility"? Karl was already becoming involved in the demands of his medical practice, his "damned"[13] practice as Käthe would occasionally refer to it later. But of what would her work consist? She was passionately interested in everything. How would she pursue the separate callings of artist, wife, and mother? The answer was in front of her: Wörther Platz, with its teeming cast of characters, its daily human comedies and tragedies, its insistent pulse of life. Wörther Platz, her microcosm in the macrocosm that was Berlin. Just as the metropolis was becoming a world city, so for Kollwitz the confines of Wörther Platz would become her world village from which she would extract images of universal significance.

But all this lay ahead for the twenty-five-year-old artist. At first Kollwitz did not see the lives around her as grist for the mill of her art. She was still, even if no longer at art school, attempting to master the technique of her trade, engraving. She did not yet consciously respond to the life-and-death dramas of tuberculosis, anemia, alcoholism, physical abuse, and unwanted pregnancies being played in the waiting room of her husband's home office and in the streets and dismal courtyards of Prenzlauer Berg.

At first it seemed as though, as an artist, she could best approach the present through the past—the burning relevancy for her, for instance, of reproducing, like silent, accusatory stations of the cross, the unfolding imagery of suffering and abortive revolt so vividly suggested to her by Gerhart Hauptmann's electrifying play about the 1844 uprising of oppressed handloom workers, *The Weavers*.[14] Kollwitz was in the audience for the play's premiere (Kaiser Wilhelm II's political police would be taking damaging notes during the next

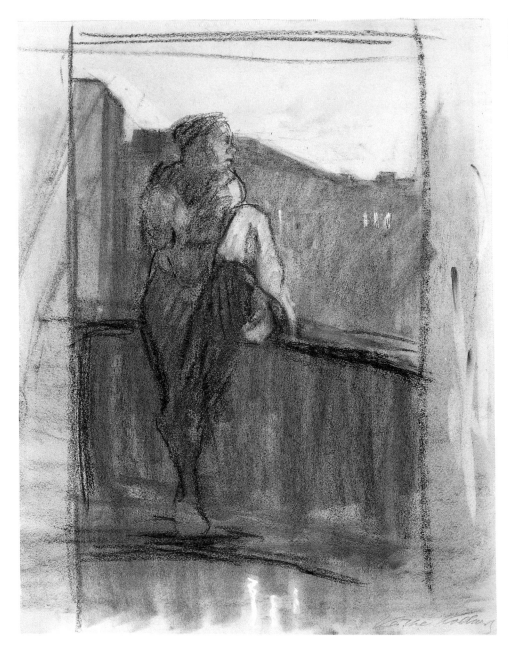

fig. 9. Kollwitz, *Self-Portrait on the Balcony*, 1892, charcoal and chalk. Private collection, Berlin

fig. 10. Kollwitz sketching the view of Wörther Platz from her balcony at Weissenburgerstrasse 25, Prenzlauer Berg, Berlin, 1925. From the Hans Cürlis film *Creative Hands*

few performances) at the Freie Bühne on the morning of 26 February 1893. It was impossible not to see how Hauptmann's "historical" drama related to modern times: just a year before in Berlin, during the last few days of February, an impromptu mob of desperate unemployed workers had gone on a three-day rampage through the city's poor eastern and southeastern quarters, breaking windows, plundering shops, and stoning the police who since that date had traded in their decorative sabers for firearms. Conservative newspaper reports of this "wild social revolution" presented the rioters as drunken derelicts (fig. 11).

Ablaze to convert her aroused sympathies into an appropriately black-and-white visual form, Kollwitz nevertheless observed Johann Joachim Winckelmann's dictum to sketch with fire but execute with phlegm. The five years she spent refining the compacted images that would emerge in 1897 as the six individual plates for *A Weavers' Rebellion* (cats. 12–14, 16–20, pp. 22–25, 141–143) were also the years that witnessed her self-directed rite of passage from apprentice into master of lithography, etching, and aquatint.

Kollwitz' public debut as an artist in Berlin placed her squarely in the camp of those artists who opposed the conservative official attitudes fostered by the nation's self-proclaimed art expert, Wilhelm II, a monarch who would also feel qualified to chastise Richard Strauss for his musical foibles. The Freie Berliner Kunstausstellung, organized by some of the same artists who would form the Berlin Secession in 1898, opened at the Lehrter Bahnhof exhibition hall in the workers' section of Wedding in July 1893. Kollwitz entered three works, including an etching of a homeless woman, her hand to her head, sitting in an attitude of despair, *At the Church Wall* (fig. 12). The artist received praise from *Die Nation* critic Julius Elias for her "decisive talent." Far less incendiary than Kollwitz' stark image of urban woe—an icon of isolation that was germinal for so many of her later works—was Ludwig von Hofmann's (1861–1945) Art Nouveau-style poster for the event (fig. 13), showing a scantily clad young Ganymede holding a lowered palm branch in one hand and offering a cup of nourishment to a very receptive and docile spread-winged eagle (to be

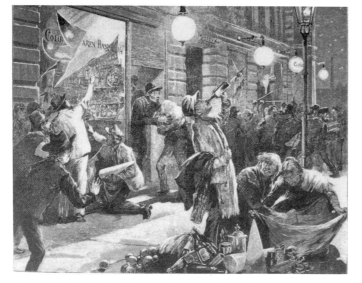

fig. 11. *Riots in Berlin, February 1892*, wood engraving

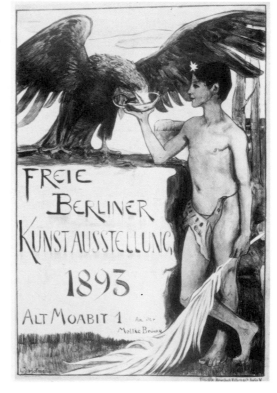

fig. 13. Ludwig von Hofmann, *Poster for the Freie Berliner Kunst Ausstellung*, 1893, color lithograph

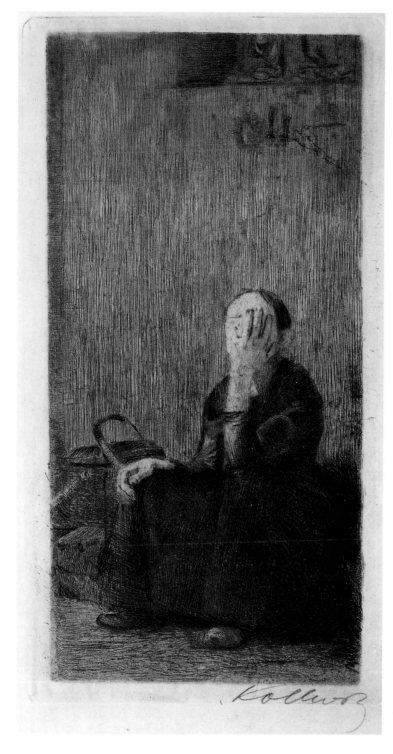

fig. 12. Kollwitz, *At the Church Wall*, 1893, etching and dry-point. National Gallery of Art, Washington, Rosenwald Collection

interpreted as "the taming of Zeus-Wilhelm II"). The impertinent poster was temporarily banned by the police for unacceptable content, and attendance at the controversial show, which also included works by Edvard Munch and August Strindberg, increased accordingly.

By the summer of 1898, after consulting with Elias, Kollwitz was ready to show her *Weavers* cycle to the public in the conservative, Paris-inspired Grosse Berliner Kunstausstellung, to which the "impressionists" Liebermann, Max Slevogt (1868–1932), and fellow East Prussian Lovis Corinth (1858–1925) also

contributed entries. The bold theme of *A Weavers' Rebellion* (like Klinger, Kollwitz had purposefully made the title of her cycle a general one, applicable to any time), its abbreviated realism of style, and above all its astonishing technical command sent waves of appreciative interest through Berlin's art world. From then on, as Kollwitz herself reminisced, "in one blow, I was numbered among the foremost artists."[15] The exhibition jury, which included the octogenarian Menzel and Liebermann, recommended that the thirty-one-year-old artist be awarded a small gold medal. What happened next made Kollwitz even more famous. Robert Bosse, the minister of culture responsible for passing such recommendations on to the kaiser, intervened. The cycle of "rather small etchings and lithographs," he wrote in his damning report, "appears to have been inspired by Gerhart Hauptmann's drama *The Weavers*."[16] Hauptmann, Bosse knew, was a red flag for the kaiser. The playwright's published stage directions for *The Weavers* had emphasized the family link between Wilhelm II and his great-granduncle King Friedrich Wilhelm IV, whose troops had quelled the weavers' revolt, by specifying that in the third-act taproom scene a color print portraying Friedrich Wilhelm IV be hung on the tavern wall. In retaliation, Wilhelm II prevented Hauptmann's receiving the annual Berlin Schiller Prize in 1896: the very idea that a pictorial version of the offending play might be honored with a gold medal from the state was more than enough to persuade the skittish emperor to withhold his approval. And although other women artists had received gold medals during the 1890s, Wilhelm II's low opinion of the practice may have played a role in Kollwitz' case. He is reported to have remarked: "I beg you gentlemen, a medal for a woman, that would really be going too far. . . . Orders and medals of honor belong on the breasts of worthy men!"[17]

Whether or not the fact that Kollwitz was a woman had anything to do with the disinclination of Wilhelm II to confer a gold medal upon her *Weavers* cycle, the irony of Hohenzollern history repeating itself can not be overlooked. Fifty-five years earlier, in the same city, another daring woman had focused public attention on the plight of German weavers. *Dies Buch gehört dem König (This Book Belongs to the King)* was the unusual but attention-getting title given by Bettina Brentano

von Arnim (1785–1859), self-proclaimed "intimate" friend of both Goethe and Beethoven,[18] to her long 1843 book pleading for social reform and describing the shocking circumstances of those handloom workers on the point of starvation living not in far-off Silesia but right in Berlin. This permanent army of the poor, camped in hovels the author had visited personally, deserved the immediate and compassionate attention of the king. And who was that king? None other than Friedrich Wilhelm IV. Von Arnim's intrepid attempt to liberalize her monarch went unnoticed (and unpunished) by him: "I cannot get started," was his evasive answer when asked what he thought of the book. The aura of this woman who attempted to advise the king was such that, as Kollwitz bemusedly related, one of the elder female members of Rupp's Free Congregation had traveled all the way from Königsberg to Berlin in a spontaneous attempt to meet the living legend and was turned away at the door by a maid.[19]

Like Bettina von Arnim, Kollwitz' realization that her lifelong mission was to alert others to human suffering had brought her into direct confrontation with a Hohenzollern ruler. His denial of a gold medal in 1898 seemed, however, to enhance her standing in the art world. That same year she accepted a teaching position at the very school for women artists where thirteen years earlier she had studied. And the following year she won a silver medal in more liberal-minded Dresden and thereby obliged the Dresden Kupferstich-Kabinett's request to acquire a copy of the *Weavers* cycle. In Berlin, Liebermann urged her to join and exhibit with the newly founded Secession. When in May 1899 the first show of the Berlin Secession opened in its own quaint little building on the Kant-strasse, next to the Theater des Westens in Charlottenburg, the fancy west section of Berlin, Kollwitz was one of the participants.

It is interesting to observe that Liebermann, at the time immensely successful as Berlin's preeminent portrait painter (Richard Strauss, among others, sat for him) but who in his younger days was dubbed the "apostle of ugliness" for his unsentimental depictions of country life, encouraged that small segment of Secession artists who, because of their ungarnished scenes of urban life, might be called the new apostles of ugliness. Most notable among these, in addition to

fig. 14. Heinrich Zille, *Portrait Sketch of Käthe Kollwitz*, c. 1910, black crayon. Present whereabouts unknown

Kollwitz, were Franz Skarbina (1849–1910), designated a socialist painter for his obvious sympathy with the inhabitants of his North Berlin working-world views, Hans Baluschek (1870–1935), a fellow teacher at the women's art school, whose 1896 twelve-sheet cycle *Berliner Bilderbuch* ironically clothed the city's disenfranchised in the German Reich colors of black, red, and gold, and a few years later, that quintessential depicter of the Berlin milieu, Zille. The latter's gross caricature-like approach, which made his Berlin denizens less accusatory than Kollwitz' (see fig. 26), extended to his portrayal of Kollwitz herself (fig. 14), a crude sketch that nevertheless captures the hand-supporting-head pose so characteristic of Kollwitz and of many of her images. Kollwitz' few prominent female colleagues among the Secessionists—Dora Hitz (1856–1924), Sabine Lepsius (1864–1942), and Maria (Schorer) Slavona (1865–1931)—specialized in portraiture and saccharin indoor genre or flower pieces and were, like many of their male colleagues, far more acceptable than the urban realists, as the Kollwitz-Skarbina-Baluschek-Zille group came to be called.

A good idea of the sensibilities that united this apostles-of-ugliness faction of the Secession (and they were definitely in the minority) can be obtained by comparing their portrayals of the common theme of the city's railroad settings. Skarbina's *Bridge over the Train Tracks—North Berlin* of c. 1895 (fig. 15) conveys the vastness of the big city silhouetted and sparkling in the dark background, while focusing on the striding stoop-shouldered railroad worker and his wife (her glance draws in the beholder) who hurry across the bridge under which rivers of tracks and steaming trains pass. Baluschek's matte-colored *Berlin Landscape—By the Railroad Station* of c. 1900 (fig. 16) also features a hurrying individual within a city outskirts setting: the single blooming chestnut tree fenced off in a *"verboten"* area by the railroad arches on the right cannot mitigate the desolate specter of the urban barracks to the upper left. While Baluschek's modestly dressed woman is carrying a wreath, apparently on her way to the cemetery, the people in Kollwitz' *Workers Going Home at the Lehrter Railroad Station* (cat. 21) of 1897 exit into their working-class neighborhood from a shift that has lasted until after dark. The lights in the factory at the left are still burning, and in addition to the lone laundress with her heavy load, two other women can be seen emerging with the men from the station door.

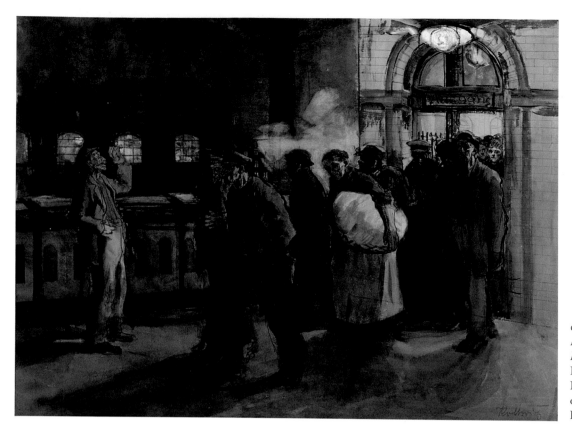

cat. 21. *Workers Going Home at the Lehrter Railroad Station*, 1897. Käthe Kollwitz Museum Köln, Kreissparkasse Köln, on Loan from the Zedelius Family

fig. 15. Franz Skarbina, *Bridge over the Train Tracks—North Berlin*, c. 1895, pastel crayon, body color, and watercolor. Berlin Museum

fig. 16. Hans Baluschek, *Berlin Landscape—By the Railroad Station*, c. 1900, mixed technique on paper. Bröhan Museum Berlin

fig. 17. Heinrich Zille, *Evening Song*, 1906, drawing

would open in 1905. At the turn of the century three more of his *folies de grandeur* were under construction: the garbled "copy" of Saint Peter's, the cathedral (1894–1905) near the royal palace; the Italian-baroque Kaiser Friedrich Museum (1897–1904) on the northern tip of the museum island; and, underway since 1898, the emperor's "great-hearted" unwanted "gift to the city," the Siegesallee (fig. 18), a broad avenue cutting through the once bucolic Tiergarten and adorned with thirty-two unsmiling, gleaming white marble statues of the Hohenzollern line from Albert the Bear to Wilhelm I, Wilhelm II's grandfather. Liebermann, with his ever-ready tongue, declared that he needed dark glasses to look at this crime against good taste; Zille however, as an impecunious student, had not been above posing for one of the obscure herm busts accompanying the rulers. (On a 1909 tour of the city, Isadora Duncan would urge the students of Berlin to demolish the outrage.) As explained by Wilhelm II in one of his more than four hundred imperial harangues, this national showplace was given to beautify and to elevate. "Even the lower classes, after their toil and hard work, should be lifted up and inspired by the force of ideals."[21] Then, as though he were thinking of Kollwitz and the other apostles of ugly urbanism, the kaiser concluded his otherwise forgettable Siegesallee inauguration speech of 6 May 1901 with this pithy pronouncement: "But when art, as often happens today, shows us only misery, and shows it to us even uglier than misery is anyway, then art commits a sin against the German people . . . [it is] descending into the gutter."[22]

Kollwitz' focus has closed down to frame her frieze of workers in horizontal constriction, whereas the vantage points of Skarbina and Baluschek[20] are still Menzel-like in their topographical sweep and detail. Akin to Kollwitz' desire to monumentalize her figures is Zille's simple looming rendition of a mother walking down a railroad track with her two children, reproduced as a 1906 *Jugend* illustration entitled *Evening Song* (fig. 17). The text beneath reads, in thick Berlin dialect, "Mommy, are there really also people who have warm food to eat every day?"

Such down-to-earth, frank reflections of life in the capital were too tarnished for the mirror of blinding magnificence that Wilhelm II was simultaneously holding up to the world. His dangerous building passion was already responsible for the tasteless pseudo-Romanesque Kaiser Wilhelm Memorial Church (1891–1895) in Charlottenburg, not far from where the Secession's new home on the Kurfürstendamm

fig. 18. View of Kaiser Wilhelm II's Siegesallee (1898–1901) in the Berlin Tiergarten, 1901, postcard

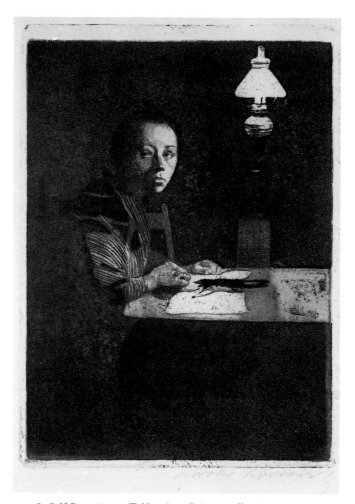

cat. 8. *Self-Portrait at a Table*, 1893. Private collection

fig. 19. Thomas Theodor Heine, *Poster for the 1905 Secession Exhibition at Kurfürstendamm 208/9*, color lithograph

That last unfortunate word, "gutter," was gleefully picked up by friends and foes alike to describe Secessionist or any art with social content. From Munich, Thomas Theodor Heine (1867–1948) produced a parody in a poster (fig. 19) for the Berlin Secession's 1905 exhibition in its new building at Kurfürstendamm 208/9: under the disdainful gaze of an older woman in pseudohistorical dress who holds aloft an urn with a dying plant, a chaste young girl clasping a large bouquet of roses stoops to pick yet another blooming specimen growing vigorously in the water-fed gutter.

Kollwitz' sobering "gutter" art and Wilhelm II's agrandizing self-glorification were equally intransigent and were directed to the same audience, Berlin. It is fascinating to consider these two protagonists, both endemic products of Prussia, both born to parents with

fig. 20. Max Koner, *Wilhelm II*, 1890, oil on canvas.
Present location unknown

extremely liberal views, and only eight years apart in age. But the heir to the Hohenzollern throne had sustained birth injuries so severe that his left arm was paralyzed and withered, a handicap for which he compensated by building up the greatest military machine in Europe, and he rebelled against his parents (the notables of the Siegesallee had pointedly stopped with Wilhelm I) by adopting a bellicose conservatism of the deepest dye, always eager to apply his constitutional and "absolute" powers to thwart progressive and socialist "enemies" of the Second Reich. "That is not a portrait, that is a declaration of war," a French general said of the official state portrait of Wilhelm II (fig. 20) intended for the German embassy in Paris. The kaiser's self-infatuated strutting, Kollwitz' vigilant seriousness of purpose (cat. 8)—what disparate messages their portraits radiate!

While Wilhelm II's avenue of illusory grandeur was nearing completion in 1901,[23] Kollwitz was conceiving very different responses to the demand of a critic of the Siegesallee for a monument not to Brandenburg-Prussia but to the proletariat. Although her answers were once again couched in historical terms—the large etching pertaining to the French Revolution, *Carmagnole*[24] of 1901 (cat. 38, p. 60), and *Peasants' War*, a seven-print cycle about the sixteenth-century south German peasant uprising (cats. 60–64, pp. 34–36)— the figures in all the works looked perturbingly modern. Some of the faces could have come straight from Prenzlauer Berg. As the new century opened, Kollwitz was indeed noting and recording the people around her. Diary entries convey her interest and sympathy for the hardships of the humble working women, some of them Karl's patients, who came to see her:

fig. 22. Kaiserin Augusta Victoria as "Mother of Our Country," c. 1915, postcard

fig. 21. Kollwitz, *Poster for the German Home Workers Exhibition*, 1906, lithograph. National Gallery of Art, Washington, Rosenwald Collection

Frau Pankopf was here. She had a completely black eye. Her husband had gone into a fit of rage. . . . The more I see of this, the more I understand that this is the *typical* misfortune in workers' families. As soon as the husband drinks or is sick and without work, the same thing happens. Either he hangs like a dead weight on his family . . . or he becomes melancholy . . . or goes mad . . . or commits suicide. For the woman it is always the same misery. She maintains the children, whom she must feed[25]

It was the startling and unequivocally contemporary quality of Kollwitz' first poster (fig. 21), designed for the 1906 German Home Workers exhibition, that put her once again on a collision course with the imperial hatred of "gutter" art. This time it was the Kaiserin Augusta Victoria, whom popular imagery would show as solicitous "Mother of Our Country" (fig. 22), distributing tasty white breakfast rolls to needy German children. Kollwitz' home-worker mother had no such nourishment to offer her children. Long hours of arduous labor under the flickering light of a kerosene lamp were required just to pay the rent. How uncannily Kollwitz' subsequent *Home Worker* of 1909 (fig. 23) resembles the actuality of one-room family life in the rental barracks that was recorded in photographs of the same period.[26] And what potent compression the artist obtained in her 1906 poster version of the home worker (see fig. 21), directing the impact of the situation from an oppressive environment to the fatigued, lamplit face of the woman whose bleary eyes say all. Not even Ernst Barlach (1870–1938),

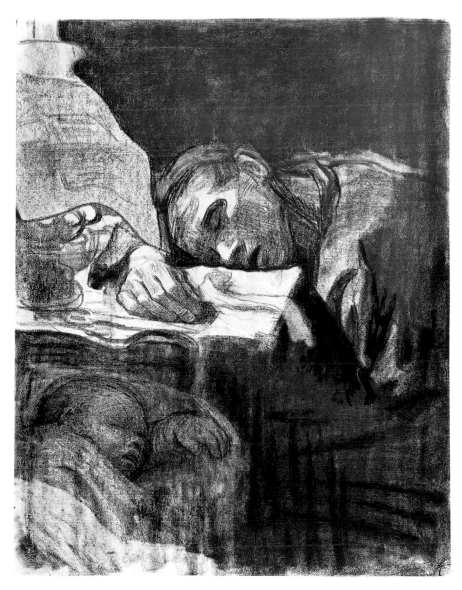

fig. 23. Kollwitz, *Home Worker*, 1909, charcoal.
Kunsthalle Bremen

fig. 24. Typical Berlin *Mietskaserne* one-room dwelling with home
worker family, c. 1910

whose later expressive woodcuts would inspire Kollwitz to restate her *Memorial Sheet to Karl Liebknecht* in that puissant medium, had achieved the trenchant economy in his early poster style (fig. 25) that Kollwitz was perfecting. And Zille, although perpetually concerned with detailing the realities of single-room slum living (fig. 26), would never be willing to sacrifice the accompanying narrative milieu for Kollwitz' sheer monumentality.[27]

Such now was the merging of consummate artistry with moral authority in Kollwitz' *Home Worker* poster of 1906. And such was the revulsion of the empress[28] before this unrelenting icon of actual misery that she refused to open the exhibition until every one of Kollwitz' posters on Berlin's ubiquitous cylindrical billboard displays had been pasted over. Later, in the social-causes poster series of the 1920s, Kollwitz, the "grandmother" of her country, would dispense with real-life models from Prenzlauer Berg and simply substitute, at first unconsciously, then consciously, her own resolute features for symbolic victims of poverty, as she did in the great, laconic poster of 1925, once again on behalf of the German Home Workers exhibition (fig. 27).

The 1906 poster represents a pivotal point in Kollwitz' career. Her breakthrough to modern subject matter for modern times, unmitigated by historical reference, may not seem so drastic in retrospect, but the change of direction for her was as major as had been David's abandonment of Greek and Roman themes, which of course could be and were read as commentaries on French eighteenth-century society and politics for the unfolding events of the French Revolution and its aftermath. Berlin of her time would be Kollwitz' motif from now on, and the cast of characters henceforth not rebels but workers and children, survivors of their circumstances. In the few years left before the nightmare of World War I the artist hammered out her effigies of proletarian life with ever-growing precision and economy, keeping "everything to a more and more abbreviated form . . . so that all that is essential is strongly emphasized and all that is unessential denied."[29]

Fourteen of her most potent drawings, including the *Home Worker* of 1909 (see fig. 23), were reproduced between the years 1908 and 1911 (with two more in 1924) in the nationally devoured weekly satirical magazine, *Simplicissimus*, based in Munich and thus out of

fig. 25. Ernst Barlach, *Poster for the Universal Exhibition for the Hygienic Provision of Milk in Hamburg*, 1903, lithograph

fig. 26. Heinrich Zille, *North Berlin, Gerichtsstrasse*, 1919, lithograph. Heinrich Zille Museum, Berlin

fig. 27. Kollwitz, *Poster for the German Home Workers Exhibition*, 1925, lithograph

Wilhelm II's direct reach. Founded in 1896, its first issue's manifesto-poem, contributed anonymously by the provocative playwright Frank Wedekind, announced that the journal's aim was "to strike the lazy nation with hot words." Thomas Theodor Heine, of "gutter" art parody fame, was the main staff artist, and other contributors included Slevogt, Zille, Barlach, and later George Grosz. Among the foreign artists was one particularly admired by Kollwitz, Théophile Steinlen (1859–1923), whose Paris studio she had visited in 1904. He was known for his lively scenes of city life as published in *Gil Blas Illustré* upon which *Simplicissimus* was modeled. In both text and illustrations the general tone of the Munich publication was far more folksy, flippant, and ribald than were the serious, dolorous notes sounded by Kollwitz (see *Out of Work*, cat. 65, p. 50), and her contributions sometimes faced cartoons or the bizarre concoctions of Heinrich

Kley (1863–1945).[30] As a pungent ensemble, however, the magazine effectively captured and reflected the disillusionment that characterized Wilhelm II's pre-World War I Germany.

It would be incorrect and limiting to think that, as Kollwitz created her scenes of urban tragedy, the capacity for joie de vivre and sensuality had faded from her own life. She had only recently extricated herself from the one friendship that ever threatened her marriage to Karl, an intense and apparently fully consummated relationship with the Viennese publisher Hugo Heller (1870–1923). Heller was a dynamic Hungarian Jew of great charm, spontaneity, and erudition whose involvement with prominent social democrat theorists (he knew Bebel and worked with Karl Kautsky) had brought him to Berlin in 1902 as a writer for Kautsky's *Die Neue Zeit*. In its pages he thoughtfully and enthusiastically reviewed Kollwitz' graphics as presented in

Max Lehrs' 1903 oeuvre catalogue. Before he returned to Vienna to open his own bookstore-gallery in 1905, he and Kollwitz had met and found they had much in common. When Heller's wife, a graphic artist whose imagery also dealt with life's downtrodden, died in March 1909, his way was clear for a new union. Kollwitz chose to remain with Karl, but entries in her diary for 1909 and 1910 recording dreams of Heller and the long-suppressed (even misdated!) "Sekreta" drawings testify to the impact and vibrancy of the Heller interlude.

Perhaps far more revelatory than the cryptic diary references of this period is Kollwitz' simultaneous empathy for the awakening sexuality of her own sons, something Karl, whose medical practice so completely absorbed him, did not seem to heed. She watched with vicarious enchantment as eighteen-year-old Hans nursed a growing crush on the vivacious Viennese dancer and friend of the family, Grete Wiesenthal, and a diary observation of 15 May 1910 seems to be as much about herself as about her sons' lovelorn attachments:

> Sensuality is blooming in all these young persons . . . just one door needs to be opened and then they will *under-stand* it too, then the veil will be gone and the battle with the most powerful of life's drives begun. Never again will they be entirely free of sensuality; often they will experience it as an enemy, now and then they will almost suffocate for the joy it brings them.[31]

Only after the personal tragedy that World War I brought to Kollwitz, the death on the battlefield of Peter, the son who wanted to be an artist like his mother, was she able to enunciate, in a silver-wedding-anniversary greeting to Karl, whose steady love had sometimes oppressed her,[32] that her decision in favor of duty was the right one: "the tree of our marriage has grown slowly, not always straight and not without obstacles. . . but it has not withered. The slender twig has become a tree after all, and at the core it is healthy."[33]

The closure encased in these carefully wrought, sincere words, written in June 1916 when Kollwitz was almost forty-nine, can be considered life's ratification of the artist's journey into self-knowledge. The compassion she had always shown for others—the animating principle of her art—was at last allowed to settle gently upon herself. And when in 1932 she and Karl watched the carved stone figures of the grieving parents, the war memorial for Peter upon which she had worked for eighteen years, being lowered into place at the military cemetery in Flanders fields where their son had fallen, the healing was complete: "I stood before the woman, saw her—my own—face, cried and stroked her cheeks. Karl stood close behind me. I did not know it yet. I heard him whisper: 'Yes, yes.' How together we were there."[34]

It was precisely this tremendous capacity for empathy, coupled with epigrammatic form, that had illuminated the path of Kollwitz' formative years. In her initial search for style and technique she had confronted content. First she voiced her revolutionary sympathies within historical settings, but then, as a new century dawned and new concerns possessed her, she moved without hesitation squarely into the present, a modern Rembrandt holding up the face of a weary Berlin home worker or, finally, the anguished countenances of universal parents for all the world to see. But, "where is the new form for the new content of these last years?"[35] she asked herself accusingly during World War I. The restrained East Prussian in her knew the answer: "one can allow oneself emotional outpourings really only after strenuous intellectual labors."[36]

From the bedrock of experience came her new, disciplined, emotion-laden forms in which only the essentials counted. During the first days of frenzy and political opportunism after the abdication of Wilhelm II (9 November 1918), Kollwitz saw and heard the radical socialist-turned-Communist Karl Liebknecht speak to demobilized troops gathered in the Siegesallee: "very hasty, passionate, with capricious gestures. Very skilled, very rousing. A Mark Antony speech (fig. 28)."[37] When Liebknecht was brutally assassinated two months later, Kollwitz, although she did not share his politics of violence (war had changed her into an "evolutionary"), accepted the request of his family to sketch him (see cat. 71, p. 51) at the morgue. The sketch became, after some twenty line drawings, compositional studies, an etching, and a lithograph (cats. 72–75, pp. 52, 53, 55), the great *Memorial Sheet to Karl Liebknecht* woodcut of 1919 (cat. 76, p. 56). Liebknecht was Kollwitz' Marat; she would never again be so

specific in a public work, not even in the memorial for Peter. But unlike David's isolated martyr of the revolution shown murdered in his bath, Kollwitz' victim of violence is presented with those whom his death has affected, the workers. As in the *March Cemetery* print of 1913 (see cat. 70, p. 92), it is the living who count, the living who must contain their grief. Liebknecht, whose huge funeral procession had begun in the Siegesallee, was laid to rest in the distant Friedrichsfelde cemetery, the same cemetery in which Kollwitz' ashes would be buried.

The disastrous social conditions of the 1920s—inflation, strikes, immense unemployment, malnutrition (in 1923 almost a quarter of the children in Berlin's elementary schools were below normal height and weight), and new exploitation of the poor—engaged all of Kollwitz' powers as artist-advocate. As the woman who "saw the suffering of the world,"[38] she used the arsenal of her art, forged in Wilhelminian Germany, to protest and plead for the dispossessed of not just the Weimar Republic but of all postwar Europe. The condensed realism of her posters, far more comprehensible to the lay public than the distortions used by the messianic second wave of German expressionists, was effective and in constant demand. The topics she addressed ranged from the plight of prisoners of war (*Free Our Prisoners*, 1919–1920), hunger abroad (*Help Russia*, 1921, *Vienna Is Dying, Save Her Children*, 1924), profiteerism at home (three leaflets with handwritten texts, 1920), alcohol abuse (*Temperance Week*, 1923),

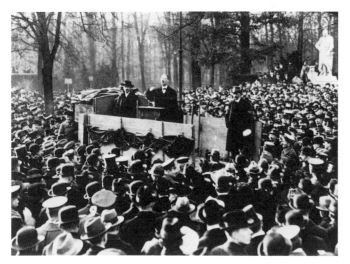

fig. 28. Karl Liebknecht Addressing a Crowd in the Siegesallee, November 1918

and the preservation of access to abortion (*Down with the Abortion Paragraph*, 1924), to pacifist causes (*The Survivors—Make War on War, Never Again War!*,[39] both 1924, cat. 90, p. 66). Kollwitz even donated a drawing to accompany the 1928 manifesto protesting the expenditure of vast sums of public money for the building of battleships. The *Gegen Panzerkreuzer* manifesto was signed by an impressive civilian flotilla of German artists and intellectuals: Kollwitz, Barlach, Baluschek, Zille, Max Pechstein, Bruno Taut, Walter Gropius, Heinrich Mann, Franz Werfel, and Arnold Zweig, among others. In her diary the fifty-five-year-old Kollwitz penned a manifesto of her own concerning "pure art" as opposed to "content" art: "Everyone works as he can. I am simply satisfied for my art to have a *purpose. I want to be effective* in this time in which people are so perplexed and in need of help."[40]

As Hitler consolidated his power ("the Third Reich begins," was Kollwitz' disgusted diary comment for the beginning of 1933[41]), the artist entered the ranks of other outspoken pacifists in France such as Romain Rolland (an old friend), and in Berlin, Albert Einstein and Erich Maria Remarque, whose anti-war novel *All Quiet on the Western Front* had sold one million copies in 1929 but was banned in its film version the next year after Nazi demonstrations against it. Her dire warnings against the specter of history's repeating itself had already taken the form of seven riveting woodcuts, *War* of 1922–1923 (cats. 77–79, 81–85, 87, pp. 57–63, 65), which obsessively circled in upon the themes of sacrifice, loss, and grief with which she was only too well acquainted. (One of the images was later translated into sculpture as *Tower of Mothers*, cat. 106, p. 64.) Now, when even this outpouring was insufficient to stay the inexorable march toward rearmament and a new war, Kollwitz vented her anxieties in a monitory dance of death series titled, simply, *Death* (1934–1935, cat. 100, p. 74). Old Königsberg memories of the watery death of a young girl surfaced in one of these images; in another the artist shows herself, tired and ready for the tap that comes on her shoulder.

"All these prints are extracts of my life,"[42] Kollwitz had written of her oeuvre. On 22 September 1942 her twenty-one-year-old grandson was killed in Hitler's delusive war (fig. 29). Once again the artist in Kollwitz was aroused. Her body was feeble, but her indignation

formidable. Using the same Goethe quotation from *Wilhelm Meister* she had cited in October 1918 to counter the senseless call for volunteers in the last days of a lost war, she hammered once again on the anvil of experience and from the context of her own life pulled forth *Seed for the Planting Must Not Be Ground* (fig. 30). This mighty last lithograph of a defiant mother—an old Kollwitz, the features tell us—protecting and constraining with raised arms the three children anxiously peering out from under her coat is the artist's last testament. "The old mother says, 'No: You stay here:—get ready for life, not for war again.' "[43] "This demand is like 'Never Again War'; not a wistful yearning but an order, a demand."[44]

"How my life was strong in passion, in life force, in pain, in joy,"[45] Kollwitz had once told her diary. Now, almost at the end of it, she could say that she had indeed made the most of her own talent and "cultivated the seed that was placed in me until the last small twig has grown."[46] Grandfather Rupp's charge—"every gift is a responsibility"—had been heeded. Kollwitz' exhortations to humanity will always resonate in the remembering hearts of those who are humane enough, and wise enough in this nuclear age, to embrace her message.

fig. 29. Adolf Hitler handing out medals to members of the Hitler Youth, 20 March 1945

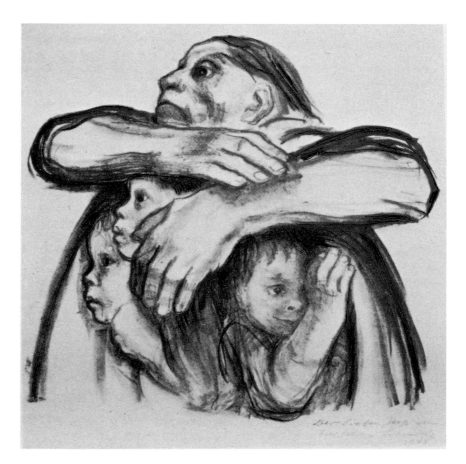

fig. 30. Kollwitz, *Seed for the Planting Must Not Be Ground*, 1942, lithograph

Notes

1. Käthe Kollwitz, *Die Tagebücher*, ed. Jutta Bohnke-Kollwitz (Berlin, 1989), 479, entry for 25 July 1920. All translations in this essay are mine. On 18 September 1908 Kollwitz began to keep the diaries from which, with the long-awaited publication of the complete journals by her granddaughter cited above , such a rich picture of the artist is to be obtained. The last entry is dated May 1943.

2. "Really, I am not at all revolutionary but rather evolutionary...." Kollwitz 1989, 483, entry of October 1920.

3. Joachim Berger, *Berlin: Freiheitlich und Rebellisch* (Berlin, n. d. [1988?]), 173. The critic is not named.

4. Kollwitz 1989, 497–498.

5. Kollwitz 1989, 498.

6. Kollwitz 1989, 717, in the memoirs of her early life written by the artist at the request of her son Hans in 1923. It would be a memory such as this that would contribute to Kollwitz' moving image of 1909, *Suicide by Drowning*, published in the 20 December 1909 issue of *Simplicissimus*.

7. Kollwitz 1989, 741, reminiscences written by Kollwitz in 1941. As late as 1944, while reexploring her favorite ("first and last") author Goethe, Kollwitz was pleasantly struck by the fact that the poet's wanderings around his old hometown of Frankfurt really seemed to have something in common with the "aimless strolling" around Königsberg of her childhood (letter of 19 October 1944 to her sister Lise), Käthe Kollwitz, *Ich will wirken in dieser Zeit*, ed. Hans Kollwitz (Frankfurt, 1956), 132, letter of 19 October. Today Königsberg is not German. Russia claimed it after World War II, and it has been renamed Kaliningrad.

8. Kollwitz' annual visits to the March Cemetery tapered off during World War I. Her diary entry for 18 March 1918 laments this fact (Kollwitz 1989, 358). The artist's 1913 *March Cemetery* lithograph (three versions exist, as well as a preparatory drawing) was distributed that year as a gift to subscribers of Berlin's Freie Bühne.

9. Kollwitz, *Briefe der Freundschaft und Begegnung* (Munich, 1966), 145.

10. Kollwitz 1989, 739.

11. The high population density continued after World War I. In 1919, for example, there were 311,631 people living in Prenzlauer Berg as opposed to 4,837 inhabitants in Lichtenrade, the suburb south of Berlin where Kollwitz' son Hans lived with his family.

12. Now appropriately renamed Kollwitzstrasse. Wörther Platz has also been renamed Kollwitz Platz and today contains not only Gustav Seitz's more-than-life-size bronze memorial statue of Kollwitz seated (1955–1958) but, what would have pleased the artist even more perhaps, a well-stocked playground (erected in 1949) for children. One of the children's favorite climbing spots is the lap of the motherly Kollwitz effigy. The Kollwitz home was totally destroyed in a bombing raid of 23 November 1943.

13. Kollwitz 1966, 145.

14. For pictorial precedents and a discussion of what Kollwitz did and did not take from Hauptmann's play see Alessandra Comini in *Early Twentieth Century German Prints in the Collection of the Grunwald Center for the Graphic Arts*, University of California at Los Angeles, *Grunwald Center Studies* 4 (1983), 42–43.

15. Kollwitz 1989, 741, reminiscences of 1941.

16. Bosse to Wilhelm II, 12 June 1898, as cited in Peter Paret, *The Berlin Secession: Modernism and Its Enemies in Imperial Germany* (Cambridge, Mass., 1980), 21. In a backhanded compliment Bosse reluctantly referred to the "technical competence" of Kollwitz' work and its "forceful, energetic expressiveness."

17. As quoted by Annemarie Lange, *Das Wilhelminische Berlin* (East Berlin, 1984), 514.

18. For more on this amazing woman's relationships with great men of the nineteenth century, see Alessandra Comini, *The Changing Image of Beethoven: A Study in Mythmaking* (New York, 1987).

19. Kollwitz 1989, 735, reminiscences of 1923.

20. In one of her rare personal comments about colleagues in the diaries Kollwitz wrote of Baluschek that he was "honorable but his passions are limited." Kollwitz 1989, 125, entry in June 1913.

21. As given in Paret 1980, 26.

22. Paret 1980, 27.

23. Heinrich Mann, who with Kollwitz would be pressured out of the Prussian Academy of Arts in 1933, published his excoriating portrait of contemporary Berlin society, *Im Schlaraffenland* (Berlin, the Land of Cockaigne) in 1901, the same year as the completion of the Siegesallee.

24. The prominence in placement and size given by Kollwitz to the figure of the drummer boy in *Carmagnole* is remarkably similar to that accorded the drummer boy in Corinth's 1894 cycle of nine engravings *Tragikomödien*, plate 8, showing Marie Antoinette on the way to the scaffold. Wilhelm II's repressive police state obviously stirred new interest in the French Revolution among German artists.

25. Kollwitz 1989, 41–43, entry of 19 September 1908.

26. The most notorious of these structures in Berlin was "Meyer's Hof" in Wedding, erected in 1874 with six successive inner courts and three hundred mostly one-and-a-half-room apartments housing around 1,500 people. At the peak of Germany's postwar unemployment, 230 families went on strike, decorating their courtyards with the slogan "Erst Essen, dann Miete" (first food, then rent). The complex was torn down in 1972.

27. Kollwitz' opinion of *Zille*, regardless of "his stories of low dives" (Kollwitz 1989, 232, entry of 30/31 March 1916), was surprisingly high. She expressed a fine appreciation of his art in 1924, saying that there were three Zilles—the

humorist, the satirist, and the restless artist who with just "a few lines, a couple of strokes, and a little color in between [produces] . . . a masterpiece." Lothar Fischer, *Zille* (Hamburg, 1979), 147.

28. Kollwitz' noncommittal reference to the kaiserin's death appears in a diary entry for April 1921, Kollwitz 1989, 499.

29. Kollwitz 1989, 62, entry of 30 November 1909.

30. For example Kley's semi-obscene *Parlor Game* drawing is on the left side of a double-page spread featuring on the right side Kollwitz' *Night Asylum* in the 16 January 1911 issue, 720–721.

31. Kollwitz 1989, 71. Kollwitz' sculptural treatment of the theme of *Lovers* (originally inspired by her contact with Rodin) may be a lingering allusion to the Heller affair.

32. "I know no one who can love so much, with his whole soul. Often this love has tortured me, I wanted to be freer." Kollwitz 1989, 89, entry of 29 September 1910.

33. Kollwitz 1989, 807.

34. Kollwitz 1989, 669, entry of 14 August 1932.

35. Kollwitz 1989, 340, entry of 6 November 1917.

36. Kollwitz 1956, 50, letter from Georgenwalde of 11 July 1914 to Hans and Peter Kollwitz; this remark addressed specifically to Peter, who had sent his mother a self-portrait, which she found to be "tortured," with the colors used only as "emotional outpourings. "

37. Kollwitz 1989, 384, entry of 23 November 1918.

38. Kollwitz 1989, 456, entry of 26 February 1920.

39. Kollwitz' choice and placement of the shouting young boy is reminiscent of her much-admired Steinlen's color lithograph cover design of 1897 for Maurice Boukay's *Chansons Rouges.* A precedent for the bared upper teeth of the boy can be found in Kollwitz' own early image *Uprising*, cat. 22. The title *Never Again War!* was taken from the French pacifist leader Henri Barbusse's novel *Le Feu* of 1916, which had been translated into German in 1918. Another Berlin-based artist, Willibald Krain (1886–1945), also published in

1924 a work by the title *Never Again War!* as a pictorial tribute to the dead of World War I.

40. Kollwitz 1989, 542, entry attributed to 4 December 1922.

41. Kollwitz 1989, 673.

42. Kollwitz 1956, 71, letter to Hans of 16 april 1917.

43. Kollwitz 1956, 123, letter of January 1942 describing the drawing she would later convert into the 1942 lithograph, written to her old friend from student days, Emma Beata Bonus-Jeep.

44. Kollwitz 1989, 704–705, entry of December 1941 concerning the drawing that became the model for *Seed for the Planting Must Not Be Ground*, see note 43 above.

45. Kollwitz 1989, 369, entry of 1 July 1918, occasioned by reading Heller's letters one last time before burning them. "What that handwriting once meant to me!" (368).

46. Kollwitz 1989, 183, entry of 15 February 1915, recording a letter she had written to Hans.

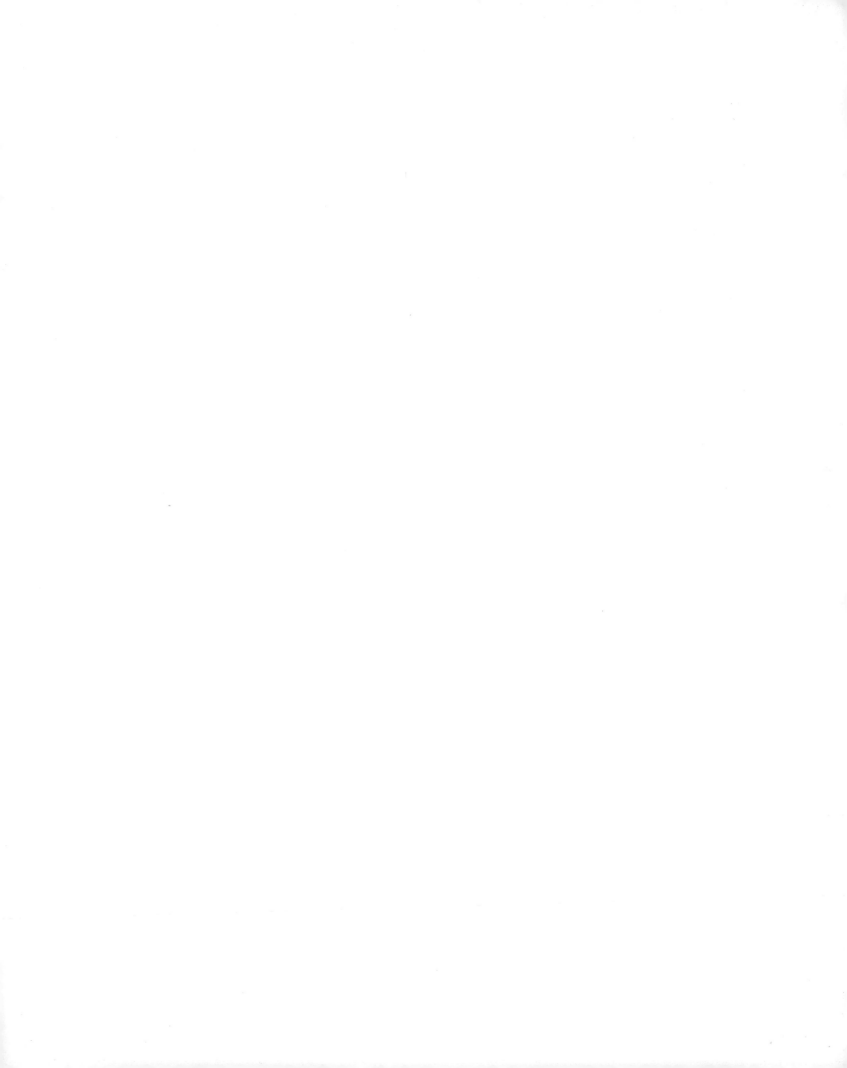

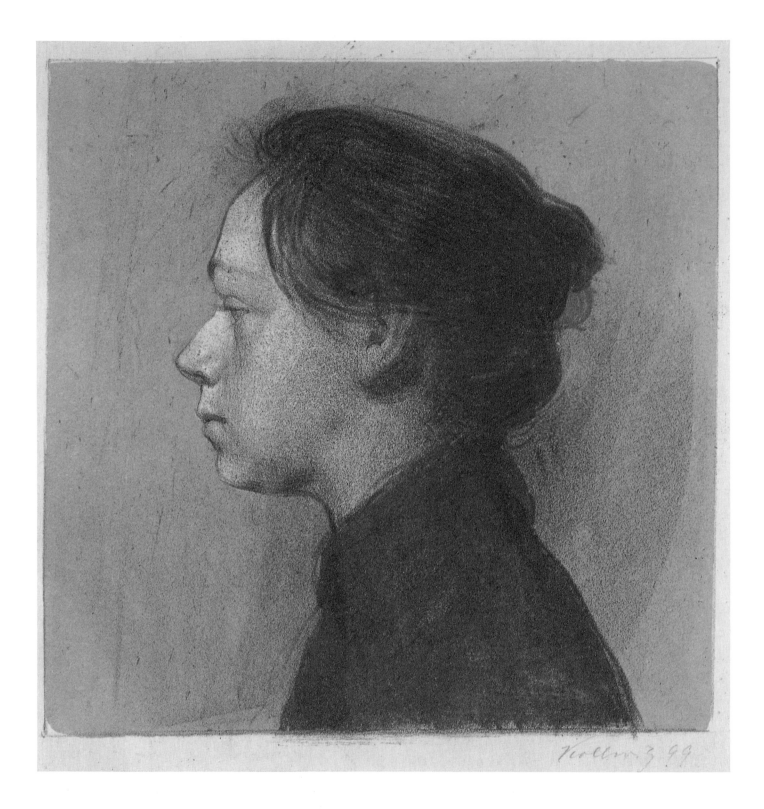

Collecting the Art of Käthe Kollwitz

A Survey of Collections, Collectors, and Public Response in Germany and the United States

HILDEGARD BACHERT

The German Framework

It was natural that Käthe Kollwitz should first come to public attention in her native land, a process that, for all intents and purposes, began with the exhibition of *A Weavers' Rebellion* at the Grosse Berliner Kunstausstellung in May 1898. The subject of this six-image series illustrating the plight of exploited cottage-industry workers immediately struck a sympathetic chord in the general public. The working classes, alienated by the idealized representations favored in official circles, had long hungered for an art that reflected their own reality. Women then as now were especially moved by Kollwitz' subtle but unmistakable feminine perspective. One such observer, identifying with the protagonists of the first *Weavers'* print, commented in 1899 that the wasted, malnourished child and its grieving mother were "a monstrous indictment of our entire contemporary social order" (fig. 1).[1]

If, from the start, the social content of her imagery was an important part of Kollwitz' popular appeal, art historians, curators, and critics were equally impressed by her powerful technical accomplishments. It was undoubtedly this as much as anything else that prompted the jury for the Berlin exhibition, which included the

venerated establishment painter Adolph von Menzel, to nominate Kollwitz for the small gold medal. Even though the minister of culture recognized the aesthetic merits of the jury's decision, Kaiser Wilhelm II felt compelled to reject the nomination because of the works' revolutionary political message.[2] The emperor, who favored conventional academic art, believed that it was "a sin against the German people" to depict scenes of misery and social turmoil. He actively endeavored to hamper the development of modern art; moreover his advocacy of German artistic superiority may be considered a harbinger of the cultural dictatorship that was to overrun the country in 1933.[3]

However, during Wilhelm's reign the official dictates were not yet all-pervasive. In 1899 Kollwitz was encouraged to participate in the Deutsche Kunst-ausstellung in Dresden, where the kaiser had less influence on cultural matters, and there she received the silver medal. Nor, despite the kaiser's 1898 rejection, was Kollwitz prohibited from exhibiting in Berlin. From 1899 on she showed regularly at the annual Secession exhibitions there, becoming a member in 1901. Perhaps more important, as a result of the 1898 exhibition she acquired her first major champion: Max Lehrs (fig. 2), director of the Dresden Kupferstich-Kabinett, the print room of the Königliche Gemälde-galerie (now Staatliche Kunstsammlungen Dresden).

LEFT: cat. 22. *Self-Portrait*, 1898. Staatliche Kunstsammlungen Dresden

fig. 1. Kollwitz, *Poverty*, 1897, plate 1 of *A Weavers' Rebellion*, lithograph, K. 34. Galerie St. Etienne, New York

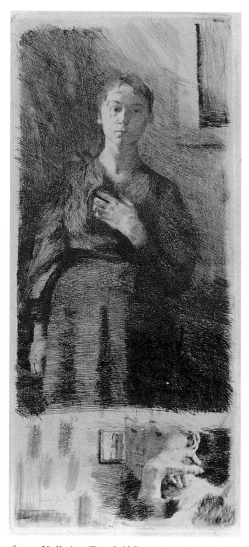

fig. 3. Kollwitz, *Two Self-Portraits*, 1892, etching, K. 9. Staatliche Kunstsammlungen Dresden

fig. 2. *Max Lehrs* (1855–1938), photo, c. 1920, by Ursula Richter. Sächsische Landesbibliothek, Abteilung Deutsche Fotothek, Dresden

A meticulous scholar and devoted public servant, Lehrs was responsive to the most advanced art of his time, and the already rich collection of the Dresden museum would eventually be considerably enhanced by his activities.[4] He was introduced to Kollwitz' work by one of his superiors, Woldemar von Seidlitz, who had seen the initial exhibition of *A Weavers' Rebellion*.[5] Not only did Lehrs immediately acquire the *Weavers* prints, but he also added several others to the museum's collection, including *Two Self-Portraits* (fig. 3). Von Seidlitz personally advanced the money, as the budget of the print department for the current year had been exhausted, and the acquisitions formally

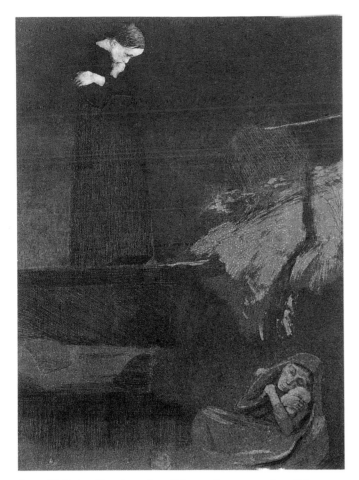

fig. 4. Kollwitz, *Gretchen*, 1899, lithograph, к. 43 IV. Staatliche Museen zu Berlin, Kupferstichkabinett

entered the inventory in 1899. Lehrs further affirmed his commitment to Kollwitz in 1904 by securing one of her most significant commissions: that for the *Peasants' War* cycle. With the financial assistance of the Verbindung für historische Kunst, the artist was able to devote the necessary years to the seven etching plates, which were assured in advance of distribution through a fairly large edition.[6] Kollwitz, for her part, acknowledged Lehrs' support by reducing her already modest prices or even donating works outright to the Dresden museum, a policy she maintained also with other museums sympathetic to her art.[7]

In 1905, dissatisfied with Dresden's meager financial resources and the administration's lack of cooperation, Lehrs left to become the director of the Kupferstich-Kabinett of the Prussian Museums in Berlin (now Staatliche Museen zu Berlin). Bringing his interest in Kollwitz with him, he acquired, during his three-and-a-half-years' tenure, many outstanding works for the Berlin museum, including an impression of *Gretchen* (fig. 4). Adept at bureaucratic maneuvering, he developed, in 1906, a scheme to skirt the official opposition to Kollwitz' more political works: fourteen items with innocuous titles were purchased outright, while twenty-two more radical pieces (including the *Weavers' Rebellion* and *Peasants' War* cycles) were given by the artist, and nine (among them, very rare impressions of early self-portraits and study plates) were presented by an anonymous donor.[8]

In 1908, Lehrs returned to Dresden's Kupferstich-Kabinett (where not a single Kollwitz had been bought during his absence), as the director's post was again vacant and the financial situation had improved. Here he remained until his retirement in 1923. Implementing a systematic plan to collect Kollwitz' complete graphic oeuvre, the Dresden museum during his tenure acquired 177 carefully selected prints and twenty-two drawings. Lehrs also wrote several scholarly articles about Kollwitz' art and, in 1902, compiled a catalogue raisonné of her first fifty prints.[9] The friendship and mutual respect that existed between Kollwitz and Lehrs, lasting until his death in 1939, is documented in the 143 letters and cards from the artist that Lehrs meticulously preserved. Yet notwithstanding his obvious admiration for Kollwitz, Lehrs, like many members of the German cultural elite, distanced himself from the political aspects of her work, preferring to stress its aesthetic merits. As he wrote in 1903: "It would be very regrettable if [Kollwitz' etchings] found approval from the public merely because of their social content. . . . Art should not and cannot serve the changing goals of parties."[10]

Although the Kollwitz holdings of the Dresden Kupferstich-Kabinett, further augmented by Lehrs' successors, were among the most sizable in pre-World War II Germany,[11] the artist was hardly neglected by museums elsewhere. In spite of the conservative attitude of the cultural ministry, the curators of the national museums in Berlin were as responsive to her

work as Lehrs, and the Berlin Kupferstich-Kabinett (prints) and Nationalgalerie (drawings) jointly constitute the largest repository of her works in the world.[12] A number of museums, among them those in Stuttgart and Munich, also house pioneering Kollwitz collections.[13] Other museums, notably in Frankfurt, Bielefeld, and Hamburg, were enriched less by the efforts of astute curators than by the generous donations of private Kollwitz collectors.[14]

By the 1920s, many collectors of contemporary art owned at least a few Kollwitz prints, and some had accumulated comprehensive holdings. Kollwitz' work was regularly for sale at the exhibitions of the Berlin Secession and of other regional artists' associations in which she participated. Additionally, commercial art dealers such as the Galerie Arnold and Emil Richter in Dresden and Paul Cassirer in Berlin were instrumental in furthering her reputation.[15] The first exhibition to feature Kollwitz' drawings (rather than her better known prints) was organized by Cassirer to celebrate the artist's fiftieth birthday in 1917 (fig. 5).[16] This highly successful show, a virtual sellout, subsequently traveled to Emil Richter's gallery in Dresden and to the artist's hometown of Königsberg.

Kollwitz' rise to the front ranks of the German art world was in part facilitated by a proliferation of inexpensive reproductions, whose market was in turn fueled by her growing fame. The first portfolio reproducing well-known prints and drawings, published in 1913 by Kunstwart, Munich, effectively familiarized two generations with Kollwitz' art. As a result of the portfolio's continued popularity, it was revised and reissued in 1924, 1925, 1927, and 1931. In 1920 a selection of twenty-four drawings was published by Emil Richter in a portfolio of facsimile reproductions so high in quality that they are often mistaken for originals.[17] By this time Kollwitz' name had become familiar to intellectuals, art lovers, students, and workers throughout Germany, and large reproductions or picture postcards of her work graced the walls of countless homes.

Reproductions were readily affordable by all except the poorest of Kollwitz' admirers, and the artist made sure that even original prints were not beyond the reach of the masses. She was not interested in small, costly editions and therefore issued quite a few prints

fig. 5. Kollwitz, *Self-Portrait, Facing Right*, 1916, charcoal, NT 733. Catalogue cover for exhibition celebrating the artist's fiftieth birthday, 1917. Private collection

in large quantities. Many owners of these inexpensive, unsigned prints sent them to her with requests for "courtesy signatures," which she usually provided free of charge. The artist was equally generous with her time, frequently creating posters for causes she believed in, to combat injustice, poverty, alcoholism, hunger, infant mortality, and other prevalent social ills. She also gave away many works as gifts to museums, political enterprises, family members, and close friends. To Beate Bonus-Jeep, a lifelong friend from her student days, Kollwitz sent innumerable prints and many drawings.[18]

Kollwitz' generosity as well as her abiding social concerns encouraged individuals from all walks of life to collect her prints and drawings. Through her posters (fig. 6) a large segment of the populace, includ-

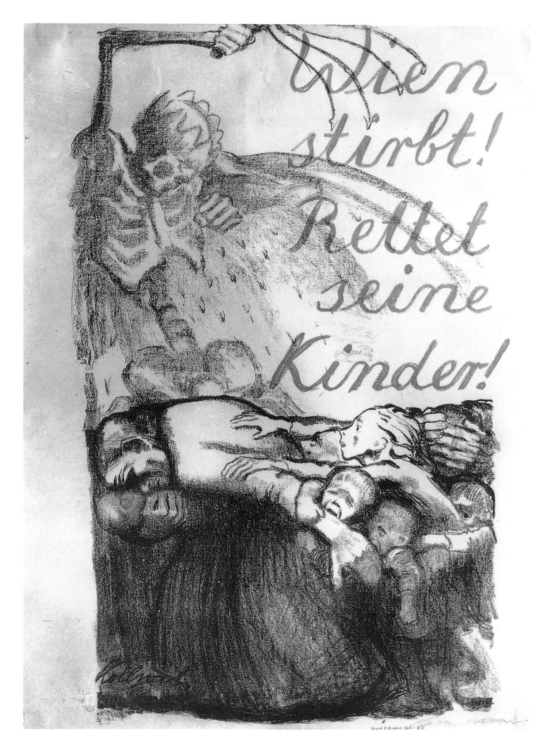

fig. 6. Kollwitz, *Vienna Is Dying! Save Its Children!*, 1920, lithograph, K. 143 II. Private collection

ing many outside normal art channels, became familiar with her name. Not surprisingly, Kollwitz collectors frequently shared the artist's social and political views, and a number were on friendly terms with her and her husband Karl. Although she never joined the Communist party, Kollwitz sympathized with the social innovations taking place in Germany, the U.S.S.R., and elsewhere after World War I. She and Karl traveled to the Soviet Union in 1927, where they received a cordial reception (fig. 7), and in 1932 their friend Otto Nagel organized a highly acclaimed exhibition in Moscow and Leningrad. Kollwitz gave an impression of the lithograph *Solidarity* (now in the Pushkin Museum) to the Soviet state.

fig. 7. Käthe Kollwitz in Moscow with Russian artists and actors during her visit in 1927

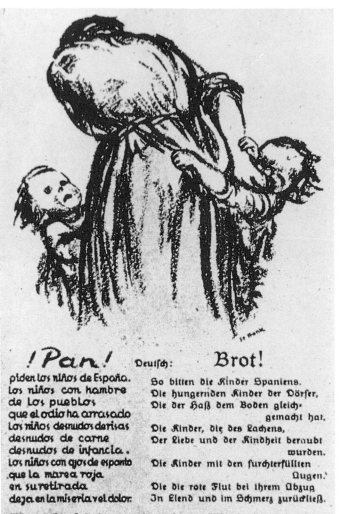

!Pan!

piden los niños de España.
Los niños con hambre
de los pueblos
que el odio ha arrasado
Los niños desnudos de risas
desnudos de carne
desnudos de infancia.
Los niños con ojos de espanto
que la marea roja
en su retirada
deja en la miseria y el dolor.

Deutsch: Brot!

So bitten die Kinder Spaniens.
Die hungernden Kinder der Dörfer,
Die der Haß dem Boden gleich-
gemacht hat.
Die Kinder, die des Lachens,
Der Liebe und der Kindheit beraubt
wurden.
Die Kinder mit den furchterfüllten
Augen,
Die die rote Flut bei ihrem Abzug
In Elend und im Schmerz zurückließ.

Bild und Text sind einem von der nationalen Hilfsaktion verteilten Aufruf
an die Bevölkerung der von den nationalen Truppen eroberten Gebiete entnommen

fig. 8. Kollwitz, *Bread!* 1924, lithograph, K. 196

Kollwitz' popularity burgeoned in the Germany of the Weimar Republic, which, released from the constraints of the monarchy, for a short period enjoyed uncommon freedom of expression. The political snares that before the First World War had entangled such early Kollwitz advocates as Max Lehrs seemingly vanished, and a liberating breeze swept through Germany's institutions of higher education. Whereas previously women (including Kollwitz) were forced to study in segregated art schools, the academies were now opened to them. In 1919 Kollwitz became the first woman to be elected to membership of the Prussian Academy of Art and to receive the title of professor. Her appointment, in 1928, as director of a master class for graphic art at that academy was further acknowledgement of her continued recognition among her male peers.

With Hitler's rise to power in 1933, however, the situation changed radically for Kollwitz and all those whose political or artistic orientation did not suit the National Socialists. Kollwitz, with other socialists and pacifists including Albert Einstein and the writer Heinrich Mann, attempted to stem the rising tide of Nazism by encouraging the different left-wing factions in the country to unite, but to no avail. The director of the Prussian Academy of Art threatened to close that institution if Kollwitz and Mann (also a member) did not resign. They therefore left "voluntarily." The moderate newspapers expressed regret at this turn of events, and one commentator noted that Kollwitz' art was worth preserving for the German people "in spite of her error," namely "her passionate efforts in behalf of Communism," "even though not all of her works are acceptable."[19] The Nazi press, of course, greeted her resignation from the academy with unequivocal approval.

Hereafter Kollwitz was forbidden to exhibit, and on at least one occasion she was interrogated by the Gestapo. However, unlike the more expressionist, *Neue Sachlichkeit*, or abstract art of her colleagues, Kollwitz' work was not generally classified as "degenerate" by Hitler's art experts.[20] And, because her style was rel-

ICH LERNTE SEHEN, WAS KLAR IST,
ICH LERNTE FÜHLEN, WAS WAHR IST,
ICH LERNTE LIEBEN, WAS RAR IST.
FRANZ LEVY 19.11.1892–18.3.1937

fig.9. Kollwitz, *Gravestone of Franz Levy*, 1938, marble. Jewish cemetery, Cologne-Bocklemünd

atively realistic and familiar to the German people, the Nazis even used some of her famous images, such as *Bread!* (fig. 8), for their own propaganda purposes.[21] The government evidently did not dare to persecute her, presumably because she was a symbol of compassion and humanitarianism to virtually an entire generation of Germans.

As the gloom of the Nazi era deepened, Kollwitz lived an ever more shadowy existence. Despite the official decrees, some courageous dealers, such as the galleries Buchholz and Nierendorf in Berlin, and Hanna Bekker vom Rath in Frankfurt, continued secretly to handle work by her and other condemned artists.[22] Kollwitz' interest in sculpture, though dating back to 1909, took on new meaning now that it had become almost impossible to publish editions of prints, for sculpture was something that she could pursue privately in her home. A particularly poignant commission was the gravestone of Franz Levy, a Cologne businessman who had died in 1937. The stone, a moving design of four entwined hands (no other human image is permitted on a Jewish grave), was installed shortly before Levy's widow and her three children emigrated from Germany to England (fig. 9).[23] Kollwitz' letters express warm sympathy for Mrs. Levy's loss and, by

inference, "deep pain, shame, and indignation" at the Nazis' treatment of the German Jews.[24]

Thousands of people, among them numerous art collectors, fled Germany in the 1930s because they were persecuted by the regime for political or racial reasons. Although these refugees could not legally export hard currency, if they left early enough they were permitted to bring along most of their property, especially art that the cultural dictators disdained. Large numbers of works by Kollwitz and other Germans thus were taken to all corners of the world, and in the process not only were saved from the destruction of the war but also helped establish the reputations of these artists outside Germany.[25] However, Kollwitz was effectively shut off from the rest of the world by the outbreak of the Second World War, and lost contact forever with many old friends and collectors who were forced to seek refuge abroad. She died in 1945 without ever again seeing most of them.

After World War II, there was a great need on the part of the older generation in Germany to reconnect with their pre-Nazi past. German museums—many unable even to heat their facilities, others in makeshift locations while their damaged galleries underwent repair—organized exhibitions of previously banned

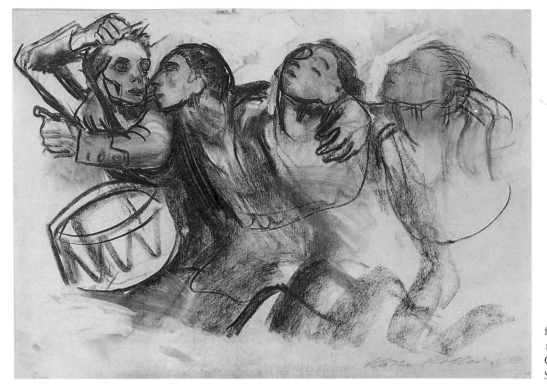

fig. 10. Kollwitz, *The Volunteers*, 1920, charcoal, NT 850. Graphische Sammlung, Staatsgalerie Stuttgart

art. Among these were numerous Kollwitz shows.[26] Most museums' holdings of modern art had been decimated by the Nazis when the art they considered degenerate was removed and destroyed, lost, or sold abroad for hard foreign currency. Thanks to the booming postwar economy, coupled with comparatively reasonable art prices, many museums were at that time able to replenish their losses. Although the museums in East Germany had much more limited means, they too managed to fill some of the gaps in their famous print collections, albeit chiefly with late works and edition prints of average quality.[27]

Gradually the art market in Germany began to revive, spurred by growing demand. Local collectors added to or formed new collections, and favorable exchange rates encouraged foreigners to buy. German-born collectors and friends of the artist who had been forced to emigrate established contact with her son Hans, at first by sending him and his family CARE packages and later by purchasing works from the large Kollwitz estate. Hans Kollwitz in many respects carried on in his mother's spirit, generously authorizing loans from the estate's holdings, making donations to museums, and supervising the production of editions of her sculptures (few of which had been cast during her lifetime). Many of Kollwitz' etching plates survived the war, and Alexander von der Becke, who had published inexpensive, unsigned editions toward the end of the artist's life, now continued to have posthumous prints pulled.[28] Though eventually discontinued, this practice has made at least some of the artist's work affordable, even to the present day.

The lucrative German market of the postwar period attracted foreign sellers as well as buyers. One landmark sale was that of the estate of Salman Schocken, a Jewish department store owner and publisher who had managed to flee Hitler's Germany with his sizable collection intact. The auction of some 260 Kollwitz works from Schocken's estate, perhaps the most important group of drawings, and prints by the artist ever to come on the market, was held in May 1967 at the Hamburg auction house of Hauswedell & Nolte and attracted collectors and dealers from all over the world. Nonetheless, some major works remained in Germany. The Staatsgalerie Stuttgart, for instance, got a special financial allowance from the state to buy seven drawings, among them *The Volunteers* (fig. 10).

In addition to attempting to rebuild its museum

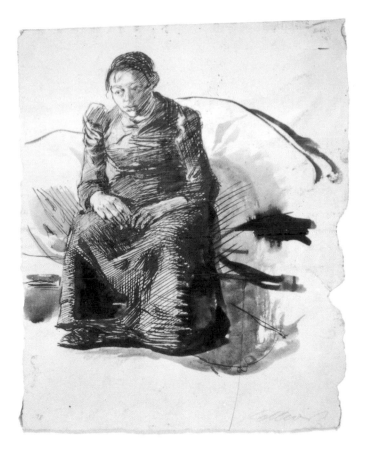

fig. 11. Kollwitz, *Self-Portrait, Full Figure, Seated*, 1893, ink, tusche, and wash. Käthe Kollwitz Museum Köln

collections, the postwar government of West Germany was well aware of the public-relations value of pre-Nazi culture. Intent on making German art better known and improving its image abroad, the German government supported many foreign exhibitions and related cultural ventures. In the late 1950s and 1960s, the Deutscher Kunstrat (German Art Council) organized and sent Kollwitz shows to such far-flung cities as London, Paris, Stockholm, and Capetown, South Africa. Recognizing the high esteem in which the artist was held abroad, the Institut für Auslands-beziehungen (Institute for Foreign Cultural Relations) continued and expanded the Kollwitz traveling exhibition program in the 1970s, 1980s, and 1990s. In Israel, where prior displays of German art had provoked angry demonstrations, a 1971 Kollwitz exhibition was warmly received. The artist came to be regarded by the Germans as a symbol of their nation's "good conscience in its darkest times"[29] and worldwide as "the embodiment of the good Germany."[30]

Meanwhile, statistics concerning Kollwitz exhibitions within Germany itself suggest that the artist's posthumous reputation has by now come to equal or surpass that achieved at the height of her career. Since 1945, Kollwitz shows in Germany have averaged roughly one a year, or a minimum of eight per decade. The artist's hundredth birthday, in 1967, was marked by at least eleven exhibitions in the two Germanies, seven of them at West German museums, one at an East German museum, and three at commercial galleries.[31] Perhaps most interesting has been the establishment in recent years of two German museums devoted exclusively to Kollwitz' work.

The first of these specialized Kollwitz museums, underwritten by the Kreissparkasse Köln, a venerable savings bank, opened in Cologne in 1985. It is located in a new building next to the bank, at the Neumarkt. The core of the collection, consisting of some of the most precious and beautiful examples of Kollwitz' oeuvre, derives from the the artist's estate (fig. 11). As of 1991, the museum's continuously expanding collection housed 150 drawings, 270 graphic works, and fifteen bronzes, most of them cast during the artist's lifetime.

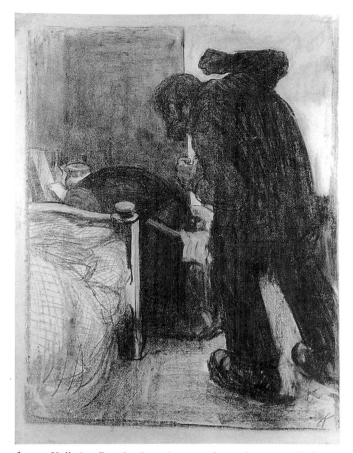

fig. 12. Kollwitz, *Drunkard*, 1908–1909, charcoal, NT 474. Käthe-Kollwitz-Museum Berlin

The second Kollwitz museum, on Berlin's Fasanen-strasse, was founded in 1986 with the comprehensive personal collection of the art dealer Professor Hans Pels-Leusden. Having opened his gallery in 1965 with a Kollwitz exhibition, Pels-Leusden continued to maintain a steady interest in her work (fig. 12).[32] One of his early Kollwitz clients, Martin Fritsch, gave up a successful business career to join the gallery's staff, and his wife Dr. Gudrun Fritsch, a child psychologist, now manages the Kollwitz Museum. Perhaps nowhere is the interaction of art dealership, collecting, scholarship, and personal commitment better demonstrated than in the activities of this remarkable group of Kollwitz admirers.

American Ascendancy

It is not surprising that Käthe Kollwitz should have acquired a loyal and early following in the countries of German-speaking Europe, which were linked to the artist's homeland by language, geographic proximity, and culture.[33] The United States, on the other hand, would at first glance appear to constitute an unlikely haven for her work. Not only did the U.S. lack the common heritage of Germany's closer neighbors; the world wars also drove a disruptive wedge between the two nations. In America as in the other Allied lands, the standard modernist canon came to be geared toward French innovations, and the resulting predilection for formalist solutions left little room for the comparatively abrasive imagery of the German expressionists. Yet, perhaps in part because she was a loner who resisted association with any particular art movement, Kollwitz to some extent was able to transcend such common prejudices.[34]

Thus it was that, in seeming defiance of history, the United States came to play a major role in fostering Kollwitz' worldwide fame. While her initial foothold here was not spectacular, it began at a remarkably early date. Several museums and private collections possessed some Kollwitz works before the First World War, among them the New York Public Library, which acquired its first prints in 1912, the year the Print Room was inaugurated.[35] The Smith College Museum purchased two works in 1913.[36] Whereas England, for example, did not see a comprehensive Kollwitz exhibition until 1967, the first American show, at New York's Civic Club, took place in 1925.[37]

But Kollwitz' real popularity here did not begin until the 1930s. Two pivotal traveling exhibitions— the first organized in 1934–1935 by the College Art Association, and the second in 1941 by the American Federation of Arts—exposed a large segment of the country to her work.[38] The Depression had made many Americans, including Ash-Can School artists, the political left, the labor movement, and the general public acutely aware of the poverty, deprivation, and injustice rife in this supposed land of plenty—and therefore receptive to art that was sensitive to these issues. Describing the climate that paved the way for the discovery of Kollwitz, the art historian and critic Elizabeth McCausland wrote that during the Depres-

sion, "an esthetic of humanism began to replace the conception of an art belonging solely to the elite. Once again, art concerned itself with that proper study of mankind, man."[39]

Kollwitz' overwhelming humanism also made her somewhat immune to the anti-Germanic sentiments triggered by the onset of World War II. Nazi censorship prevented Kollwitz from ever overtly depicting the outrages of Hitler's regime, but many perceived an instinctive connection between her subjects and the events of the holocaust. In Los Angeles in 1937, an illustrious crowd paid $1.00 per person to attend a showing of four Kollwitz drawings and twenty-one prints at the Jake Zeitlin Bookshop and Galleries (fig. 13). The event had been organized as a benefit for the Hollywood Anti-Nazi League.[40] Arthur Millier, the critic for the *Los Angeles Times*, called the show "a soul-shattering yet exalting experience," and dubbed Kollwitz "the greatest woman artist of our time, certainly the most complete master of tragedy, perhaps the greatest living artist of either sex."[41]

Back in Germany, Kollwitz was not unaware of her new-found American renown, nor of the irony that this should have developed at a time when in her native land she was "counted among those . . . who are no longer entitled to live." "Being left out and silenced was the applied method," she wrote her friend Hanna

Löhnberg, who had emigrated to the United States. "Now something begins to bloom again over there, that is gratifying."[42] "Ignored in her own country," Elizabeth McCausland noted, "[Kollwitz] took on the stature of an artist of the people for every country. Her voice spoke more loudly that it was silenced elsewhere. The passion of her speech, the magnitude of her character, were inescapable. At last we heard and made our own one who belongs to the world."[43]

Kollwitz' presence in the United States was further enhanced through the art brought over by refugees from Germany, Austria, and other Nazi-occupied nations. This turn of events directly shaped the career of Ferdinand Roten, one of the artist's earliest American dealers. Roten was a Baltimore stockbroker who, after the crash of 1929, endeavored to make ends meet as a frame maker. Under pressure from German immigrants who needed to sell their art to raise cash, he gradually drifted into the print business.[44] In 1933 he organized a pioneering Kollwitz exhibition for the Worcester Art Museum, and the museum's director, Francis Henry Taylor, heralded Kollwitz as "one of the most powerful and vivid artists at work at the present time."[45] While Roten handled many rare and important Kollwitz pieces, he is perhaps best remembered for the inexpensive prints he sold at American colleges and universities in the years immediately following World War II. Priced at between ten and forty dollars each, these unsigned, often posthumous Kollwitz etchings served as an invaluable introduction to art and collecting for several generations of young students.

New York City, a leading mecca for German refugees as well as the burgeoning center of the American art scene, was well stocked with Kollwitz' work by the late 1930s. Exhibitions were being mounted by such dealers as Hudson D. Walker, the Henry Kleemann Gallery, and Curt Valentin's Buchholz Gallery.[46] Walker, American by birth, presided over an old established firm, whereas Kleemann and Valentin (both of whom knew Kollwitz personally) had recently come from Germany. Herbert Bittner, also a German immigrant, was responsible for promoting Kollwitz' work at Westermann's gallery and bookstore.[47] Another bookshop-cum-gallery with an early interest in Kollwitz was that of Erhard Weyhe on Lexington Avenue.

In terms of prolonged commitment to Kollwitz, the

fig. 13. Invitation to the Käthe Kollwitz exhibition at the Zeitlin Bookshop and Gallery, Los Angeles, 6 June 1937

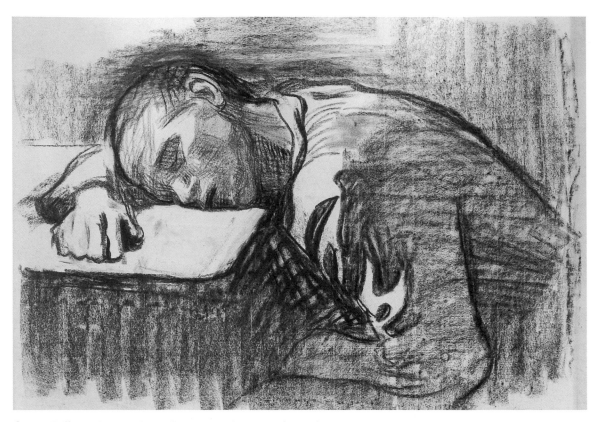

fig. 14. Kollwitz, *Homeworker, Asleep at the Table*, 1909, charcoal, NT 499. Los Angeles County Museum of Art, Graphic Arts Council Funds

Galerie St. Etienne was an especially influential New York gallery. Founded in 1939 by Otto Kallir, who had been forced by the Nazi annexation of Austria to abandon his original Neue Galerie in Vienna,[48] it has to date organized some thirty Kollwitz exhibitions in its New York location and close to fifty traveling shows. Kallir initially drew from the stock developed by other New York dealers such as Valentin and Weyhe, but as late as the 1950s most of his Kollwitz inventory came from German refugees (fig. 14).[49] The better-off immigrants numbered equally among the gallery's Kollwitz customers as increasingly did American-born collectors and museums (the latter often encouraged by reduced prices and outright gifts). Over the course of the years, the Galerie St. Etienne amassed a large archive of photo material and information on Kollwitz, which contributed substantially to the catalogues raisonnés of the artist's prints and drawings (both, not coincidentally, co-published by the gallery).[50]

The accessibility of Kollwitz' work, in terms of its popular imagery as well as its relatively low prices, eventually made it a staple in the inventories of art dealers nationwide. Such galleries as those of Martin Gordon in New York, Raymond Lewis in San Francisco, Robert Light in Santa Barbara, Hyman Swetzoff in Boston, Alan Frumkin in Chicago and New York, and the print department of New York's venerable Kennedy Galleries have all at one time or another in the last decades focused on the art of Käthe Kollwitz. Some of these dealers, for example Alice Adam and Eva Worthington in Chicago or Peter Deitsch in New York, handled a wider range of German art, but the majority were not specialists in that area. Their increasing involvement is therefore indicative of the growth of Kollwitz' appeal among the general American populace.

The spread of interest in Kollwitz' work from German refugees to the broader public that took place

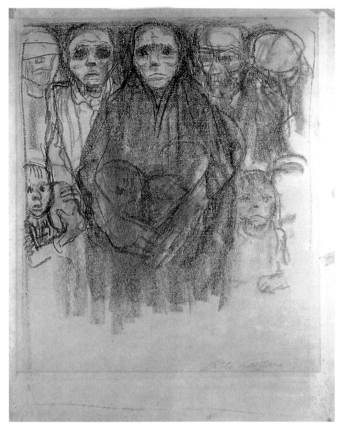

fig. 15. Kollwitz, *The Survivors*, 1922–1923, charcoal, NT 980. National Gallery of Art, Washington, Rosenwald Collection

by an anonymous collector.[51] Walter Landauer, a geneticist on the faculty of the University of Connecticut in Storrs, donated his substantial Kollwitz holdings, comprising six drawings and 103 prints, to the university's museum in the mid-1960s. Like many, he was attracted to Kollwitz' art by its thematic content, which he said "widened my horizons and greatly strengthened my social convictions."[52]

Another major benefactor, of considerably greater means than Landauer, was Lessing J. Rosenwald, retired chairman of the board of Sears, Roebuck & Co. Rosenwald began acquiring Kollwitz' work in 1939 under the influence of his advisor and friend at the Philadelphia Museum of Art, Carl Zigrosser, as well as the dealers Robert Carlen in Philadelphia and Hudson D. Walker in New York. His Kollwitz collection, assembled over a period of about fifteen years, eventually numbered twenty-seven drawings (for instance fig. 15) and more than 115 prints, many of them rare, early impressions, or working proofs. Singularly eager to share his outstanding collection, which in addition to the Kollwitzes included some 22,000 prints and drawings from six centuries, Rosenwald established an intimate museum at his home in Jenkintown, Pennsylvania, and also organized frequent traveling exhibitions. While the collection continued to expand, he resolved in 1943 to donate it in stages to the National Gallery of Art, eventually completing the gift as a bequest upon his death in 1979.[53]

Even when Kollwitz collectors have not donated their collections intact to museums, they tend to be marked by a generosity of spirit akin to that expressed in the art itself. Erich Cohn, a successful New York businessman who had emigrated from Germany in 1912, was one of Kollwitz' most sympathetic early supporters in the United States. His friendship with the artist dated from the 1920s, and was maintained through frequent personal visits and correspondence. Following Hitler's rise to power, Cohn tried to secure Kollwitz safe passage to America, but she, fearing Nazi reprisals against her family, gratefully refused the offer. After World War II, Cohn continued to collect the artist's work from her son Hans as well as from dealers, constantly upgrading his holdings by trading, selling, and buying. Although the bulk of his collection was sold toward the end of his life and after his death, he

in the commercial galleries was paralleled within the American museum community. Starting in the 1930s, museum directors and curators who had emigrated from Germany, among them Carl O. Schniewind and subsequently Harold Joachim at the Art Institute of Chicago, W. R. Valentiner at the Detroit Institute of Arts, and Carl Zigrosser at the Philadelphia Museum of Art, began buying works by Kollwitz and other Germans. Charles Rossiter, director of the print department at Boston's Museum of Fine Arts, made significant Kollwitz acquisitions in the 1950s. The collections of these museums, formed at a time when the purchase of even a rare Kollwitz did not impose a serious financial burden, could not easily be duplicated today.

Private collectors, too, significantly enriched the Kollwitz holdings of American museums. The Minnesota Museum of Art in Saint Paul, for example, houses a major Kollwitz collection, most of which was given

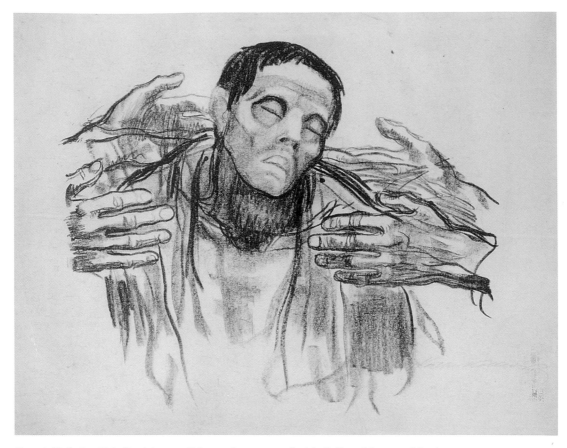

fig. 16. Kollwitz, *Help Russia!*, 1921, lithograph, K. 154 II. Smith College Museum, Northampton, gift of Erich Cohn, 1936

was a prolific lender and donor who gave many works to charities and museums both in this country and in Israel (fig. 16).

American Kollwitz collectors of more recent vintage manifest the same combination of social and aesthetic principles that have historically characterized the artist's admirers. They may be found in every corner of the country. Some are feminists who, like one noteworthy Colorado collector of self-portraits, take special interest in pieces that reflect Kollwitz' role as a woman. Others, like the late New York art dealer Edward Sindin, came to Kollwitz as a natural outgrowth of a broader interest in humanistic modernism. Richard A. Simms, undoubtedly the most important Kollwitz collector in America today, has a similarly wide-ranging feeling for humanistically oriented graphic art. Over the years Kollwitz has become his principal passion, and his obsessive study of her work has grown to encompass obscure period literature and the meticulous examination of multitudinous states and impressions. His extensive knowledge of the artist's work has enabled him to assemble a first-rate Kollwitz collection, which he readily makes available for exhibitions and for inspection by interested scholars.

The proliferation of Kollwitz' work in American museums and private collections has meant that exhibitions are readily organized; indeed, a number of museums, for example those in Storrs and Saint Paul, are capable of mounting comprehensive showings from their own inventories alone. The National Gallery of Art, with its enviable holdings, arranged significant Kollwitz shows in 1963 and 1970, but its current presentation is the first American exhibition to contain the complement of international loans necessary for an indepth understanding of the artist. Under the circumstances, it is perhaps appropriate to reexamine briefly Kollwitz' place in art history, which has remained somewhat uncertain even as she has won her way into

the collections of dozens of major museums and hundreds of individual citizens.

Despite or perhaps because of her broad-based appeal, Kollwitz has had a hard time penetrating the modernist canon. Among this male-dominated elite, where French formalism has long held sway, her status as a humanistically motivated German female does count against her.[54] And even studies geared to expressionism often omit her, since she cannot properly be classified as a member of that movement. Whatever her politics, Kollwitz was not a stylistic radical, and she therefore is often dismissed by historians who look for innovation as the primary hallmark of achievement. As a printmaker, Kollwitz can too readily be accused of practising a minor artform; had she executed the same images in paint or focused more intently on sculpture, her career path would have been entirely different. On the deepest level, however, Kollwitz' reputation has languished as a result of the ongoing debate over whether the integrity of her art is compromised by its social content or, conversely, affirmed by that content.

From the very start of her career, even Kollwitz champions such as Max Lehrs have felt a need to downplay the social aspect of her work. More antagonistic observers were quick to condemn the artist for, in the words of no less a personage than George Grosz, creating nothing but "an invented, high-minded poor-people's ballet."[55] The younger German artist Horst Janssen declared that Kollwitz began "as an excellent etcher. . . . [But] then she was confronted by fate with the real misery of the years 1918,'19, '20 etc., and the images of this misery upset her genuinely. . . . Wanting to react immediately. . . and quickly, . . . she exchanged the etching needle for broad charcoal and soft lithographic crayon, and it was all over with the art."[56] In a similar vein, the American critic Hilton Kramer wrote that "Kollwitz's art remained to the end more concerned with its themes than with style as an end in itself. . . . [She] was not a great artist, but her vision was authentic and her own."[57] Another *New York Times* reviewer, John Russell, found Kollwitz' work merely depressing.[58] "Nowhere in the work of Käthe Kollwitz is there a hint of good cheer," he wrote. "The best we can hope for ourselves is death on the barricades."[59] Russell's fellow Englishman, Nigel Gosling, was even blunter in his appraisal, calling Kollwitz' late

drawings "positively distasteful," while admitting that "a sensitive viewer will feel a guilty twinge at reacting unfavorably to such agonizingly sincere and passionate appeals."[60]

On the other hand, Kollwitz' proponents have on the whole been more numerous and more impassioned than her attackers. One of the most vehement defenses was written by Robert Breuer in 1917:

> It is not true that we ever said art may not have any intellectual content, that it must be satisfied to follow optical laws and please the receptiveness of the senses. Such a theory would be nonsense. . . . Kollwitz is assured her place in eternity because. . . every stroke from her hand is saturated with the rhythm of her time, with the suffering and dying of the people, and with the great hope for a future kingdom. All great art is prophetic, is a scream from the deep and a flight to heaven. . . . True art results from a melding of content with form."[61]

A similar point of view was voiced more succinctly nearly twenty-five years later by Elizabeth McCausland: "The concept of form separable from content must be anathema to Kollwitz. . . . With Kollwitz, content is form."[62] The artist Leonard Baskin likewise pleads for art with a message: "Kollwitz in our current artistic ambience is misunderstood by sentimentalists or dismissed by formalists. All art is propaganda. All art is tendentious. The communication of an artistic idea is an act of propaganda. . . . To carp at Kollwitz for her propaganda, her literary or journalistic qualities is cant. And cant is what we must excise, not content."[63]

Perhaps Frank Whitford, writing for the catalogue of a British Kollwitz exhibition in 1981, best sums up the situation. "Any kind of art with a message is unpopular today," he notes. "Most modern art has been concerned with other things and most obviously with problems which have to do with art itself rather than life." However, he continues, Kollwitz "was never in the least interested in that kind of art. Popular or not, Kollwitz's work is undeniably impressive and deeply moving, even though the emotions it provokes are frequently uncomfortable. And although her style might seem to belong more to the nineteenth than to the twentieth century, she is one of the greatest artists of the modern age."[64]

In the century since Kollwitz first came to public

attention, the content of her work has always conditioned responses to it, both negative and positive. She has, as a result, been claimed by many different political causes, yet her images have survived because of a universality that transcends such transitory associations. Given the magnificent power of her art, which surely rests on formal achievement, it would seem to matter little that her vision cannot be reconciled with the stylistic canon that has dominated certain interpretations of twentieth-century art history. Indeed, with the shift to the more figurative, realistic approach that has characterized much contemporary art in the last decade and the increasing acceptance of political content, such formalist orthodoxy now seems passé. It is perhaps time for the art establishment to recognize fully the greatness of Käthe Kollwitz, which people the world over have long acknowledged in their hearts.

I am deeply grateful to Jane Kallir, without whose collaboration this essay could not have been written.

Notes

1. Alma Guttzeit, "Das Kind in der Dresdener Kunstausstellung," *Dresdener Kunst und Leben* (25 September 1899), 743–745, as quoted in Werner Schmidt, ed., *Die Kollwitz-Sammlung des Dresdner Kupferstich-Kabinettes* [exh. cat. Käthe Kollwitz Museum] (Cologne, 1989), 197–198. All translations in this essay are mine unless otherwise noted.

2. Robert Bosse, minister of culture, wrote in a report to Wilhelm II of 12 June 1898: "The technical competence of her [Kollwitz'] work, as well as its forceful, energetic expressiveness may seem to justify the decision of the jury from a purely artistic standpoint. But in view of the subject of the work, and of its naturalistic execution, entirely lacking in mitigating or conciliatory elements, I do not believe I can recommend it for explicit recognition by the state." As quoted in translation in Peter Paret, *The Berlin Secession* (Cambridge, Mass., and London, 1980), 21.

3. In a speech in 1901, the kaiser proclaimed: "The supreme task of our cultural effort is to foster our ideals. If we are and want to remain a model for other nations, our entire people must share in this effort, and if culture is to fulfill its task completely it must reach down to the lowest levels of the population. That can be done only if art holds out its hand to raise the people up, instead of descending into the gutter." *Die Reden Kaiser Wilhelms II*, 3: 61–62, as quoted in translation in Paret 1980, 27.

4. The Königliche Gemäldegalerie, Dresden, owner of Raphael's *Sistine Madonna*, was among the first to acquire works by Courbet, Manet, and Toulouse-Lautrec, in defiance of nationalist opposition.

5. Von Seidlitz' official title was chief councillor to the administrators of the royal Saxon collections (Vortragender Rat der Generaldirektion der Königlich-Sächsischen Sammlungen).

6. Cologne 1989, 15.

7. Cologne 1989, 13–14.

8. Cologne 1989, 16.

9. Max Lehrs, "Käthe Kollwitz," in *Die Graphischen Künste* 26 (1903), 60–67.

10. Lehrs 1903, 60.

11. The Dresden museums, along with many others, suffered great losses when, after World War II, occupying Russian forces commandeered numerous art treasures and transported them to the Soviet Union, ostensibly for safekeeping but also as compensation for the many valuable objects looted by the Germans from Russian churches and museums. Although in 1958, as part of a comprehensive Soviet restitution effort, Dresden got back most of its paintings as well as a major part of its Kollwitz collection, sixty-five prints and ten drawings are still missing (Cologne 1989, 20, 192–196).

12. The Berlin Kupferstich-Kabinett acquired its first Kollwitz prints in 1902, three years before Lehrs' arrival, and in 1904 the Nationalgalerie's director Hugo von Tschudi bought five drawings. After Lehrs returned to Dresden, Johannes Sievers and, subsequently, Max Friedländer made substantial Kollwitz acquisitions for the Berlin Kupferstich-Kabinett. Tschudi's successor at the Nationalgalerie was also partial to Kollwitz, and in 1964 the artist's son Hans Kollwitz donated a large collection of drawings from the Kollwitz estate to the museum.

13. In Lehrs' 1903 catalogue raisonné, the "Stuttgarter Kabinet" is listed as the owner of the beautiful and rare *Self-Portrait in Profile, Facing Left* (Lehrs 34/K. 40 II). By 1912 the Munich Kupferstich-Kabinett owned *Unemployment* (Sievers/K. 100 II) and *Working Woman (with Earring)* (Sievers/K. 105 III), according to Johannes Sievers, *Die Radierungen und Steindrucke von Käthe Kollwitz* (Dresden, 1913).

14. Helmut Goedeckemeyer's Kollwitz collection, assembled over several decades, is now at the Staedelsches Institut in Frankfurt/Main. Heinrich Becker's Kollwitzes are in the museum in Bielefeld. Heinrich Reemtsma's Kollwitz works are at the Ernst Barlach Haus in Hamburg, where the most numerous and important works by Barlach (an artist Kollwitz greatly admired) are housed.

15. For instance, in 1911, the Berlin Kupferstich-Kabinett purchased several outstanding proofs and worked-over prints from the firm of Emil Richter.

16. Kollwitz had submitted about 250 drawings, from which Cassirer selected those he considered most characteristic and powerful (Jutta Bohnke-Kollwitz, ed., *Käthe Kollwitz, Die Tagebücher* [Berlin, 1989], 312, 819). The catalogue lists 159 drawings, forty-nine graphics, and an unspecified number of sculptures.

17. Richter also served as a publisher of Kollwitz' original etchings, having acquired most of the extant plates in 1917 (Kollwitz 1989, 309).

18. See Beate Bonus-Jeep, *Sechzig Jahre Freundschaft mit Käthe Kollwitz* (Bremen, 1963), 81. See also note 27.

19. *Berliner Börsenzeitung*, (16 February 1933), as quoted in Kollwitz 1989, 912.

20. Although Kollwitz' work was included in the original Munich presentation of the famous 1937 "Degenerate Art" exhibition, it was removed from the subsequent showings in Berlin and elsewhere. See Stephanie Barron, ed., *Degenerate Art: The Fate of the Avant-Garde in Nazi Germany* [exh. cat. Los Angeles County Museum of Art] (Los Angeles, 1991), 92.

21. Kollwitz' *Bread!*, with a signature "St. Frank," was published in a Nazi periodical; the image was used to illustrate an inflamatory poem against Loyalists in the Spanish Civil War (1936–1939).

22. Kollwitz wrote to the sculptor Kurt Harald Isenstein in Denmark on 30 July 1937 (two weeks after her seventieth birthday): "Here in Germany I was feted in that my exhibition at Buchholz [in Berlin] was prohibited." Quoted in Kollwitz 1989, 925.

23. The inscription on the gravestone, in the Jewish cemetery at Cologne-Bocklemünd, reads: "I learned to see, which is obvious/ I learned to feel,

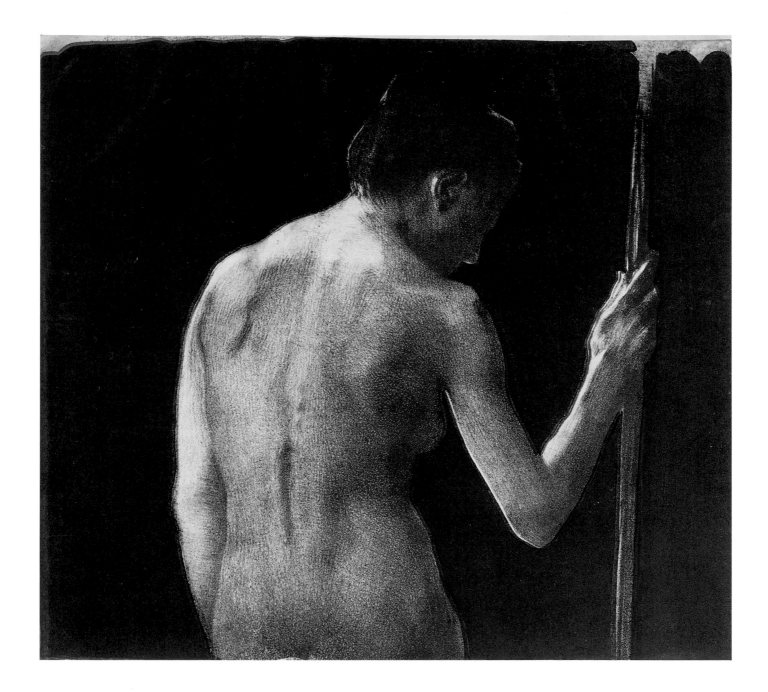

Annotated Checklist

1. *Self-Portrait en face, Laughing,* c. 1888–1889

pen and ink and wash, 304 x 240 (12 x 9½), signed center: *Schm.,* NT 7

Käthe-Kollwitz-Museum Berlin

See illustration on page 16.

In one of the only cheerful views of Kollwitz known, the twenty-two-year-old artist gazes directly out at the viewer.[1] Here she was interested in exploring the intricacies of her own face. A right-handed draftsman, Kollwitz worked with what appears in the image as her left arm while studying her mirror reflection. In a self-consciously Old Master fashion she modeled the round face with its high forehead in a web of pen scratches whose painterly tan-

gle evokes Rembrandt's handling of some of his own self-portraits. The mixture of very fine strokes with broader ones is spirited and lively. These lines move in all directions; certain areas, such as the area to the right side of her nose, have been left blank to suggest light. Although such passages as the transition from her left jawline to her neck are slightly awkward, the whole works effectively and is astonishingly fresh. Kollwitz brushed in an ink wash to create the sense of hair, clothing, and background around the delicate pen work. The quality of the line refers to the etching process, to which she was introduced at about this time, and the suggestion of tone through the washes may signal what would become a preoccupation with aquatint and various innovative ways of creating atmosphere on the plate.

1. See Nagel 1965, where the drawing was dated 1885.

2. *Self-Portrait,* 1889

pen with black and brownish-black ink wash on cream wove paper, 309 x 242 (12¼ x 9⅝), signed and dated l.r.: *Schmidt/1889,* NT 12

Käthe Kollwitz Museum Köln, Kreissparkasse Köln, on loan from a private collection

See illustration on page 17.

3. *Self-Portrait with Student Colleague,* 1889

pen and ink and wash on heavy wove paper, 295 x 270 (11⅝ x 10⅝), signed l.l.: *Schmidt (Kollwitz)/ München 1889,* NT 13

Private collection, courtesy Galerie St. Etienne, New York

See illustration on page 16.

A rich counterpoint of line and tone informs the diminutive and intimate lamplit scene of the artist and a school friend sketching on

their drawing boards. Like a number of the early works, this image possesses an atmospheric, even painterly quality. Employing an array of vertical strokes also seen in the sheet of *Two Self-Portraits* from two years later (cat. 4), a technique reminiscent of the realist approach of Wilhelm Leibl, Kollwitz contrasted the deeply shadowed side of the face to the brightly illuminated cheek. Her pen has also delineated, in remarkably economical fashion, particulars of her hands, the face, hands, and blouse of her companion, and the lamp, a stately presence in itself. The rest of the composition has been sensitively and expertly brushed in with ink wash. Rather than separate objects or areas from each other by line, the artist layered the ink washes to different densities as she suggested forms revealed by the flame of an oil lamp. Though there is a sense of mystery evoked by the indeterminate setting, it is of secondary importance to rapt concentration on making art.

4. *Two Self-Portraits*, 1891

pen and ink and wash, 395 x 283 (15½ x 11⅛), NT 30

Staatliche Museen zu Berlin, Kupferstichkabinett

See illustration on page 18.

5. *Self-Portrait*, 1891

pen and ink and wash, heightened with white on brownish wove paper, 400 x 320 (15⁷⁄₁₆ x 12⅜), signed l.r.: *Kathe Kollwitz*, NT 32

The Art Institute of Chicago, Gift of Mrs. Tiffany Blake, Mr. and Mrs. Alan Press, and the Print and Drawing Fund

See illustration on page 18.

Dating from about 1891–1892, this remarkable self-portrait is one of the most meticulously wrought forms of her entire body of surviving drawings. Kollwitz sculpted her face in a mesh of black ink and white gouache lines that resemble scratches, crosshatching and modeling with the precision and appearance of a chiaroscuro woodcut. The finish of the face and hands is something that, for all its careful beauty, must not intrinsically have interested Kollwitz, for it does not recur in her extant work. It probably comes closest to emulating the style of her mentor Karl Stauffer-Bern, even if she did not subscribe to his priorities of a hard, tight finish. This sheet demonstrates that Kollwitz too was capable of achieving such an effect.

6. *Scene from Germinal*, 1891

pen and black ink with gray washes heightened with white, 465 x 605 (18½ x 23⅞), signed l.r.: *Kollwitz*, not in NT

Private collection

See illustration on page 20.

7. *Self-Portrait en face*, 1892

pen and brush, and ink with light green and blue watercolor and black wash, sheet: 289 x 254 (11⅝ x 10), signed l.r.: *Kollwitz*, NT 75

Käthe Kollwitz Museum Köln, Kreissparkasse Köln, on loan from a private collection

See illustration on page 18.

This sheet has been dated to about 1892, based upon the probable age of the artist as well as the style. It represents one of the less frequent frontal self-portraits. Executed on the verso of another self-portrait (NT 27), the head, delicately penned in soft brown ink, has rarely been reproduced to reveal its placement in a small area on the large sheet of thick paper. However, its position is important for a number of reasons, among which is the suggestion that Kollwitz may have intended to fill in the details of the upper body. Secondly, in the margins there are traces of light blue and light green washes, which hint at the interest in color that remains a relatively little-known and still surprising aspect of Kollwitz' work.

8. *Self-Portrait at a Table*, 1893

etching and aquatint, 178 x 128 (7 x 5), signed l.r.: *Kathe Kollwitz*, inscribed l.l.: *O. Felsing Berlin gdr.*, K. 14 IIIa

Private collection

See illustration on page 104.

cat. 9

Kollwitz' expressed dissatisfaction with intaglio methods may relate directly to her experience with an image such as *Self-Portrait at a Table*, in which she sits drawing by oil lamp and looks directly at the viewer. The present impression represents the third state of five. A combination of etching and aquatint, the plate has been bitten so deeply that the rich, dark background stands above the lighter areas; the bite is so deep that passages such as those meant to define her shoulders emerge too definitively as autonomous shapes to contribute effectively to the overall sense of modeling. The subtlety and tonal range achieved with pen and ink in *Self-Portrait with Student Colleague* (cat. 3) have been lost here. Nonetheless, the heavy use of aquatint creates a

rich, even ominous sense of atmosphere; following the lead of Klinger, copious aquatint was a fashionable device of the time for treating themes of fantasy or melancholy, so much so that the print historian Curt Glaser referred to it with a touch of irony in his 1923 book on the modern print, saying that "there appeared masses of cyclical portfolios of etchings, in which the eternally rewarding themes of Women and Love and Death and the Beyond were treated with much profundity and aquatint."[1]

1. See Glaser 1923, 466: "Massenhaft entstanden zyklische Folgen von Radierungen, in denen das ewig dankbare Thema von Weibe und der Liebe und vom Tode und dem Jenseits mit viel Tiefsinn und Aquatinta abgewandelt wurde."

9. *Scene from Germinal*, 1893

etching in brown, 237 x 526 (9⅜ x 20¾), signed l.r.: *Kathe Kollwitz*, inscribed l.l.: *O. Felsing Berlin gdr.*, K. 21 III

Private collection

10. *Self-Portrait Full-length, Seated*, 1893

pen and ink and wash on laid paper, 332 x 247 (13⅛ x 9½), signed l.r.: *Kathe Kollwitz*, NT 86

Dr. Eberhard Kornfeld

See illustration on page 19.

The acute subjectivity of Kollwitz' work often entailed the actual inclusion of the maker. One of the first examples of this practice is the *Self-Portrait Full-length, Seated*. Kollwitz used this drawing as a study for a picture based on a scene from Max Halbe's play

Youth, which opened in 1893. Although the play today seems thin, contrived, and badly written, its forthright treatment of sexual and moral dilemmas sustained audiences' interest for several decades; it played throughout the German Empire and German-speaking countries in Middle and Eastern Europe, opening in New York City as late as 1916.[1] The melodrama clearly made a great impact on the young Kollwitz.

Self-Portrait Full-length, Seated represents one of the more finished studies for a trial etching based on the play, made the same year, and a finished version of 1904 (K. 18 and K. 73). Kollwitz would later claim also that she made the drawing after her first dispute with her husband.[2] Here she captured mood not just in the facial expression, but also in the mien of the figure. In a richly modulated tonal blend of ink planes, lively zigzagging scratches, and areas of blank paper for highlights, Kollwitz portrayed herself as a rather dour young woman, slightly bent over, with an expression hovering between introspection and wariness. To her left are sketches of part of a face, concentrating on the nose and lips and, below that, a fine sketch of a hand and forearm.

1. Ludwig Lewisohn, "Introduction," in Max Halbe, *Youth*, tr. by Sara Tracy Barrows (Garden City and New York, 1916), xv.
2. Cited in Nagel 1965, 16.

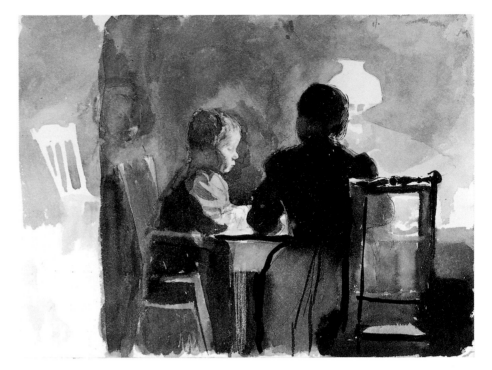

cat. 11

11. *Under the Table Lamp,* 1893–1894

pen and ink and wash, 247 x 334 (9¾ x 13⅛), NT 109

Staatliche Kunstsammlungen Dresden

The child in this atmospheric drawing is the artist's son Hans at the age of about two. Another version of the same scene may be found on the verso.

12. *Poverty,* 1893–1894

rejected plate for sheet 1 of *A Weavers' Rebellion*, etching and drypoint with corrections in graphite, 189 x 162 (7½ x 6½), inscribed by the artist below: *Radieren: Kind. Frau. Kind hinten Wasserkopf. Kleid vorderer Frau rechts/polieren: Scheitel. Knie./Kind Stirn, Auge/Kalte Nadel: Aussicht,* K. 23 II

Staatliche Kunstsammlungen Dresden

See illustration on page 22.

13. *Poverty*, 1895

rejected plate for sheet 1 of *A Weavers' Rebellion*, etching, drypoint, and aquatint, 280 x 392 (11⅝ x 15⅞), K. 26

Staatliche Kunstsammlungen Dresden

14. *Poverty*, 1895

study for sheet 1 of *A Weavers' Rebellion*, pen and ink, chalk and wash on cream wove paper with touches of yellow, 289 x 227 (11⅜ x 8¹⁵⁄₁₆), signed l.r.: *Kollwitz*, NT 120

Sprengel Museum Hannover

See illustration on page 23.

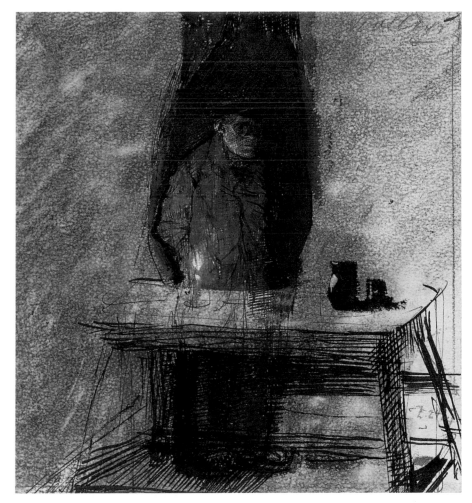

cat. 15

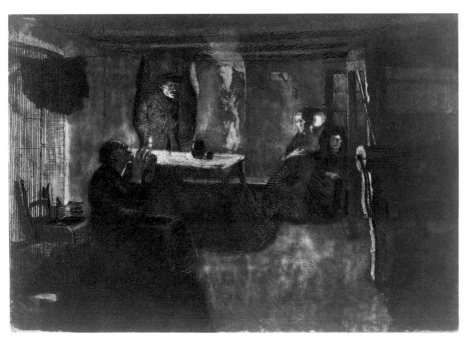

cat. 13

15. *Man Standing behind a Table*, 1895

colored chalk, pen and ink, watercolors on white paper, 166 x 154 (6½ x 6⅛), signed u.r.: *Kollwitz*, NT 119

Staatliche Kunstsammlungen Dresden

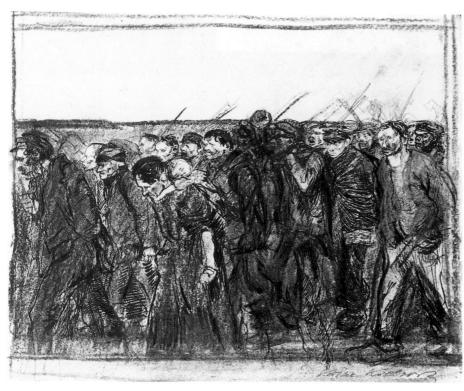

cat. 16

18. *Storming the Gate*, 1897

proof for sheet 5 of *A Weavers' Rebellion*, etching, 247 x 305 (9¾ x 12), signed l.r.: *Käthe Kollwitz*, K. 33 II

National Gallery of Art, Washington, Gift of Frederick C. Oechsner

The etching for *Storming the Gate* reverses the composition of the preparatory drawing (cat. 17) and exhibits the vitality and elasticity of Kollwitz' line. One may trace here the artist's interest in translating a range of tonal effects from the subtly modulated wash study into the intaglio process. Klipstein attributed the stippled effect visible on the stucco wall to the texturing of the copper plate with

16. *The Weavers' March*, 1896

study for sheet 4 of *A Weavers' Rebellion*, charcoal, ink, and graphite on heavy wove paper, 285 x 317 (11¼ x 12½), signed l.r.: *Käthe Kollwitz*, NT 125

Private collection, courtesy Galerie St. Etienne, New York

17. *Storming the Gate*, 1897

study for sheet 5 of *A Weavers' Rebellion*, pen and ink, black and white wash, and graphite on heavy wove paper, 584 x 438 (23 x 17¼), signed l.r.: *Käthe Kollwitz*, NT 135

Private collection, courtesy Galerie St. Etienne, New York

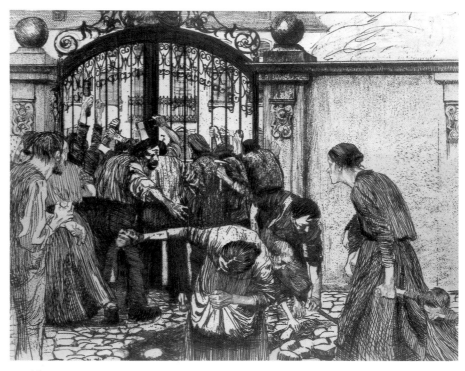

cat. 18

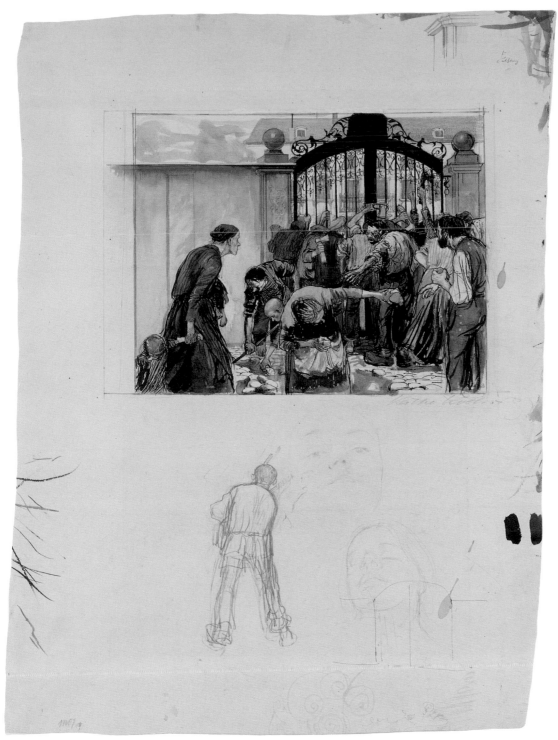

cat. 17

sand- or emery paper. A particu-
larly expressive example of this
technique occurs in the upper
right corner, where the loose wash
evocation of trees above the gar-
den wall in the preparatory draw-
ing has become a flourish of emery
dots and a few lyrical, etched
scratches. Kollwitz' interest in
depicting vegetation was so mini-
mal that it is not surprising to see
her treat real nature with a few
abstract squiggles while simultane-
ously minutely detailing the iron
tendrils of the elaborate gate.

19. *Death*, 1897

proof for sheet 2 of *A Weavers'
Rebellion*, color lithograph on japan
paper mounted on card, 222 x 184
(8¾ x 7³/₁₆), signed l.r.: *K. Kollwitz*,
K. 35 I

Private collection

See illustration on page 24.

20. *End*, 1897

study for sheet 6 of *A Weavers'
Rebellion*, graphite, pen, and ink
with wash, heightened with white,
409 x 492 (16⅛ x 19⅜), signed l.l.:
Kollwitz, signed l.r.: *Käthe Kollwitz*,
NT 133

Staatliche Kunstsammlungen
Dresden

See illustration on page 25.

21. *Workers Going Home at the
Lehrter Railroad Station*, 1897

graphite, pen, and watercolor
heightened with white, 392 x 518
(15⅜ x 20⅜), signed l.r.: *Kollwitz*,
NT 146

Käthe Kollwitz Museum Köln,
Kreissparkasse Köln, on loan from
the Zedelius Family

See illustration on page 102.

Kollwitz was still at the peak of
her interest in narrative motifs
when she made this sheet depict-
ing a mass of people filing out of
the station after a long day's work.

The drawing resembles the
imagery of contemporaries such as
Hans Baluschek. Kollwitz subject-
ed the figures to sharp scrutiny,
studying the different types of the
industrial proletariat. She worked
in watercolor heightened with
white gouache to create a dark
blue night, contrasting the smoky,
forbidding factories with the warm
yellow and red exterior of the sta-
tion. The care with which she
approached the design is apparent
in the careful perspectival scoring
of the enameled brick walls. The
unusually detailed quality of this
work is explained by the fact that
it was reproduced in the art maga-
zine *Pan*.

22. *Self-Portrait*, 1898

color lithograph on japan paper,
image 166 x 161 (6½ x 6½), signed
l.r.: *Kollwitz 99*, K. 40 II

Staatliche Kunstsammlungen
Dresden

See illustration on page 116.

23. *Uprising*, 1899

graphite, pen, and colored inks
heightened with white on brown
paper, image 366 x 294 (14⅜ x
11⅝), NT 156

Staatliche Museen zu Berlin,
Kupferstichkabinett

See illustration on page 33.

24. *Uprising*, 1899

etching printed in brown on cream
laid japan paper, hand colored with
red and black ink, image 260 x 295
(10¹⁵/₁₆ x 11¾), K. 44 I

Staatliche Museen zu Berlin,
Kupferstichkabinett

See illustration on page 33.

25. *Woman Arranging Her Hair*,
1900

color lithograph, 172 x 292 (6⅞ x
11⅞), signed u.r. in the stone: *K*,
K. 45, unique impression

Staatliche Kunstsammlungen
Dresden

See illustration on page 49.

The nude studies completed
around the turn of the century are
some of Kollwitz' loveliest and
most lyrical "pure art" images. She
seems to have made them princi-
pally for herself; they were not
printed in editions and are known
in very few impressions. *Woman
Arranging Her Hair* is a unique
impression, printed on the verso of
a trial proof for a rejected version
of *The Plowers* (K. 60).[1] This ex-
traordinary fragment was printed
in three colors: black for the key
stone, orange for the highlights on
the forearms, and a startlingly rich
green for the tone stone. Made
as Kollwitz was preparing *The
Downtrodden* and simultaneously
working up etched nudes as stud-
ies (K. 46 and K. 47), this color

lithograph is even more surprising in its intimacy and informality. There is virtually no sense of place, only the slice of the figure counterbalanced by a sweep of brushy strokes at the right. In subject it relates to Degas and his interpretation of Japanese art. In the almost symmetrical curve of the woman's fingers and the angles of the elbows there is a distinct evocation of the contemporary decorative style of art nouveau, a rare feature in Kollwitz' oeuvre.

1. Klipstein also listed *Woman Arranging Her Hair* as rejected.

26. *The Downtrodden*, 1900

etching, drypoint in blackish-brown on two sheets (left side acquired from the artist in 1901, and the right side acquired from the artist in 1902), with corrections in graphite, 237 x 828 (9⅜ x 32¹⁵⁄₁₆), K. 48 I, trial proof

Staatliche Kunstsammlungen Dresden

See illustration on page 27.

27. *The Downtrodden*, 1900

etching and drypoint, 239 x 836 (9⅜ x 32¹⁵⁄₁₆), signed l.r.: *Käthe Kollwitz*, inscribed l.r.: *O. Felsing Berlin gdr.*, K. 48 III

Private collection

See illustration on page 27.

28. *Life*, 1900

left: pen and black ink and wash heightened with white on white laid paper; center: black chalk over graphite with gray wash on white laid paper; right: black chalk and graphite with pen and black ink and wash on brown paper, sheet: 325 x 929 (12¾ x 36⁹⁄₁₆), signed l.r.: *Kollwitz*, inscribed center: *DAS LEBEN*, NT 158

Graphische Sammlung, Staatsgalerie Stuttgart

See illustration on page 28.

29. *Sitting Woman*, 1900

graphite, pen and ink, and wash on laid paper, 452 x 312 (17⅞ x 12 ½), NT 160

Staatliche Museen zu Berlin, Kupferstichkabinett

See illustration on page 30.

30. *Child's Head in a Mother's Hands*, 1900

graphite on white wove paper, 208 x 208 (8³⁄₁₆ x 8³⁄₁₆), signed and dated l.r.: *Kollwitz/ Kollwitz I. 1900*, NT 162

Staatliche Kunstsammlungen Dresden

See illustration on page 30.

31. *Self-Portrait at the Window*, 1900

pen and brush with black ink, touched with violet and ocher, 565 x 435 (22¼ x 17⅛), signed and inscribed l.r.: *Käthe Kollwitz/ zu « das Leben»*, NT 165

David S. Tartakoff

See illustration on page 28.

32. *Self-Portrait en face with Right Hand*, 1900

pastel, 580 x 475 (22⅞ x 18⅝), signed l.r.: *Kollwitz*, NT 168

Private collection, Berlin

See illustration on page 146.

33. *Self-Portrait in Profile Facing Right*, 1900

pastel, 470 x 365 (18½ x 14½), signed l.r.: *Kollwitz*, NT 166

Chris Petteys

See illustration on page 147.

A painterly approach may be discerned in two remarkable self-portraits executed in pastel, both dated to about 1900. They are unusual and noteworthy in Kollwitz' oeuvre not only for their depth of characterization, but also because of the color and the medium. To eyes accustomed to the expressivity and profundity of her black and white images, the sensitive and subtle colorism of these pastels is especially moving. Neither sheet suffers from the sentimentality that can accompany

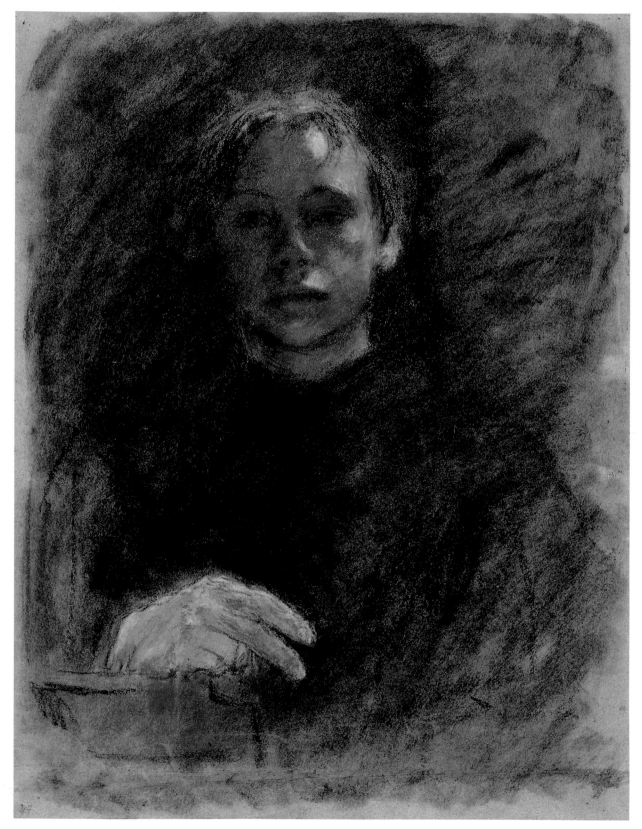

cat. 32

cat. 33

this medium, but rather exhibits the straightforwardness reflective of the best of Kollwitz' imagery.

Self-Portrait en face with Right Hand is especially gentle and meditative and exhibits a lyrical, searching treatment that disappeared in the later works, in which the utmost economy of handling and deep melancholy prevailed. In the present drawing the artist rubbed the pastel across the surface, allowing the tooth of the tan paper to create texture and the tiny cavities to serve as subtle highlights. She blended white pastel to illuminate the side of the face, where an unseen light source reveals its contours. Obviously looking directly into a mirror, she depicted her actual left hand resting somewhat awkwardly at lower left, while we understand her right one to be at work capturing the likeness. The background is minimally suggested through a far broader rubbing of the material; there is an intimation that the several black lines descending from her shoulder suggest the motion of her arm as she works.

In *Self-Portrait in Profile Facing Right*, the artist appears older and rounder of face. Kollwitz employed a subdued palette of black, blue, and sea-green with touches of white and brick-orange. Lightly outlining her head against the background, she constructed the facial features through a web of strokes, a kind of cross-hatching that she used in her pen drawings. Again she exploited the tooth of the paper to lend warmth, movement, and transparency to the medium. That Kollwitz herself

valued this work is suggested by its provenance; one writer stated that it came from the collection of Ernst Heinrich, prince of Saxony, who provided rooms in a house across from his country palace in Moritzburg near Dresden for the artist's use in 1944 when she fled Berlin in the wake of heavy allied bombing.[1]

1. See Fecht 1988, no. 11, 106.

34. *Self-Portrait and Nude Studies*, 1900

graphite, pen and black ink with wash, heightened with white on brown paper, sheet (irreg.): 280 x 445 (11 x 17½), signed and inscribed l.r.: *Käthe Kollwitz/ Martha Schwann, Lothring. 44*, NT 167

Graphische Sammlung, Staatsgalerie Stuttgart

See illustration on page 29.

The monumental *Self-Portrait and Nude Studies* owes its impact to the accomplished and confident rendering of the figures, the scale of the sheet and placement of the elements. At the right are inscriptions documenting the name of a woman, presumably the model, and the times and days that she posed. In the area of the face, Kollwitz counterpointed brushy fluidity with linear precision. For the body she worked, as indicated, directly from the model; she would later affirm the importance of so doing when she wrote to a young painter that it was as impor-

tant to study from nature and to seize each detail as it was to practice recording from memory.[1] During this early period, the former predominated.

Kollwitz would later use the nude study for one of the allegorical figures in *The Downtrodden*.

1. Letter of 29 July 1919 to Hanna Löhnberg, in Kollwitz 1966, 31.

35. *Man Kneeling before a Female Nude Seen from Behind*, 1900

charcoal and blue chalk, 640 x 501 (25³⁄₁₆ x 19¾), NT 169

Graphische Sammlung, Staatsgalerie Stuttgart

See illustration on page 31.

One rarely associates Kollwitz with the depiction of sexuality. Nonetheless, a small number of her works express this aspect of her personality, which has emerged more strongly since the recent publication of the complete edition of her diaries. In *Man Kneeling before a Female Nude*, a male figure seems to bow reverently before a nude woman whose uplifted arms suggest that she is pulling a garment over her head. The action allows the artist to study the planes of her back and buttocks, which, like the *Seated Female Nude* (cat. 36), have been rendered by rubbing in different densities of colored chalk over tan paper, producing areas of light and shadow and using the tooth of the sheet for surface texture. The man's gaze appears to be directed toward the woman's genitals,

unseen to the viewer, and there is a hint that were his arms depicted they would grasp the woman around the knees. By virtue of as well as in spite of its unfinished state, Kollwitz has succeeded in evoking an atmosphere of highly charged erotic tension in an indeterminate, mysterious fashion.

Ten years later, plausibly in the aftermath of a relationship with the Viennese book dealer and gallery owner Hugo Heller (1870–1923), Kollwitz executed a series of overtly erotic drawings, which she called the "Sekreta" (see NT 558–563). She did not intend that they be seen, and only relatively recently have they been made available for public viewing.

36. Seated Female Nude, 1900

pastel and black chalk on French pastel paper with a sand surface, 748 x 560 (29⁷/₁₆ x 22¹/₁₆), signed l.r.: *Käthe Kollwitz*, NT 170

Private collection

See illustration on page 32.

As part of her training and constant exercising of her skills in this early period, Kollwitz made extensive life studies.[1] This is one of her most powerful. Kollwitz worked in colored chalks on a large sheet of emery paper. Her sketchy technique sets it apart from the two quite finished self-portraits in colored chalk, though it shares their painterly lushness. Although the face is the most elaborated area in this work, it was not the features of the young woman that the artist

was exploring but rather the set of her bowed head, the shape of her torso, and the position of her legs. The greenish-yellow shading around the head and right arm reinforce the decorative, vaguely French feeling of the study. Kollwitz created a vivid sense of tactility, of firm, rounded flesh, betraying a sensuality that has only relatively recently come to light as part of her work.

1. Here the chronology of Nagel and Timm's catalogue raisonné is accepted. Often their dating is speculative and based upon stylistic and thematic relationships.

37. Nude Study for "Das Leben," 1900

pen, graphite, and ink wash heightened with white, 230 x 270 (9 x 10⁵/₈), signed l.r.: *Kathe Kollwitz*, not in NT

Käthe-Kollwitz-Museum Berlin

See illustration on page 29.

38. Die Carmagnole, 1901

etching, aquatint, and soft-ground etching in brown, 573 x 410 (22¹/₂ x 16¹/₈), signed l.r.: *Kathe Kollwitz*, inscribed l.l.: *O Felsing Berlin gdr.*, K. 49 V

Private collection

See illustration on page 60.

39. Self-Portrait Facing Left, 1901

lithograph on gray paper heightened with white chalk, 272 x 205 (10⁵/₈ x 8), signed l.r.: *Käthe Kollwitz*, K. 50, before first state

Staatliche Kunstsammlungen Dresden

See illustration on page 150.

40. Self-Portrait Facing Left, 1901

color lithograph on blue laid paper, 268 x 204 (10¹/₂ x 8), K. 50 I

Mr. and Mrs. Philip A. Straus

See illustration on page 151.

In the *Self-Portrait Facing Left* from 1901, Kollwitz' enduring fascination with surface texture emerges in a rather unexpected manner. The texture of the laid paper visible in this self-portrait leads one to believe that this is a transfer lithograph. However, this impression of the keystone, possibly before the first state, shows no evidence of these laid lines; the image was clearly drawn directly onto the stone. It appears that the artist transferred the imprint of the textured paper instead to the background stone, which she printed in orange-brown, later scratching in highlights over it. In Klipstein's account of this work, he suggested that, for the second state, a third plate was used for the scratched-in highlights. It is unclear why this should be so, since the effects could have been

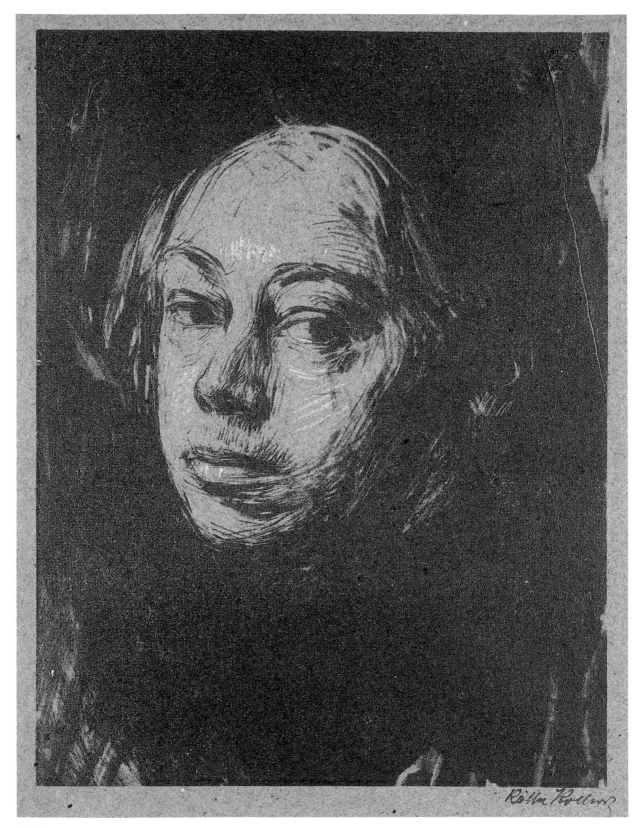

cat. 39

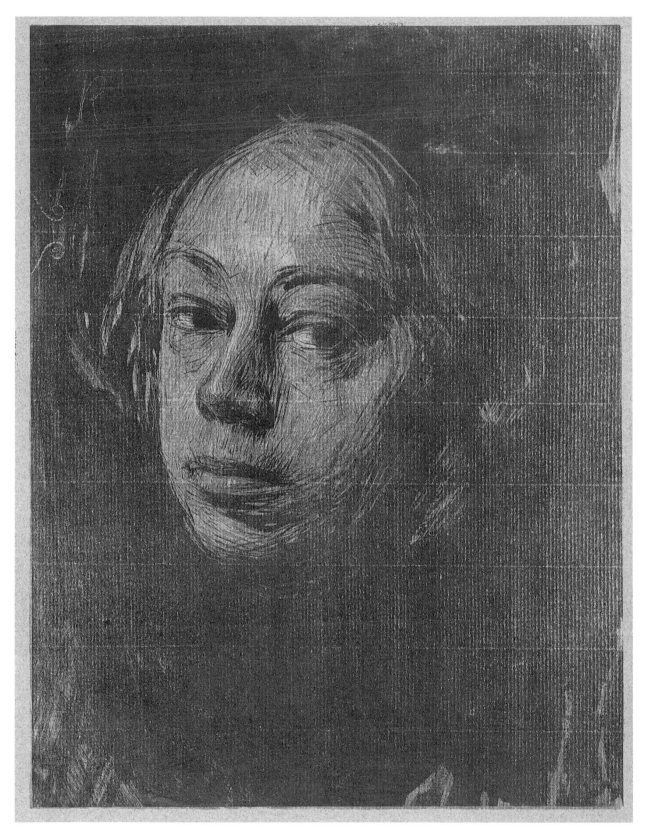

cat. 40

achieved simply by placing the highlights on the tone stone.

Among the impressions of this print that make use of the two stones, those in which the tone stone was printed second show clearly the laid lines, as in the present impression. By contrast, in impressions where the drawing stone was printed last, the texture is less prominent. The former is draftsmanly and textural; the latter emphasizes the glowing brown, highlighted face floating in a rich black background, recalling the disembodied heads that were a standard feature of symbolist art and that of Edvard Munch in particular (as in *Self-Portrait with Skeleton Arm*, 1895). Kollwitz often printed this image on blue paper, which accentuated its coloristic effect and contributed a decorative framing element.

41. *Nude from Rear Holding a Staff*, 1901

two-color lithograph, 270 x 300 (10⅞ x 11⅞), K. 51

Staatliche Kunstsammlungen Dresden

See illustration on page 136.

42. *Woman with Orange*, 1901

color etching, aquatint, and lithograph on paper mounted on gray-violet card, image: 279 x 160 (11 x 6¼), signed l.r.: *Käthe Kollwitz*, K. 56

Staatliche Kunstsammlungen Dresden

There are only a few impressions known of *Woman with Orange*, another of the rare works Kollwitz executed in color around the turn of the century. It figures among the sheets in which Kollwitz explored the effects of light and shadow and is frankly decorative. The lamp with its delicately wrought frame, which finds its only parallel in Kollwitz' design for the gate in cats. 17, 18, forms a graceful ornament to set off the head of the unknown woman as she gazes at the viewer with a meditative smile. It recalls the imagery and, to an extent, the composition of prints by the Nabis. Edouard Vuillard and Pierre Bonnard, in particular, concentrated on interior scenes, often configured vertically, like *Woman with Orange*. One often finds in their work devices such as the slanted table in the foreground, which provides an entrance into the image as well as strong surface pattern, and the decorative lamp, with its veiled light suggesting a certain melancholic personal symbolism. As with most of Kollwitz' work in color, this sheet does not range far chromatically, remaining within a scale of rich browns, oranges, and the soft yellow pro-

vided by the oil lamp. To emphasize its status as a special art object, and as clear evidence of influence from the era, Kollwitz cut out the image and mounted it on a sheet of textured gray paper to create a frame. She also signed it in the plate with a decorative cartouche bearing her initials, a flourish that she dispensed with afterward.[1]

As is true for many of her prints from this period, the means by which Kollwitz created the color effects are far from obvious. In *Woman with Orange* Kollwitz introduced the unusual combination of etching and lithography that would recur two years later with *Woman and Dead Child*. The exact method she employed remains open to speculation. Klipstein maintained that she used a copper plate for the drawing and two stones for the colors, presumably the orange and the beige lamp. Along with Max Lehrs (*Die graphischen Künste* 26, [1903], 59, 66–67), Antony Griffiths suggested three plates, two aluminum and one copper; and Tom Fecht suggested that it was printed from two copper plates and one lithographic stone.[2] While it is extremely difficult to say for sure, one can discern between the few known impressions genuine differences that probably represent successive states, though none is listed in Klipstein's catalogue. For example, an impression on deposit in the Käthe Kollwitz Museum in Cologne exhibits orange shading around the midportion of the lamp as well as scraping in the aquatint of the slanted table. Further, the

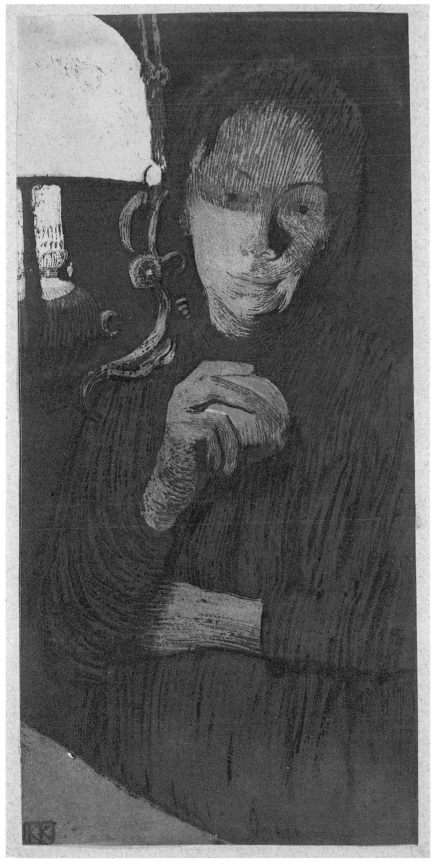

strokes in the dress differ greatly from the configuration of lines in that area in the Dresden impression. In the latter too the table has been executed with an even layer of aquatint. Although the exact progression of states remains to be sorted out, these details demonstrate the range and elusiveness of Kollwitz' technical invention.

1. Kollwitz shaved off varying amounts of the left edge of the composition in the few known impressions, leaving more or less of the lamp and its base visible.
2. Carey and Griffiths in London 1984, 65; and Fecht 1988, no. 37, 107.

43. *Outbreak*, 1903

proof for sheet 5 of *Peasants' War*, etching and soft-ground etching overworked with graphite and ink wash, 507 x 592 (20 x 23¼), signed and inscribed l.l.: *III Kollwitz*, signed l.l. in the stone: *K Kollwitz*, K. 66 III

Private collection

See illustration on page 37.

In the trial proof of the third of eleven states[1] of *Outbreak*, one may clearly discern the texture of cloth overlaid on the plate not only in the sky but across much of the rest of the surface as well. Here the artist also touched areas in ink wash—for example, around Black Anna's hands and around the figures to her left—to suggest where changes would be implemented in later states. This beautifully crisp black impression, among many that were later printed in brown or slightly reddish

browns, bears witness to the artist's manner of developing an image and represents a fresh, early stage in the genesis of the motif. Later on, Kollwitz worked up the figures further and blended layers of aquatint into a denser pattern of interwoven textures.

1. The last four states do not involve changes in the actual composition but are various edition states with their accompanying markings. See Klipstein 1955, no. 66.

44. *Working Woman with Blue Shawl*, 1903

color lithograph, 352 x 246 (13⅞ x 9¾), K. 68 I

Private collection

See frontispiece.

Kollwitz made the bust-length *Working Woman with Blue Shawl* in the same year as *Woman with Dead Child*. The early impression reproduced here is a beautiful example of a motif that exists in many impressions of greatly varying quality.[1] In it one can discern the three stones and the freshness of the keystone with its fine modeling lines. Later impressions from the large edition published by the Viennese Gesellschaft für vervielfältigende Kunst, a print collectors' society, tend to be flatter and harder. This sheet, by contrast, exhibits the artist's sensitivity to the qualities of the lithographic medium and her skill at sculpting form from light and shade. One of the most eloquent features of the motif is the dignity

it imparts to the sitter; without belaboring her apparent working-class origins, Kollwitz conveyed profound respect and empathy for this person.

1. It remains unclear whether this impression represents a first or a second state.

45. *Female Nude with Green Shawl Seen from Behind*, 1903

color lithograph overworked with colored chalks, 626 x 472 (24½ x 18½), K. 69

Kunsthalle Bremen

See illustration on page 47.

46. *Female Nude with Green Shawl Seen from Behind*, 1903

color lithograph, 610 x 462 (23½ x 18½), K. 69

Staatliche Kunstsammlungen Dresden

See illustration on page 48.

This is the most beautiful of the color lithographs of nudes, perhaps even of all Kollwitz' color prints. It dates from 1903, one of the artist's most productive years. A woman sits with bowed head facing away from the viewer, who can reflect upon her gracefully modeled back. Kollwitz worked with crayon, scraping away the material on the shoulders in particular to evoke a fall of light revealing subtle planes and contours of the skin. Clearly suggested are the muscles and

bones underneath; even at rest, the body is vibrant and tactile. Over the image made by the key stone Kollwitz printed a green tone solely in the area of the shawl.

Kollwitz seldom experimented with different color combinations or versions. She made almost no changes to this nude except, on two or so of the few known impressions, to add some blue. (Klipstein noted that in some first-state impressions, she actually added a blue stone.) Otherwise she slightly varied the shade of the shawl on the Bremen impression, where the scintillating blue-green hues and a slight overworking with blue crayon or chalk render it one of the most aesthetically stunning works Kollwitz ever made. The predominating sense of quietude and the delectation of color, surface texture, and abstract, sculptural form create a moment of poetic contemplation entirely devoid of rhetoric.

47. *Pietà*, 1903

color lithograph overworked with blue, red, black, and brown chalk, sheet: 450 x 604 (17⅞ x 23⅞), K. 70 I

Staatliche Museen zu Berlin, Kupferstichkabinett

See illustration on page 41.

48. *Woman with Dead Child–Pietà,* 1903

colored chalks on brownish paper, 476 x 584 (18¾ x 23), signed l.r.: *K. Kollwitz,* NT 234

Käthe Kollwitz Museum Köln, Kreissparkasse Köln

See illustration on page 40.

49. *Pietà,* 1903

lithograph, 475 x 627 (18⅞ x 24¾), K. 70

National Gallery of Art, Washington, Rosenwald Collection

See illustration on page 41.

50. *Woman with Dead Child,* 1903

black chalk and charcoal heightened with white on two sheets of attached green paper, 390 x 480 (15⅜ x 18⅞), signed and dated l.l.: *Kollwitz 03,* NT 241

Private collection

See illustration on page 12.

51. *Woman with Dead Child,* 1903

etching overworked with charcoal on heavy wove paper, sheet: 420 x 484 (16½ x 19), K. 72 I

Private collection, courtesy Galerie St. Etienne, New York

See illustration on page 44.

Kollwitz recalled the occasion when she began work on *Woman with Dead Child*[1]: "When he [Peter] was seven years old and I made the etching 'Woman with Dead Child,' I drew myself in the mirror, holding him in my arm. That was very tiring, and I moaned. Then his little child's voice said comfortingly: 'Don't worry, Mother, it will be very beautiful.'"[2]

It is likely, as Gunther Thiem has suggested, that the drawing in Stuttgart (NT 242) is the work that was transferred to the copper plate for the first state and then used again for the third state.[3] The rare first-state impression reproduced here is exclusively tonal, clearly revealing the grain of the paper from which it was transferred and showing further additions in charcoal under the head of the child and the left arm of the woman.

Kollwitz elaborated the work over eight states. After the initial transfer of the preliminary drawing to the plate by means of the soft-ground etching process, she proceeded to enrich the surfaces by progressively adding texture to different sections of the figures and working up the image with soft-ground procedures as well as direct etched and engraved areas. The remarkable trial proofs re-

produced here show how Kollwitz experimented with her media: she touched up prints with charcoal, graphite, and gold wash, and later made a print with a gold tone stone, to produce different aesthetic effects and psychological overtones.

1. See "Käthe Kollwitz an Dr. Heinrich Becker. Briefe," brochure (Städtisches Museum Bielefeld, 1967), note 4, 27. Griffiths posited that NT 239 may be the work in question. See Carey and Griffiths in London 1984, 66.
2. Kollwitz, Letter to Arthur Bonus of 3. Osterfeiertag, in Bonus 1925, 7.
3. Thiem in Stuttgart 1967, no. 26, 37. He suggests that after the transfer to the plate was made the drawing was further elaborated.

52. *Woman with Dead Child,* 1903

etching and soft-ground etching overworked with graphite and gold wash, 425 x 486 (16¾ x 19⅛), K. 72 IV

National Gallery of Art, Washington, Gift of Philip and Lynn Straus, in Honor of the Fiftieth Anniversary of the National Gallery of Art

See illustration on page 44.

53. *Woman with Dead Child,* 1903
soft-ground etching and engraving, overworked with graphite, charcoal, and gold on cream wove paper, sheet: 425 x 491 (16¾ x 19⅜), signed l.l.: *Kollwitz,* K. 72 III

Trustees of the British Museum, London

See illustration on page 45.

54. *Woman with Dead Child*, 1903

etching and soft-ground etching, overprinted lithographically with a gold tone plate, sheet: 422 x 487 (16⅝ x 19⅛), K. 72 VI

Trustees of the British Museum, London

See illustration on page 46.

55. *Woman with Dead Child*, 1903

etching and soft-ground etching on pale green tissue mounted on wove paper, 422 x 487 (16¾ x 19⅛), signed u.r.: *Kollwitz 03*; inscribed l.l.: *O. Felsing Berlin gdr.*, K. 72 VIII a

Private collection

See illustration on page 42.

56. *Dead Boy*, 1903

black chalk heightened with white on greenish paper, 379 x 623 (14⅞ x 24½), NT 245

Staatliche Museen zu Berlin, Kupferstichkabinett

See illustration on page 43.

57. *Black Anna*, 1903

graphite and black chalk heightened with white on brownish card, image: 555 x 431 (23 x 16⅞), inscribed by the artist l.: *zu lang*; l.r.: *doppelseitig*, NT 191

Staatliche Museen zu Berlin, Kupferstichkabinett

See illustration on page 38.

58. *Self-Portrait en face*, 1904

color lithograph, 479 x 330 (18⅞ x 13 irreg.), signed l.r.: *Kollwitz*, K. 75

Museum of Fine Arts, Boston, Frederick Brown Fund

See illustration on page 6.

Bold and sculptural, this frontal self-portrait, with the thirty-seven-year-old artist gazing meditatively at the viewer, was worked directly onto the stone in lithographic crayon. The lithograph was made in several versions: in two, three, and four colors. In the impression illustrated here Kollwitz worked with a reddish-yellow keystone and two tone stones, one in yellow-brown and the other in a strong dark blue that intensifies the facial expression.

The handling of light and shadow here exhibits Kollwitz' interest in an allover painterly unity of elements as opposed to an additive collection of details.[1] It is not surprising that this approach would have made the addition of color such a logical choice, though it seems to be valued more for its creation of a sense of indeterminate atmosphere than for strictly chromatic effects.

1. Schmidt argued that this approach links Kollwitz' art far more to that of the naturalist Wilhelm Leibl than to the work of Klinger. He suggested that Kollwitz rejected Klinger's classical, additive method in favor of conceiving things in terms of light and space in painterly unity. See Schmidt 1967, 84.

59. *Woman Supporting Her Chin with Her Right Hand*, 1905

lithograph on brown paper, 484 x 323 (19¹/₁₆ x 12¾), signed l.l.: *Kollwitz*, K. 83

National Gallery of Art, Washington, Rosenwald Collection

60. *Whetting the Scythe*, 1905

study for sheet 3 of *Peasants' War*, etching and soft-ground etching overworked with graphite and ink and black, yellow, and brown chalks on heavy cream wove paper with drawing on another piece of paper pasted on, 299 x 295 (11¾ x 11⅝), signed l.l.: *Kollwitz*, K. 90 III

Sprengel Museum Hannover

See illustration on page 35.

The third sheet from *Peasants' War* depicts a woman sharpening a scythe. Although normally an innocent action—caring for a tool of primary importance in farm life—Kollwitz infused this image with a sense of danger and horror. She focused on the top half of the figure, lighting her from below and narrowing the eyes into bestial slits. After experimentation, the artist settled upon the menacing position of the hands and a close-up view, which force us to understand that what this image really documents is the readying of a combat weapon.

As with the other sheets for the cycle, Kollwitz built up the image with successive layers of soft-

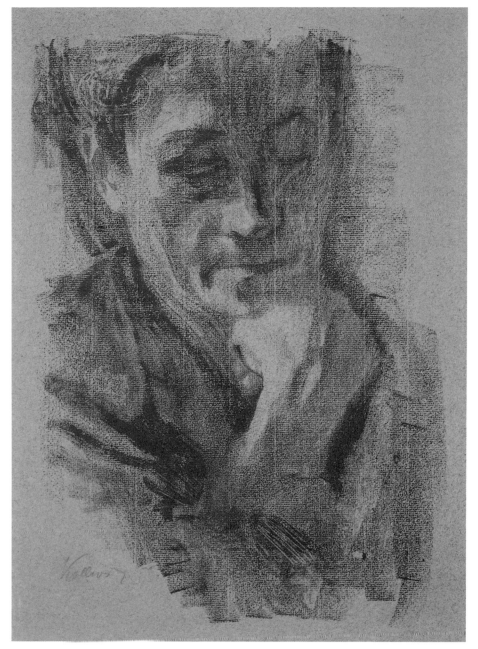

cat. 59

reworked the area of the woman's right hand in chalks on another sheet, cut it out, and pasted it onto the print. (Another impression that she handled in a similar fashion can be found at the Achenbach Foundation in San Francisco, along with the drawing upon which she based the first state of the print, NT 397.)

61. *Plowers and Woman*, 1905

study for sheet 1 of *Peasants' War*, charcoal heightened with white on tan paper, 362 x 569 (14¼ x 22⁷⁄₁₆), signed l.r.: *K. Kollwitz*, not in NT

Private collection

See illustration on page 34.

The first sheet of *Peasants' War* is *The Plowers*, which was one of the two motifs, including *Arming in a Vault*, that Kollwitz initially rendered as a lithograph in 1902 (K. 60, 61).[1] The motif of a peasant woman old before her time, silently observing two men laboriously pulling the plow, was subjected to numerous transformations before the artist was satisfied. Other trials include an unusual oil study, now in the Akademie der Künste (formerly East Berlin) (NT 196), which represents one of the handful of extant "paintings" (this is more strictly an oil sketch) executed by the artist.[2] In the oil study as in some of the other drawings, Kollwitz included the figure of a helmeted soldier dragging the men through their work and symbolizing their oppression. Later, as in

ground tones, transferring the grain of laid Ingres paper and the imprint of a mechanically ruled screen that was probably transferred photomechanically to the plate. The addition of texture heightens the sense of the coarse harshness of the peasants' existence and the urgency of their resistance to oppression. In this third-state impression, Kollwitz' method of correcting a proof is visible. She touched in changes with graphite and ink and

the study reproduced here and in the final etched version (K. 94), Kollwitz removed the allegorical figure and eventually the figure of the woman as well, allowing the back-breaking posture of the plowers to speak for itself. Other preparatory sketches are NT 196, 197, 199, 202–212.

1. Griffiths suggested that Kollwitz received the commission from the Society for Historical Art on the basis of *Outbreak* and thereafter decided to unify the cycle by working exclusively in large-scale etching. She therefore rejected the two lithographs, eliminated the smaller plate of *Uprising* and proceeded in the direction indicated by *Outbreak*. See Carey and Griffiths in London 1984, no. 34, 68.
2. Most of Kollwitz' works in oil date from her teenage years. A number of these are reproduced in Fecht 1988, nos. 2, 3, 4, 5. *The Plowers* is no. 92, reproduced in color.

62. *Arming in a Vault*, 1906

study for sheet 4 of *Peasants' War*, charcoal and wash heightened with white on gray laid paper, 460 x 315 (18 ¼ x 12⅜), signed and dated l.r.: *Käthe Kollwitz 1906*, NT 215

National Gallery of Art, Washington, Rosenwald Collection

See illustration on page 35.

63. *Battlefield*, 1907

study for sheet 6 of *Peasants' War*, charcoal and chalk heightened with white on charcoal gray paper, 435 x 542 (17⅛ x 21⅜), signed l.r.: *Käthe Kollwitz*, NT 410

Staatliche Graphische Sammlung München

See illustration on page 35.

This sheet is one of the strongest of the preparatory studies for *Battlefield*.[1] The composition records the aftermath of the peasants' clash with the oppressors, a night scene depicting a mother with a lantern searching the body-strewn field for her dead son. Kollwitz blocked out the entire composition and smudged the surface in order to convey an oppressive nocturnal mistiness. As in the final version of *The Plowers*, the revolutionaries have yet again been literally "put down," so that they do not emerge above the horizon line. Only the verticality of the figure of the helpless mother disrupts the strict horizontality of the scene, much like Black Anna in *Outbreak*, only now she is hunched over, searching through piles of tangled limbs. The lamp illuminates her gnarled hand touching the chin of one young face, possibly the son she fears to find.

1. See also Nagel-Timm 1972/1980, 408, 409, 411–415.

64. *Battlefield*, 1907

proof for sheet 6 of *Peasants' War*, etching and soft-ground etching on pale green chine collé mounted on wove paper, 412 x 529 (16¼ x 20⅞), inscribed top: *III Luft z. Teil gehöht. Mittelfigur stark, anderes wenig stark gehöht*, K. 96 III

Private collection

See illustration on page 36.

This third-state impression of *Battlefield* exhibits Kollwitz' subtle handling of the intaglio processes before applying successive layers of tone. Eventually Kollwitz needed to cover the extensive background area of this large image as expediently as possible, and for this reason, in addition to aesthetics, chose to lay down a half-tone screen of fine regular dots. Although this background, which appears in later states, is interesting texturally, it tends to flatten the final edition state of the etching. In this crisp early impression, however, one may study a rarely seen stage in the process by which Kollwitz constructed the extraordinarily complex prints of this period in her career.

65. *Out of Work*, 1909

charcoal and white wash over graphite on dark brown wove paper, 295 x 445 (11⁷⁄₁₆ x 17½), signed and inscribed l.r.: *Kathe Kollwitz/Arbeitslosigkeit 1909*; verso inscribed: *Kathe Kollwitz/Berlin/Weissenburger str. 25*; recto inscribed l.l. edge: *(schwarz + braun)*, NT 545

National Gallery of Art, Washington, Rosenwald Collection

See illustration on page 50.

To *Out of Work* as well as to the other single sheets Kollwitz submitted to *Simplicissimus*, the editors of this magazine affixed a title, "The Only Good Thing," and a legend: "If they didn't need soldiers, they would also tax the children."[1] The artist made a number of preliminary studies for the motif *Out of Work*. The simplified, concentrated drawing represented here was the one reproduced by *Simplicissimus*, whereas the related etching (K. 100) was based upon a drawing in Frankfurt (NT 544), with additional alterations to the figure of the man. Kollwitz worked out the design with extensive areas of white gouache, which form a strong contrast to the brown paper and to the brooding male figure at left whose shadowed face stands out against the garment of his sick wife. The pathos of the scene relates to the left wing of *The Downtrodden*, with its depiction of the despairing worker family.

1. See Nagel-Timm 1972/1988, 545, 294.

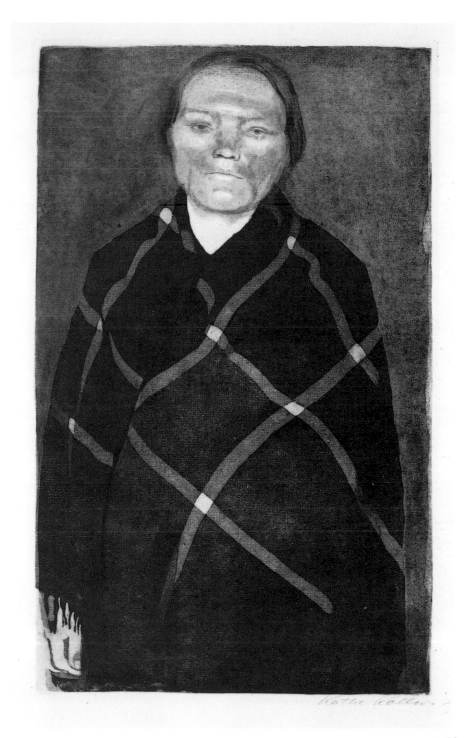

cat. 66

66. *Pregnant Woman*, 1910
soft-ground etching, 377 x 236 (14⁷⁄₈ x 9¼), signed l.r.: *Kathe Kollwitz*, inscribed l.l.: *O Felsing Berlin gdr.*, K. 108 IV a

Private collection

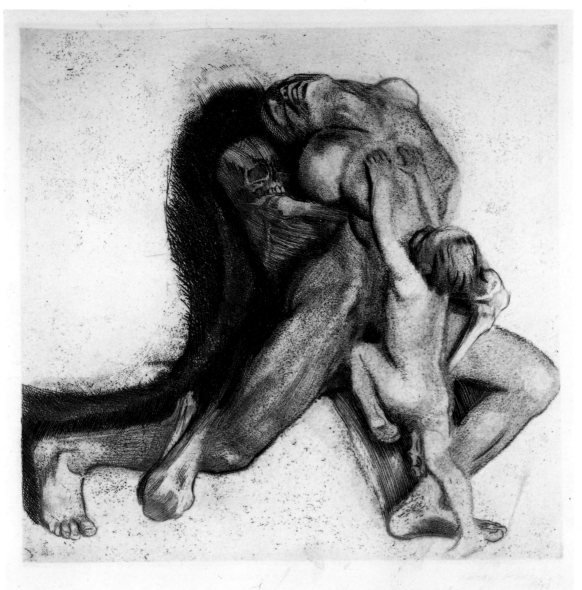

cat. 67

67. *Death and Woman*, 1910

etching and soft-ground etching,
447 x 446 (17⅝ x 17½), signed l.r.:
Kathe Kollwitz/1910, inscribed l.l.:
O Felsing Berlin gdr., K. 103 V a

Private collection

68. *Death, Mother, and Child*, 1910
charcoal on laid paper, 480 x 633
(18⅞ x 24⅞), signed l.r.: *Kathe
Kollwitz*, NT 605

National Gallery of Art, Wash-
ington, Rosenwald Collection

See illustration on page 51.

This is one of the most moving
drawings Kollwitz ever made on
the theme of death and leave-

taking. The image is often mis-
understood and shown on its side.
Death, minimally indicated by a
bony arm at what is in fact the
upper left, grasps a child around
the middle, dragging him upward
and away. The mother reaches up
in an attempt to wrest him back;
she cups his head in her hands and,
in a gesture of yearning tender-
ness, presses her cheek to his. One
can see where Kollwitz experi-
mented with another position for

the child's head and for one of the mother's hands in her search for the most affecting configuration.

In other versions of this subject (NT 593–651), where more of the child's body is visible, the reference to the motif of Christ's descent from the cross is obvious.

69. *Self-Portrait en face*, 1911

black, violet, and gray chalk on brown paper, 360 x 309 (14⅛ x 12⅛), signed and dated l.r.: *K. Kollwitz 11*, NT 690

Staatliche Kunstsammlungen Dresden

See illustration on page 70.

70. *March Cemetery*, 1913

lithograph overworked with red watercolor and brush and black ink, 558 x 460 (22 x 18½), signed l.l. and l.r.: *Kathe Kollwitz*, K. 125 I

Private collection

See illustration on page 92.

71. *Head of Karl Liebknecht on His Deathbed*, 1919

charcoal on japan paper, 278 x 414 (10⅞ x 16½), signed and inscribed l.r.: *Kollwitz/Karl Liebknecht*, NT 767

Private collection

See illustration on page 51.

72. *Memorial Sheet to Karl Liebknecht*, 1919

charcoal on laid paper cut and reattached and glued over another sheet, 480 x 633 (18⅞ x 24⅞), NT 773

Private collection

See illustration on page 52.

73. *Memorial Sheet to Karl Liebknecht*, 1919

etching and soft-ground etching, 337 x 530 (13¼ x 20⅞), K. 137 I

Private collection

See illustration on page 52.

74. *Memorial Sheet to Karl Liebknecht*, 1919

lithograph overworked with charcoal, 420 x 660 (16½ x 25¹⁵/₁₆), signed l.r.: *Kollwitz* and inscribed: *untere Abschnitte Ecke rechts Radier. besser/Mann links Rad besser/Mann weinend rechts Rad. gut, doch Oberkörper/ vorn überhängender*, K. 138

Private collection

See illustration on page 53.

75. *Memorial Sheet to Karl Liebknecht*, 1920

pen and ink and wash, heightened with pink and white on gray laid paper, sheet (sight): 379 x 539 (14¹³/₁₆ x 21¼), NT 781

Käthe-Kollwitz-Museum Berlin

See illustration on page 55.

76. *Memorial Sheet to Karl Liebknecht*, 1919

woodcut, inscribed with white chalk on japan paper, 350 x 550 (13⅞ x 21⅞), inscribed center: *15 Januar 1919*; signed l.l. and l.r.: *K*, K. 139 II

Private collection

See illustration on page 56.

Kollwitz made numerous studies for the *Memorial Sheet to Karl Liebknecht* as she investigated the potential of the woodcut, a medium new to her. After attempting to render the image as an etching and later as a lithograph, she finally turned to the plank. But even then she touched up trial proofs, searching for the most satisfying composition. In cat. 75, to which she added touches of white and pink on the rightmost figures and white on the fourth figure from the left, she still did not arrive at the final configuration; the mourners underwent further adjustments through four states. Cat. 76 is the second state of the woodcut, an impression that came from the artist's own collection. In white chalk she wrote in the date of Liebknecht's assassination at the bottom as a prelude to an inscription that appeared in the final state. There Kollwitz carved on the bottom edge the legend "Die Lebenden dem Toten. Erinnerung an den 15 Januar 1919 (The living to the dead. Remembrance of 15 January 1919)." The first part of the legend inverts the title of a poem by Ferdinand Freiligrath (1810–1876) about the dead of the

1848 Revolution (*Die Toten an die Lebenden*), whom Kollwitz eulogized in her lithograph *March Cemetery*. In her memoirs from 1923, Kollwitz mentioned the impression made upon her when her father read the poem aloud to her as a child.

As Richard A. Simms has suggested, the compressed, friezelike quality of the figures recalls Masaccio's fresco cycle in the Brancacci Chapel in Florence, which Kollwitz surely visited in 1907 during her trip to Italy.

77. *The Volunteers*, 1920

study for sheet 2 of *War*, graphite on brownish laid paper, 506 x 666 (19¹⁵⁄₁₆ x 26½), signed l.r.: *Käthe Kollwitz*, NT 849

Private collection, Berlin

See illustration on page 60.

78. *The Volunteers*, 1920

study for sheet 2 of *War*, charcoal on cream laid paper, 450 x 600 (17¹¹⁄₁₆ x 23⅝), signed l.r.: *Kathe Kollwitz/1920*, NT 851

Private collection, Berlin

See illustration on page 61.

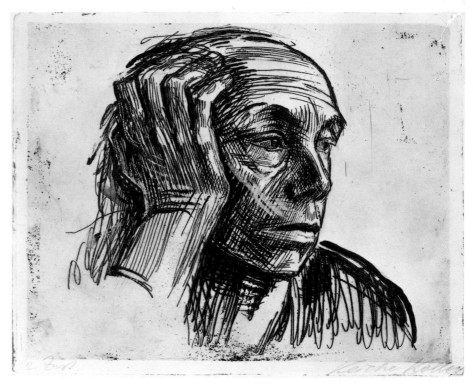

cat. 80

79. *The Volunteers*, 1920

study for sheet 2 of *War*, pen and brush and ink, 400 x 554 (15¾ x 21¾), signed and inscribed l.r.: *Käthe Kollwitz/Die Freiwilligen*, NT 852

Dr. Eberhard Kornfeld

See illustration on page 62.

80. *Self-Portrait*, 1921

etching touched with black ink and white, 217 x 266 (8⅞ x 10½), K. 155 II

Museum of Fine Arts, Boston, Frederick Brown Fund

81. *The Mothers*, 1921

study for sheet 6 of *War*, pen and brush and ink heightened with white on separate pieces of paper pasted together, 450 x 589 (17⅞ x 23⅛), signed and inscribed l.r.: *Käthe Kollwitz/ Zeichnung zu den Müttern*, NT 858

Museum of Fine Arts, Boston, Frederick Brown Fund

See illustration on page 58.

One of the most remarkable studies for the *War* series is *The Mothers*. Here the women band together in a protective mass, pressing inward, allowing no exit for the children or entrance to threats to their safety. Like the Bern study for *The Volunteers*, it is a drawing in brush and ink height-

ened with white. Kollwitz glued together several layers of paper, making corrections on other pieces and laying them over the larger sheet as she saw possibilities for changes. This represented a new manner of working for the artist, since she had to build up layers of black, which signified the planes of the woodblock, and add white accents or leave bare paper to guide her in the cutting away of the relief surface. Some changes are visible from the woodcut design (fig. 1). For example, in the drawing the woman slightly to the left of center curves her right arm protectively around an infant's head, supporting her elbow with her left hand. In the woodcut, by contrast, the left hand now cups the child's head and the right forearm grasps his back. The result is greater symmetry with the figure to the right of center who looks to the right as she stretches an arm around the central mother. In all, Kollwitz reduced the areas of white in the printed composition

from those in the drawing, emphasizing the garment of the child in the foreground, who, its mother's hand over its head, is barely visible. Gone is the jagged cutting that carried meaning in *The Volunteers*. In the printed version of *The Mothers*, the edges have been smoothed to signal the cohesion and inviolability of the group. This is suggested as well in the study by the line of white that smooths the rightmost contour of the cluster.

82. *The Sacrifice*, 1922

trial proof for sheet 1 of *War*, woodcut overworked with white on thick japan paper, 419 x 438 (16½ x 17⅛), signed l.r.: *Kathe Kollwitz*; inscribed l.l.: *2.Zustand*, K. 177 II

National Gallery of Art, Washington, Rosenwald Collection

See illustration on page 57.

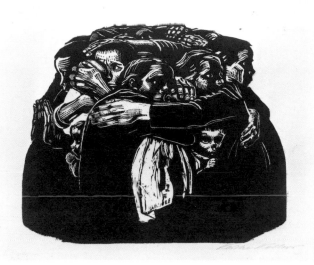

fig. 1. Kollwitz, *The Mothers*, 1922-1923, woodcut. Private collection

83. *The Volunteers*, 1922
sheet 2 of *War*, woodcut on thick japan paper, 350 x 490 (13¾ x 19¼), signed and inscribed l.r.: *Kathe Kollwitz/Bl. 2 zu Folge Krieg/die Freiwilligen*, K. 178 IV a

Private collection

See illustration on page 63.

84. *The Widow* I, 1922

portfolio cover for *War*, woodcut on heavy brown paper, sheet 672 x 485 (26 7/16 x 19), K. 180, edition A

National Gallery of Art, Washington, Rosenwald Collection

See illustration on page 59.

85. *The People*, 1922

trial proof for sheet 7 of *War*, woodcut overworked in white on japan paper, 360 x 300 (14⅜ x 11⅞), K. 183 V

National Gallery of Art, Washington, Rosenwald Collection

See illustration on page 59.

86. *Self-Portrait*, 1923

woodcut touched with black ink on japan paper, 150 x 155 (5⅜ x 6⅛), signed l.r.: *Kathe Kollwitz*, K. 168 XIII

National Gallery of Art, Washington, Rosenwald Collection

See illustration on page 70.

Since Kollwitz often experimented with a new medium by portraying

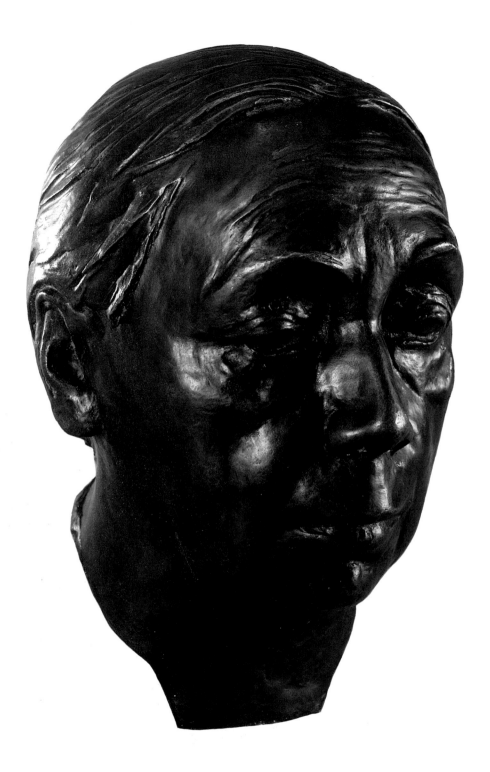

Chronology

1867 Käthe Schmidt born on 8 July in Königsberg, daughter of Karl Schmidt, a master mason trained in the law, and Katharina Schmidt, née Rupp, daughter of Julius Rupp, founder and leader of the first Protestant Free Religious Congregation in Germany. Käthe was the third of four children, Konrad (1863–1932), Julie (1865–1917), Käthe, and Lise (1870–1963). She would always be closest to her younger sister.

Käthe Kollwitz, c. 1872

LEFT: cat. 105. *Self-Portrait*, 1926–1936. Hirshhorn Museum and Sculpture Garden, Smithsonian Institution, Washington, Gift of Joseph H. Hirshhorn, 1966

1881–1882 First art lessons with engraver Rudolf Maurer in Königsberg.

1884 Trip to Switzerland with mother and sister Lise. Visits Konrad in Berlin; an enthusiast of Engels, he is studying philosophy and political economy and exposes Käthe to socialism. Sojourn in Munich, where Kollwitz sees the work of Peter Paul Rubens. The sisters meet the playwright Gerhart Hauptmann and his circle.

1885–1886 Attends the School for Women Artists in Berlin, studying with the Swiss artist Karl Stauffer-Bern, with the intention of becoming a painter. On Stauffer-Bern's suggestion, sees Max Klinger's cycle of etchings, *A Life*, which will influence her later decision to become a graphic artist. Brother Konrad takes her to visit the graves of those who died in the March Revolution of 1848, a subject she will later depict in a lithograph.

1886 Returns to Königsberg, where she studies with Emil Neide. Becomes engaged to Karl Kollwitz, a medical student.

1888–1889 Studies for two years in Munich in the painting class of Ludwig Herterich. Paints genre pictures, now missing, and family portraits. Meets female colleagues such as the painter Maria Slavona and her lifelong friend Emma Jeep (after her marriage Beate Bonus-Jeep), whose book *Sechzig Jahre Freundschaft mit Käthe Kollwitz* is an important source of biographical information on Kollwitz.

1890 Returns to Königsberg. Rents a studio and produces first etchings. Pursues interest in scenes from the lives of workers.

1891 13 June marries Dr. Karl Kollwitz. They move to Berlin, to 25 Weissenburger Strasse, today Käthe-Kollwitz-Strasse in the Prenzlauer Berg district of the city, where Karl establishes his practice. There comes into direct contact with the industrial poor who make up the majority of her husband's patients, from whom she chooses her models. Reads Max Klinger's treatise *Painting and Drawing*, which solidifies her commitment to the graphic arts.

1892 Her first son, Hans, is born.

1893 Attends opening performance of Gerhart Hauptmann's *The Weavers*, 26 February. Abandons projected series based on Emil Zola's *Germinal* to pursue a cycle based on Hauptmann's play. Exhibits two paintings and some etchings in the Free Berlin Art Exposition. Receives a positive review from the critic Julias Elias.

1896 Her second son, Peter, is born. Makes first lithograph, *Portrait of Hans Kollwitz* (к. 30).

Karl Kollwitz, c. 1890

Käthe Kollwitz, c. 1890

1893–1898 Works on *A Weavers' Rebellion*.
Experiments with both etching and
lithography, using both media in the
final cycle.

1898 *A Weavers' Rebellion* is exhibited to
the public at the Greater Berlin Art
Exposition. The jury, of which Adolph
von Menzel was a member, agrees to
award her the small gold medal but,
through the intervention of the minister
of culture, the prize is vetoed by Kaiser
Wilhelm II. Despite this, the Dresden
Print Cabinet, under the direction of
Max Lehrs, starts collecting her work.
Begins to teach etching and drawing at
the School for Women Artists in Berlin,
where she was formerly a student.

1899 Awarded medal from German Art
Exposition in Dresden at the suggestion
of the prominent impressionist Max
Liebermann. Becomes member of the
Berlin Secession. Makes *Uprising*, a sheet
that will lead to the creation of her next
cycle, *Peasants' War*.

1900–1903 A particularly prolific and rich period
begins. Executes many self-portraits,
nudes, *Woman with Dead Child* series, *Die
Carmagnole*. From these years date her
experiments with color printing, pastels,
and colored chalks. The Berlin Print
Cabinet begins to collect her work and
Max Lehrs publishes the first catalogue
raisonné of her prints to date in the peri-
odical *Die bildenden Künste*. On the basis
of *Outbreak* (1903), receives commission
from the Society for Historical Art for
Peasants' War, for which she begins work
on experimental sheets in 1902.

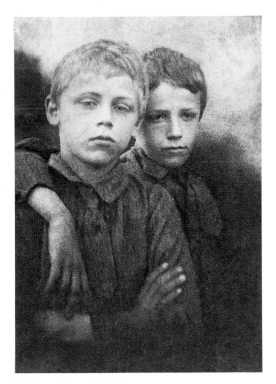

Hans and Peter Kollwitz, c. 1904

1904 Sojourn in Paris for several weeks.
Studies sculpture at the Académie Julian,
meets Rodin in his studio, sparking a
lifelong interest in that medium. Makes
drawings and pastels from life in the mar-
kets and bohemian night spots of the city.
Meets Théophile Steinlen.

1905 Continues work on *Peasants' War*.
Performs intricate experiments with
intaglio processes.

1906 The poster Kollwitz makes for the
German Home Workers Exhibition is
removed from billboards by the express
command of the German empress.

1907 Awarded the Villa Romana Prize, estab-
lished by Max Klinger, for several
months' study in Florence. The impact of
her stay, which she herself minimized at
the time, may be underemphasized; the
Memorial Sheet to Karl Liebknecht (1919),

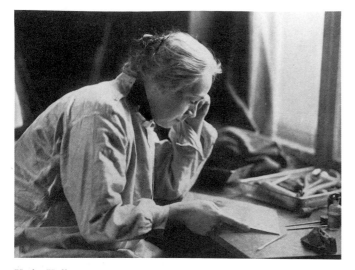

Käthe Kollwitz, c. 1906

in particular, seems to reflect awareness of early Italian frieze painting. In the company of an Englishwoman, Stan Harding-Krayl, hikes from Florence to Rome.

1908 Completes the large-format cycle *Peasants' War*, her most ambitious work technically. It cements her reputation as one of the foremost German print-makers. Begins the diaries, which continue to 1943.

1909 Begins working in sculpture. Models a portrait relief of her grandfather Julius Rupp for a celebration of the founder of the Free Congregation; it is destroyed in World War II. Starts a series of drawings for the satirical magazine *Simplicissimus*, which appear over the next several years until 1911.

1910 Continues making drawings for *Simplicissimus*, including *Out of Work*, while simultaneously exploring more cosmic themes such as *Death, Woman, and Child*.

1912 Receives commission for a poster *For Greater Berlin*. Works on sculpture.

1913 Johannes Sievers' catalogue raisonné of graphic works is published by Emil Richter in Dresden. Sculptures *Lovers I* and *Lovers II* are completed.

1914 With the outbreak of World War I, sons volunteer for army service. The younger, eighteen-year-old Peter, is killed on 22 October in Dixmuiden in Belgium. Later that year, Kollwitz begins planning a sculptural memorial to him.

1915 Works further on the memorial to Peter. It will occupy her for the next seventeen years until it is finally in place in 1932.

1916 Kollwitz devotes much time to her diary, which abounds with reflections on grief and the meaning of war.

1917 A series of exhibitions honors the artist's fiftieth birthday, including showings at the Cassirer Gallery in Berlin; the Kunsthalle in Bremen; the Berlin Secession. She receives great attention and favorable publicity.

1918 The Social-Democratic newspaper *Vorwärts* publishes Kollwitz' response to the poet Richard Dehmel's appeal to all capable Germans to sacrifice themselves to the death for the Fatherland. She answers that enough people have died and that no more should fall. She quotes from a greater poet than he, Goethe, with the words, "Seed corn must not be ground." This will be the title of her last lithograph in 1942.

1919 Becomes a member of the Prussian Academy of Arts and is named professor. Has her own studio through the academy. On the request of the Liebknecht family, she draws the murdered Spartacist leader Karl Liebknecht on his deathbed. Makes her first woodcuts, *Two Dead Ones* (K. 140) and *Memorial Sheet to Karl Liebknecht* (K. 130), which she finishes the following year.

1920 Produces posters for various social causes relating to the aftermath of the war, including broadsides against usury and *Vienna is Dying, Save Her Children.* The Emil Richter Press publishes a portfolio of twenty-four reproductions of drawings (Richter-Mappe). The *Memorial Sheet to Karl Liebknecht* is published. Son Hans marries Ottilie Ehlers, a Berlin printmaker.

1921 Poster *Help Russia* for the IAH (Internationale Arbeiterhilfe, International Workers' Aid organization). Peter, the first grandchild, is born.

1922 Poster *The Survivors—War on War.* Works on portfolio *War.* Notes in her diary, "I intend to have an effect on these times, in which human beings are so at a loss and so helpless."

1923 The cycle *War* is published, with seven woodcuts. Twin granddaughters Jutta and Jördis are born.

1924 A cycle of eight drawings illustrating Gerhart Hauptmann's *Departure and Death* appears. Posters *Never Again War!* for Youth Day in Leipzig, and *Bread!* for the IAH portfolio *Hunger.* Further work on the monument to Peter. First German art exhibition in the Soviet Union opens with many sheets by Kollwitz.

1925 Cycle entitled *Proletariat*, with three woodcuts, appears. Film *Creative Hands* by Hans Cürlis is produced with sequences on Kollwitz, George Grosz, and others. Travels to Ascona. Sea voyage to Coruna, Madeira, Santa Cruz de Tenerife, Canary Islands, Cadiz.

1926 Visits Belgium with husband Karl to see the military cemetery where Peter is buried and where she proposes to place her monument to him.

1927 Many exhibitions and notices in the press celebrate Kollwitz' sixtieth birthday. The city of Berlin makes a gift to her of the granite from which the monument to Peter, the figures of the mourning father and mother, will be carved. In November, Käthe and Karl travel to Moscow for the tenth anniversary of the October Revolution. Her works are exhibited and she is excited by the new regime there.

1928 Becomes director of the master studio for graphic arts at the Academy of Arts. Works principally on sculpture.

1929 Awarded the Order Pour le Mérite for her work for peace.

1930 The youngest grandchild, Arne-Andreas, is born.

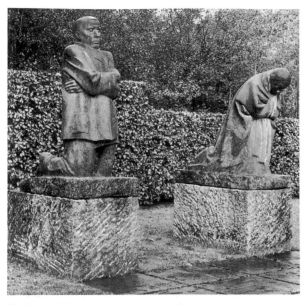

Kollwitz, *Mourning Parents*, installed 1932, granite. Military cemetery at Dixmuiden, Belgium

1931 Exhibits the plaster models for Peter's monument at the academy.

1932 The figures for the mourning parents, now carved in granite, are finally placed in the military cemetery at Dixmuiden in Belgium. Death of brother Konrad.

1933 After the takeover of power by the National Socialists, Käthe and Karl add their signatures to an "Urgent Appeal" to unify leftist party candidates against the fascists. As a consequence, Kollwitz and Heinrich Mann are forced to resign from the Academy of Arts; she loses her directorship of the graphic arts classes and her studio. Karl is hindered in continuing to practice medicine and Hans loses his position as a physician. Käthe takes a studio at the communal studios in the Klosterstrasse, joining a number of young artists.

1934 Begins her last series, eight large-format lithographs on the subject Death. Feels the isolation of being watched, if not directly threatened.

1935 Begins work on the bronze relief for the family grave in the Central Cemetery in Berlin, entitled, after Goethe, *Rest in the Peace of His Hands*.

1936 Kollwitz' sculptures are removed from the exhibition *Berlin Sculptors—From Schlüter to the Present*. Because of an interview published in the Soviet Newspaper *Izvestia*, Kollwitz is interrogated by the Gestapo and threatened with removal to a concentration camp. Unofficially prevented from exhibiting her work.

1937 An exhibition planned by the Galerie Nierendorf on the occasion of her seventieth birthday is prohibited and Kollwitz exhibits some of her work in her studio at the Klosterstrasse. Finishes work on the monumental sculpture *Mother with Twins*; the painter Leo von König provides her

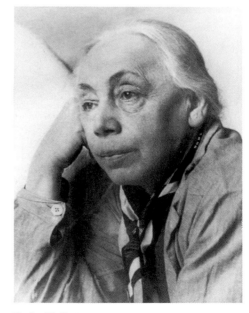

Käthe Kollwitz, c. 1937

with the funds to have it cut into stone. Makes drawings of the sculptor Ernst Barlach on his deathbed in Güstrow. The *Degenerate Art* exhibition, in which some of her work is initially included, is circulated by the Nazis.

1939 Outbreak of World War II.

1940 Karl becomes ill and gives up his practice. He dies on 19 July. Käthe leaves her studio in the Klosterstrasse and sets up a workspace in the living room of her home.

1942 Makes last lithograph, *Seed Corn Must Not Be Ground* (κ. 267). Her grandson Peter killed on the Eastern Front in September.

1943 In the summer, Kollwitz is evacuated to Nordhausen to escape the bombings in Berlin. There she stays with her sculptor-friend Margret Böning. In November, an air attack destroys her house in the Weissenburger Strasse, and much of her work, as well as printing plates, is lost.

1944 On the invitation of Prince Ernst Heinrich of Saxony, Kollwitz is moved to the Rüdenhof, a small house near the Schloss Moritzburg outside Dresden.

1945 Kollwitz dies on 22 April and is buried in the cemetery at Moritzburg. Her final resting place is in the Central Cemetery in Berlin-Friedrichsfelde.

Peter Kollwitz, the artist's grandson, 1941

Select Bibliography

Barthel 1964/1977/1987
Barthel, Rolf, *Zwischenspiel auf
Bischofstein: Käthe Kollwitz und
ihre Freunde auf dem Eichsfeld
und in Nordhausen* (Mühlhausen,
1964, 1977, 1987).

Bauer 1967
Bauer, Arnold, *Käthe Kollwitz.*
Köpfe des 20. Jahrhunderts, Bd.
46 (Berlin, 1967).

Berlin 1967/1968
Käthe Kollwitz [exh. cat.
Akademie der Künste] (Berlin,
1967/1968).

Berlin 1988
Schmidt, Gudrun,
*Ateliergemeinschaft Klosterstrasse:
Vom Stillen Kampf der Künstler*
[exh. cat. Galerie Mitte] (Berlin,
1988).

Berlin 1989
Fritsch, Gudrun, ed., *Zwischen
den Kriegen: Druckgraphische
Zyklen von Kollwitz, Dix,
Pechstein, Masereel u.a.* [exh. cat.

Käthe-Kollwitz-Museum
Berlin] (Berlin, 1989).

Bohnke, Jutta, "Käthe Kollwitz
und Köln," brochure, Käthe-
Kollwitz-Sammlung der
Kreissparkasse Köln, n.d.

Bonus 1925
Bonus, Arthur, *Das Käthe-
Kollwitz-Werk* (Dresden, 1925).

Bonus-Jeep 1948/1963
Bonus-Jeep, Beate, *Sechzig
Jahre Freundschaft mit Käthe
Kollwitz* (Bremen, 1948, repr.
1963).

Bussmann, Georg, and Bettina
Schlegelmilch, "Zur Rezeption
des Werkes von Käthe
Kollwitz," in Frankfurt
1973/1974.

Cambridge 1981/1982
*Käthe Kollwitz 1867–1945: The
Graphic Works*, ed. Frank
Whitford [exh. cat. Kettle's
Yard] (Cambridge, England,
1981/1982).

Cologne 1985
Käthe Kollwitz Handzeichnungen
[cat. Käthe Kollwitz Museum
Köln] (Cologne, 1985).

Cologne 1988
*Die Kollwitz-Sammlung des
Dresdner Kupferstich-Kabinettes:
Graphik und Zeichnungen 1890–
1912*, ed. Werner Schmidt [exh.
cat. Käthe Kollwitz Museum
Köln] (Cologne, 1988).

Comini, Alessandra, "State of the
Field 1980. The Women Artists
of German Expressionism,"
Arts Magazine (November
1980), 147–153.

Dittrich, Christian, with Werner
Schmidt, "Vermisste
Zeichnungen des Kupferstich-
Kabinettes Dresden," *Staatliche
Kunstsammlungen Dresden*
(1987).

Elias 1917
Elias, Julius, "Käthe Kollwitz,"
Kunst und Künstler 16 (1917),
540–549.

Fecht 1988
Fecht, Tom, ed., *Käthe Kollwitz, Works in Color*, trans. A. S. Wensinger and R. H. Wood, New York, 1988 (orig. pub. 1987).

Fischer, Hannelore, "Engagierte Kunst in der Frühphase der Weimarer Republik. Plakate und Flugblätter von Käthe Kollwitz 1919–1924" (unpub. M. A. thesis), Cologne, 1984.

Frankfurt 1973/1974
Käthe Kollwitz [exh. cat. Frankfurt Kunstverein] (Frankfurt, 1973).

Friedrich, Glaubrecht, "Käthe Kollwitz als Zeichnerin," *Dresdner Kunstblätter* 4 (1960), 148–150.

Gay, Peter, *Weimar Culture. The Outside as Insider* (New York and Evanston, 1968).

Glaser 1923
Glaser, Kurt, "Käthe Kollwitz," in *Die Graphik der Neuzeit vom Anfang des 19. Jahrhunderts bis zur Gegenwart* (Berlin, 1923), 466–470.

Hamburg 1981/1982
Dreimal Deutschland. Lenbach — Liebermann — Kollwitz [exh. cat. Kunstverein] (Hamburg, 1981/1982).

Hasse, Sella, "Begegnung mit Käthe Kollwitz," *Bildende Kunst* 2 (1955), 105–107.

Hinz 1980
Hinz, Renate, ed., *Käthe Kollwitz: Druckgraphik, Plakate, Zeichnungen* (Berlin, 1980).

Hoechst 1985
Käthe Kollwitz 1967–1945: Zeichnungen, Druckgraphik, Skulpturen aus dem Bestand der Galerie Pels-Leusden, Berlin und anderen Sammlungen [exh. cat. Jahrhunderthalle] (Hoechst, 1985).

Jansen 1988
Jansen, Elmar, *Ernst Barlach — Käthe Kollwitz: Die Geschichte einer verborgenen Nähe* (Berlin, 1988).

"Käthe Kollwitz Museum Köln," Sonderheft, *Kölner Museums-Bulletin* 1–2 (1991).

Kearns 1976
Kearns, Martha, *Käthe Kollwitz: Woman and Artist*, New York, 1976.

Kleberger 1980
Kleberger, Ilse, «*Eine Gabe ist eine Aufgabe*» : *Käthe Kollwitz* (Berlin, 1980).

Klein 1975
Klein, Mina C., and H. Arthur Klein, *Käthe Kollwitz: Life in Art* (New York, 1975).

Kliemann, Helga, *Die November-gruppe* (Berlin, 1969).

Knesebeck 1989
Knesebeck, Alexandra von dem, "Die Bedeutung von Zolas Roman «Germinal» für den Zyklus «Ein Weberaufstand» von Käthe Kollwitz," *Zeitschrift für Kunstgeschichte* 3, Bd. 52 (1989), 402–422.

Kollwitz 1952/1981
Kollwitz, Käthe, *Ich will wirken in dieser Zeit* [selections from diaries, letters by Friedrich

Ahhlers-Hestermann] (Frankfurt, 1952), ed. Hans Kollwitz (Frankfurt, 1981).

Kollwitz 1955/1988
Käthe Kollwitz, *The Diary and Letters of Käthe Kollwitz*, ed. Hans Kollwitz, trans. Richard and Clara Winston (Chicago, 1955/1988).

Kollwitz 1966
Kollwitz, Käthe, *Briefe der Freundschaft und Begegnungen*, ed. Hans Kollwitz (Munich, 1966).

Kollwitz 1967
Kollwitz, Käthe, *An Dr. Heinrich Becker; Briefe* (Bielefeld, 1967).

Kollwitz 1981
Kollwitz, Käthe, *Bekenntnisse* (Leipzig, 1981).

Kollwitz 1988
Kollwitz, Käthe, *Ich sah die Welt mit liebevollen Blicken: Käthe Kollwitz, Ein Leben in Selbstzeugnissen*, ed. Hans Kollwitz (Wiesbaden, 1988).

Kollwitz 1989
Kollwitz, Käthe, *Die Tagebücher*, ed. Jutta Bohnke-Kollwitz (Berlin, 1989).

Krahmer 1981
Krahmer, Catherine, *Käthe Kollwitz in Selbstzeugnissen und Bilddokementen* (Hamburg-Reinbek, 1981).

Kuhn 1921
Kuhn, Alfred, *Käthe Kollwitz: Graphiker der Gegenwart*. Bd. 6 (Berlin, 1921).

London 1984
Carey, Frances, and Antony Griffiths, *The Print in Germany*

1880–1933: The Age of Expressionism [exh. cat. The British Museum] (London, 1984).

Los Angeles 1983
Barron, Stephanie, ed., *German Expressionist Sculpture* [exh. cat. Los Angeles County Museum of Art] (Chicago and London, 1983).

Los Angeles 1988
Barron, Stephanie, ed., *German Expressionism 1915–1925: The Second Generation* [exh. cat. Los Angeles County Museum of Art] (Los Angeles, 1988).

Los Angeles 1991
Barron, Stephanie, *"Degenerate Art": The Fate of the Avant-Garde in Nazi Germany* [exh. cat. Los Angeles County Museum of Art] (Los Angeles, 1991).

Martschenko, Jelena, "Ich sah Russland im Lichte dieses Sterns. Uber die Wirkung des Schaffens von Käthe Kollwitz in der Sowjetunion," *Bildende Kunst* 15 II (1967), 595–599.

McCausland 1937
McCausland, Elizabeth, "Käthe Kollwitz," *Parnassus* 9, no. 2 (February 1937), 20–25.

Miller, Alice, *The Untouched Key: Tracing Childhood Trauma in Creativity and Destructiveness*, trans. from the German by Hildegarde and Hunter Hannum (New York, 1990, orig. pub. 1988).

Nagel 1963
Nagel, Otto, *Käthe Kollwitz* (Dresden, 1963).

Nagel 1965
Nagel, Otto, *Die Selbstbildnisse der Käthe Kollwitz* (Berlin, 1965).

New York 1976
Käthe Kollwitz [exh. cat. Galerie St. Etienne and Kennedy Galleries] (New York, 1976).

New York 1987/1988
Käthe Kollwitz: The Power of the Print [exh. cat. Galerie St. Etienne] (New York, 1987/1988).

Nündel 1964
Nündel, Harri, *Käthe Kollwitz* (Leipzig, 1964).

Paret 1980
Paret, Peter, *The Berlin Secession: Modernism and Its Enemies in Imperial Germany* (Cambridge, Mass., and London, 1980).

Pommeranz-Liedtke, Gerhard, *Der graphische Zyklus von Max Klinger bis zur Gegenwart* (Berlin, 1956).

Radycki 1982
Radycki, J. Diane, "The Life of Lady Art Students: Changing Art Education at the Turn of the Century," *Art Journal* (Spring 1982), 9–13.

Reidemeister, Leopold, *Käthe Kollwitz. Das plastische Werk* (Hamburg, 1967).

Rigby, Ida Katherine, *An alle Künstler! War–Revolution–Weimar* [exh. cat. San Diego State University] (San Diego, 1983).

Roussillon, France, "La Sculpture de Käthe Kollwitz" (unpub. Ph.D. diss., Paris-Sorbonne, 1983).

Schmidt 1967
Schmidt, Werner, "Zur künstlerischen Herkunft von Käthe Kollwitz," *Jahrbuch Staatliche Kunstsammlungen Dresden* (1967), 83–90.

Schneede, Uwe M., *Käthe Kollwitz: Die Zeichnerin* [exh. cat. Hamburg Kunstverein] (Munich, 1981).

Selle, Carol O., and Peter Nisbet, *German Realist Drawings of the 1920s* [exh. cat. Harvard University Art Museums, Busch-Reisinger Museum] (Cambridge, Mass., 1986).

Singer 1914
Singer, Hans W., *Die moderne Graphik* (Leipzig, 1914).

Struck 1908
Struck, Hermann, *Die Kunst des Radierens* (Berlin, 1908).

Stuttgart 1967
Thiem, Gunther, *Die Zeichnerin Käthe Kollwitz* [exh. cat. Staatsgalerie, Graphische Sammlung] (Stuttgart, 1967).

Timm 1974/1980
Timm, Werner, *Käthe Kollwitz*. Welt der Kunst (Berlin, 1974, 1980).

Varnedoe and Streicher 1977
Varnedoe, J. Kirk, and Elizabeth Streicher, *Graphic Works of Max Klinger* (New York, 1977).

Walker 1979
 Walker, John A., "Art & The
 Peasantry 2," *Art & Artists* 154,
 vol. 13, no. 10 (February 1979),
 14–17.

Weinstein, Joan, *The End of
Expressionism: Art and the
November Revolution in Germany,
1918–1919* (Chicago and
London, 1990).

Zigrosser 1946/1961
 Zigrosser, Carl, *Käthe Kollwitz*
 (New York, 1946, 1961).

Zigrosser 1969
 Zigrosser, Carl, *Prints and
 Drawings of Käthe Kollwitz* (New
 York, 1969).

Index

Photo Credits

All photographs supplied by owners of works of art except the following:

"Kollwitz Reconsidered": fig. 6, Jörg P. Anders, Berlin; fig. 9, H.-P. Cordes Fotograf, Hamburg.

"Kollwitz in Context": fig. 1, Jörg P. Anders, Berlin; fig. 2, *Merian: Monatsheft der Städte und Landschaften* (Hoffman & Campe Verlag, Hamburg); fig. 3, *Königsberg in alten Ansichtskarten* (Flechsig Verlag Würzburg, Frankfurt, 1985); figs. 4, 8, 22, Udo Christoffel, ed., *Berlin in Bildpostkarten* (Vieth Verlag, Berlin, 1987); fig. 6, J. Kirk Varnedoe, *Graphic Works of Max Klinger* (Dover, New York, 1977); fig. 7, Ulrich Eckhardt, *Der Modes Mendelsshon Pfad* (Berlin, 1987, pamphlet); fig. 10, Tom Fecht, *Käthe Kollwitz: Works in Color* (Schocken Books, New York, 1988); fig. 11, *Berlin zur Kaiserzeit*, ed. Klaus J.

Lemmer (Berlin, 1978); figs. 13, 18, 28, Martin Hürlimann, *Berlin, Köonigsresidenz-Reichshauptstadt-Neubeginn* (Atlantis Verlag, Zurich, 1981); fig. 14, Hans Ostwald, *Das Zillebuch* (Berlin, 1929); fig. 17, Lothar Fischer, *Heinrich Zille* (Rowoholts Monographien, Hamburg, 1979); fig. 19, Karl-Heinz Metzger and Ulrich Dunker, *Dur Kurfürstendamm* (Bezirksamt Wilmersdorf, Berlin, 1986); fig. 20, Friedrich Hartau, *Wilhelm II* (Hamburg, 1978); fig. 24, Annemarie Lang, *Das Wilhelminische Berlin* (Dietz, Berlin, 1984); fig. 25, Elmar Jansen, *Barlach-Kollwitz* (© Union Verlag, Berlin, 1989); fig. 29, Catherine Krahmer, *Kollwitz* (Hamburg, 1981).

"Collecting the Art of Käthe Kollwitz": fig. 4, Jörg P. Anders, Berlin; fig. 6, Courtesy Galerie St. Etienne, New York; fig. 7,

Käthe Kollwitz Museum Köln; fig. 8, Otto Nagel, *Käthe Kollwitz* (Dresden, 1963); fig. 9, Rheinisch Bildarchiv, Cologne; fig. 13, Josephine Zeitlin; fig. 16, Jim Strong, Hempstead, N. Y.

"Catalogue": cats. 2,7,93,102, Rheinisches Bildarchiv Köln; cat. 21, Herman Lilienthal, Bonn; cats. 105,107, Lee Stalsworth; cat. 107, fig.2, Koninklijk Institut voor het Kunstpatrimonium, Brussels.

"Chronology": p. 182, left, Käthe Kollwitz, *Ich sah die Welt mit liebevollen Blicken…*(Fackelträger-Verlag Schmidt-Küster GmbH Hannover, 1988); all other figs., Käthe Kollwitz Museum Köln, Kreissparkasse Köln.